LIFE

ALBUM
1996
Pictures of the Year

LIFE ALBUM
1996
Pictures of the Year

EDITOR Melissa Stanton

PICTURE EDITOR Patricia Cadley **DESIGNER** Marti Golon

SENIOR EDITOR Claudia Glenn Dowling

SENIOR WRITERS Richard C. Lemon, Harriet Barovick

ASSISTANT PICTURE EDITOR Maggie Berkvist

RESEARCH Seth Goddard, Romy Pokorny, Pamela Stock

ASSISTANT DESIGNER Ernest Vogliano

COPY EDITOR Nikki Amdur **TECHNOLOGY** Steve Walkowiak

CONTRIBUTING WRITERS: Allison Adato, Margot Dougherty, Charles Hirshberg,
Kenneth Miller, Robert Sullivan

And all members of the **LIFE COPY DEPARTMENT**

TIME INC. HOME ENTERTAINMENT

MANAGING DIRECTOR David Gitow

DIRECTOR, CONTINUITIES David Arfine

DIRECTOR, NEW BUSINESS DEVELOPMENT Stuart Hotchkiss

FULFILLMENT MANAGER Michelle Gudema

PRODUCT MANAGERS Robert Fox, Michael Holahan, Jennifer McLyman,
John Sandklev, Alicia Wilcox

EDITORIAL OPERATIONS MANAGER John Calvano

PRODUCTION MANAGER Donna Miano-Ferrara

ASSISTANT PRODUCTION MANAGER Jessica McGrath

PRODUCTION CONSULTANT Joseph Napolitano

FINANCIAL MANAGER Tricia Griffin

ASSISTANT FINANCIAL MANAGER Heather Lynds

ASSOCIATE PRODUCT MANAGERS Ken Katzman, Daniel Melore, Allison Weiss, Dawn Weland

ASSISTANT PRODUCT MANAGERS Alyse Daberko, Charlotte Siddiqui

MARKETING ASSISTANT Lyndsay Jenks

PICTURE SOURCES are listed by page. 46: United Feature Syndicate (top); Agostini/Gamma Liaison. 47: (clockwise from top left) Lynda Churilla/Outline; Nina Sabo; Paul Smith/Retna; Joe McNally/LIFE; Robin Kaplan/PHOTOlink (4); Clive Coote/Disney Enterprises Inc.. 54: Lisa Rose/Globe Photos. 55: (clockwise from top left) Paul Morse/LGI (2); Lisa Rose/Globe Photos; Dave Lewis/Rex USA Ltd.; Marissa Roth/Retna Ltd.; Steve Granitz/Retna Ltd.; Lisa Rose/Globe Photos (2); Gary Hershorn/Reuters/Archive Photos; Mylan Ryba/Globe Photos. 64: Frank Micelotta/Outline Press. 65: (clockwise from top left) Globe Photos; Lisa O'Connor/Celebrity Photo; Alex Berliner; Jim Smeal/Galella Ltd.; Scott Downie/Celebrity Photo; Ted Soqui/Sygma; Graham Kuhn/Sygma; Albert Ortega/Sipa Press; Charles W. Plant/Sipa Press; P. Caron/Sygma; 94-95: (clockwise from top left) Al Bello/Allsport USA; Rick Stewart/Allsport USA; Al Teilemans/Sports Illustrated; Bob Martin/Sports Illustrated; Manny Millan/Sports Illustrated; David Madison/Duomo; Simon Bruty/Allsport USA; Robert Beck/Sports Illustrated; Lori Adamski-Peek; Doug Pensinger/Allsport USA; Manny Millan/Sports Illustrated; David Turnley/Black Star; Bill Frakes/Sports Illustrated; Dan Helms; Michael Cooper/Allsport. 130: Villard/Sipa Press. 131: (clockwise from top left) Ted Soqui/Sygma; Heinz Kluetmeier; Eric Draper/AP/Wide World Photos; Craig Blakehorn/Comedy Central; Ed Bailey/AP/Wide World Photos; Andrea Renault/Globe Photos; Mark Lennihan/AP/Wide World Photos; Mark Seliger/Outline Press. 136: (left to right) Rick T. Wilkins/Reuters/Archive Photos; S. Cardinale/Sygma; Dave Chancellor/Alpha/Globe Photos; David Berkwitz/Sipa Press. 137: (clockwise from top left) D. Kampfner/Gamma Liaison; Fitzroy Barrett/Globe Photos; Nina Berman/Sipa Press; Nick Elgar/London Features.

FOUNDER Henry R. Luce 1898-1967

EDITOR-IN-CHIEF Norman Pearlstine
EDITORIAL DIRECTOR Henry Muller
CORPORATE EDITOR James R. Gaines
EDITOR OF NEW MEDIA Paul Sagan

TIME INC.
CHAIRMAN Reginald K. Brack Jr.
PRESIDENT, CEO Don Logan

MANAGING EDITOR Daniel Okrent
EXECUTIVE EDITOR Jay Lovinger
ASSISTANT MANAGING EDITOR Susan Bolotin
DIRECTOR OF PHOTOGRAPHY AND NEW MEDIA David Friend
DIRECTOR OF DESIGN Tom Bentkowski
SENIOR EDITORS Margot Dougherty (Los Angeles), Robert Friedman, Killian Jordan, Melissa Stanton, Robert Sullivan
CHIEF OF REPORTERS June Omura Goldberg
COPY CHIEF Robert Andreas
WRITERS Allison Adato, George Howe Colt, Claudia Glenn Dowling, Charles Hirshberg, Kenneth Miller
ASSOCIATE EDITORS Anne Hollister, Doris G. Kinney, Joshua R. Simon
ASSISTANT EDITORS Miriam Bensimhon (News Desk), Sasha Nyary
REPORTERS Harriet Barovick, Jimmie Briggs, Jen M.R. Doman, Cynthia Fox,
CONTRIBUTING EDITORS Lisa Grunwald, Janet Mason, Richard B. Stolley
PICTURE EDITOR Barbara Baker Burrows
ASSOCIATE PICTURE EDITOR Marie Schumann
ASSISTANT PICTURE EDITORS Azurea Lee Dudley, Vivette Porges
STAFF PHOTOGRAPHER Joe McNally
PICTURE DESK Melanie deForest, Suzette-Ivonne Rodriguez, Chris Whelan, Hélène Veret (Paris), Edward Nana Osei-Bonsu (Financial Manager)
ASSOCIATE ART DIRECTOR Marti Golon
ASSISTANT ART DIRECTOR Jean Andreuzzi
COPY DESK Madeleine Edmondson (Deputy), Nikki Amdur, Christine McNulty, Larry Nesbitt, Albert Rufino
FINANCIAL MANAGER Eileen M. Kelly
TECHNOLOGY MANAGER Michael T. Rose
TECHNOLOGY Steve Walkowiak
ADMINISTRATION Evelyn Thompson, Rakisha Kearns-White
WEST COAST BUREAU Margot Dougherty
SPECIAL CORRESPONDENTS Jenny Allen, Todd Brewster, Marilyn Johnson (New York), Judy Ellis (Los Angeles), Linda Gomez (Sacramento), Sue Allison (Washington), Igor P. Malakhov (Moscow), Mimi Murphy (Rome), Tala Skari (Paris)
CONTRIBUTING PHOTOGRAPHERS Harry Benson, Brian Lanker, Co Rentmeester (Contract); David Burnett, Enrico Ferorelli, Donna Ferrato, Dana Fineman, Frank Fournier, Henry Groskinsky, Derek Hudson, Lynn Johnson, Andy Levin, John Loengard, Mary Ellen Mark, Michael Melford, Carl Mydans, Lennart Nilsson, Michael O'Neill, Gordon Parks, Eugene Richards, Bob Sacha, David Turnley
LIFE PICTURE SALES Maryann Kornely (Director)
TIME-LIFE NEWS SERVICE Joëlle Attinger (Chief)
TIME INC. EDITORIAL SERVICES Sheldon Czapnik (Director), Claude Boral (General Manager), Thomas E. Hubbard (Photo Lab), Lany Walden McDonald (Research Center), Beth Bencini Zarcone (Picture Collection), Thomas Smith (Technology), James Macove (Marketing)
TIME INC. EDITORIAL TECHNOLOGY Paul Zazzera (Vice President), Damien Creavin (Editorial Technology)

PUBLISHER Edward R. McCarrick
ADVERTISING SALES DIRECTOR Donald B. Fries
ADVERTISING SALES New York: Judith A. Horan (Eastern Advertising Director), Geoffrey P. Maresca, Kip Meyer, Diane Miller, Patrick J. O'Donnell, Suzanne Timmons, George Walter
Chicago: Ney V. Raahauge (Midwest Advertising Director), Stephen D. Krupkin
Detroit: Robert G. Houghtlin (Detroit Advertising Director), P. Thornton Withers
Los Angeles: Janet Haire (Western Advertising Director), Lynnette Ward
San Francisco: William G. Smith (Manager)
Special Representatives: Paul A. Belanger (Canada), Dean Zeko (Dallas), Peter Carr (San Diego and Mexico)
MARKETING/FRANCHISE DEVELOPMENT Mark L. Hintsa (Director), Gianine DeSimone (Manager)
SALES DEVELOPMENT Claudia L. Jepsen (Director), Michelle Olofson, Michael Wolfe, (Managers), Jennifer Reed (Art Director), Marybeth Burnell (Design Associate)
CONSUMER MARKETING Monika Winn (Director), Joanne Ragazzo (Planning Manager), Marilou Mallabo (Renewals Manager), Beth Freeman (Assistant Manager), Samuel Tisdale
BUSINESS OFFICE Nancy J. Phillips (Financial Director), Nancy Blank, Anita Raisch, Dawn Vezirian (Assistant Managers)
PRODUCTION Murray Goldwaser (Director), Steven Bessenoff, Lawrence P. Bracken, Len Lieberman (Managers), Jill Gerlin
PUBLIC RELATIONS Alison Hart (Director), Alex Keane
ADMINISTRATION Adrienne Hegarty, Meghan Anderson, Lisa DiPressi, Susan W. Harper, Nancy J. Harrar, Caroline Hoover, Amy Ryan, Ann Spohrer

Pictures of
the Year

LIFE
ALBUM

By the Editors
of LIFE

CONTENTS

Nineteen Hundred Ninety-Six

A new year is always a new beginning, but the whole year of 1996 seemed to be one long fresh start. Bill Clinton trounced Bob Dole, earning himself and his First Lady four more years in which to polish their somewhat tarnished images. It was off with health care reform and on with welfare reform. Peace may have finally gotten a toehold in Bosnia and Chechnya, but hostilities resumed between the Israelis and Palestinians. Evidence surfaced of primitive life on Mars and water on the moon. The New York Yankees got back in the game; golf prodigy Tiger Woods and Olympian Michael Johnson each made it to the top of theirs. The Most Eligible John F. Kennedy Jr. began life as a married man with Carolyn Bessette, providing the public with a new royal couple. Perfect timing, since both the Princess of Wales and her sister-in-law the Duchess of York started over this year as singles—the former as bachelorette-about-town, the latter as author of a tell-not-quite-all autobiography. Oprah Winfrey began a monthly book club on her TV show, making *The Deep End of the Ocean,* by first-time novelist Jacquelyn Mitchard, float to the top of the best-seller list. Madonna, written off last year as old hat, put on two new ones, as an operatic leading lady and mother. Conversely, the nation tuned out House Speaker Newt Gingrich, 1995's big noise. Olestra, a new synthetic oil, made scrumptious snacks like potato chips fat free, if not entirely risk free. And the Macarena gave America a new group dance for the ages—or at least what seemed like ages. It was also a year of terrible endings and painful beginnings. The families of those who perished on TWA Flight 800, ValuJet Flight 592 and in the year's many other tragedies had to start over, too, learning to live without their loved ones. Life, as always, was both bitter and sweet in unpredictable fits and starts. On the following pages, LIFE presents the year's new beginnings—and middles and ends. Let's begin . . .

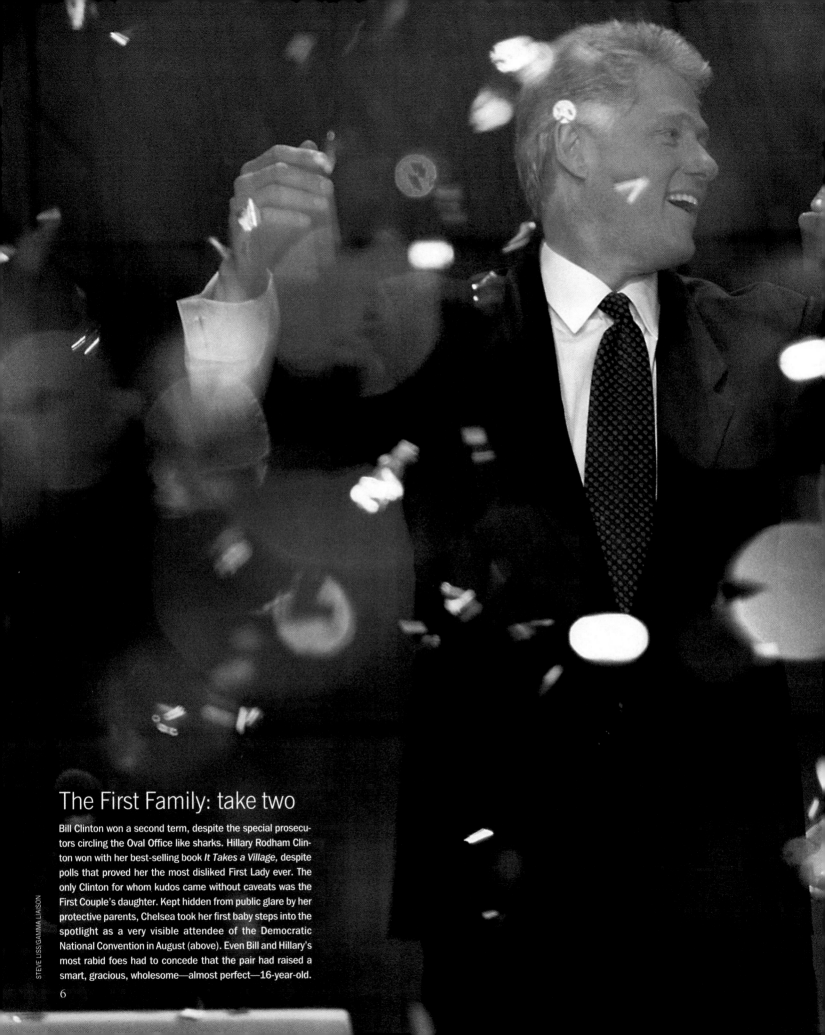

The First Family: take two

Bill Clinton won a second term, despite the special prosecutors circling the Oval Office like sharks. Hillary Rodham Clinton won with her best-selling book *It Takes a Village*, despite polls that proved her the most disliked First Lady ever. The only Clinton for whom kudos came without caveats was the First Couple's daughter. Kept hidden from public glare by her protective parents, Chelsea took her first baby steps into the spotlight as a very visible attendee of the Democratic National Convention in August (above). Even Bill and Hillary's most rabid foes had to concede that the pair had raised a smart, gracious, wholesome—almost perfect—16-year-old.

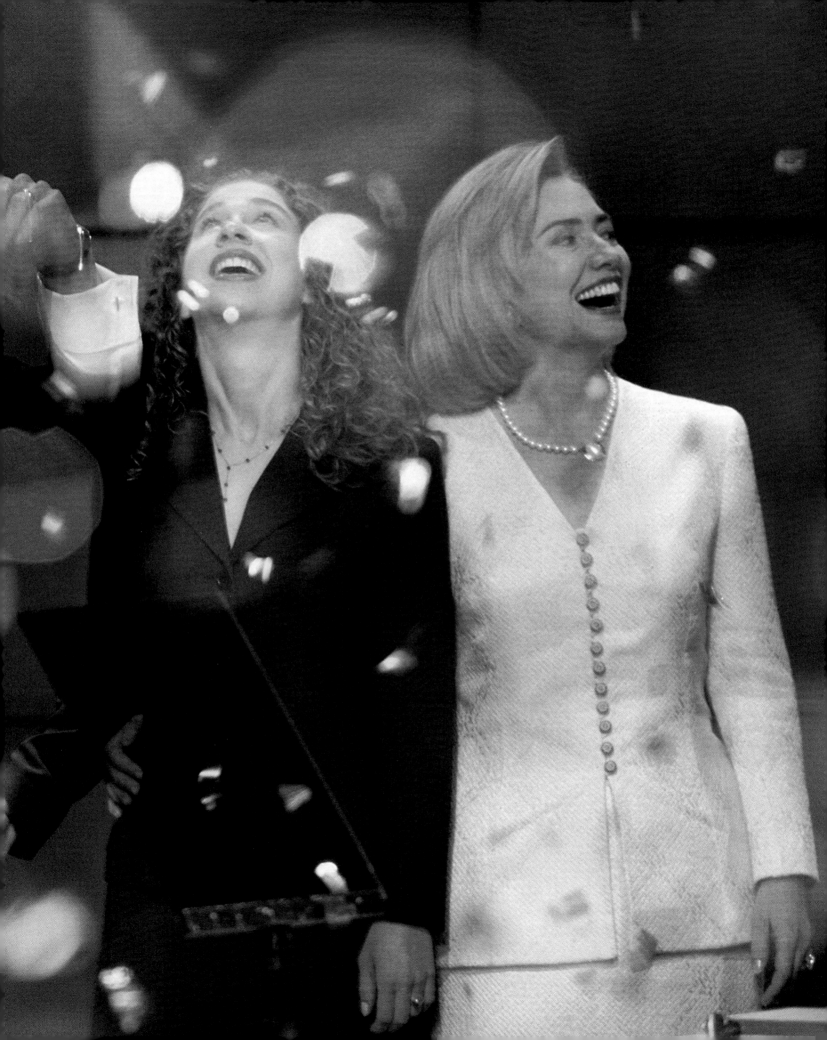

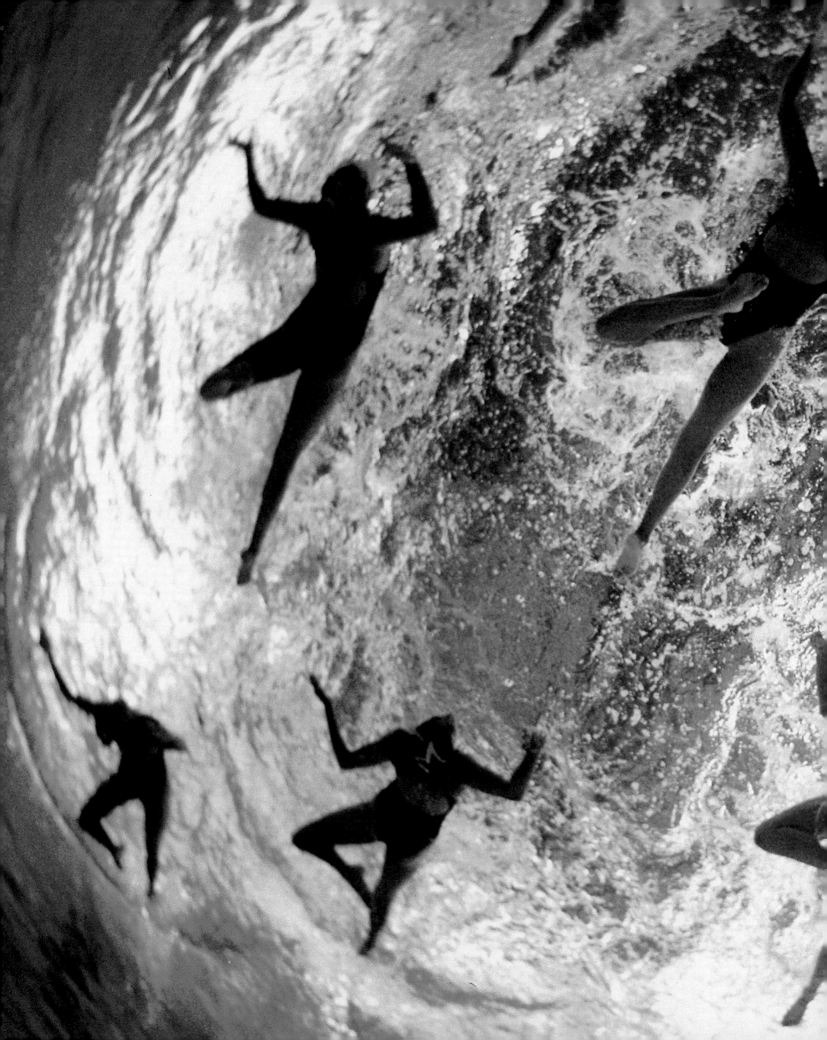

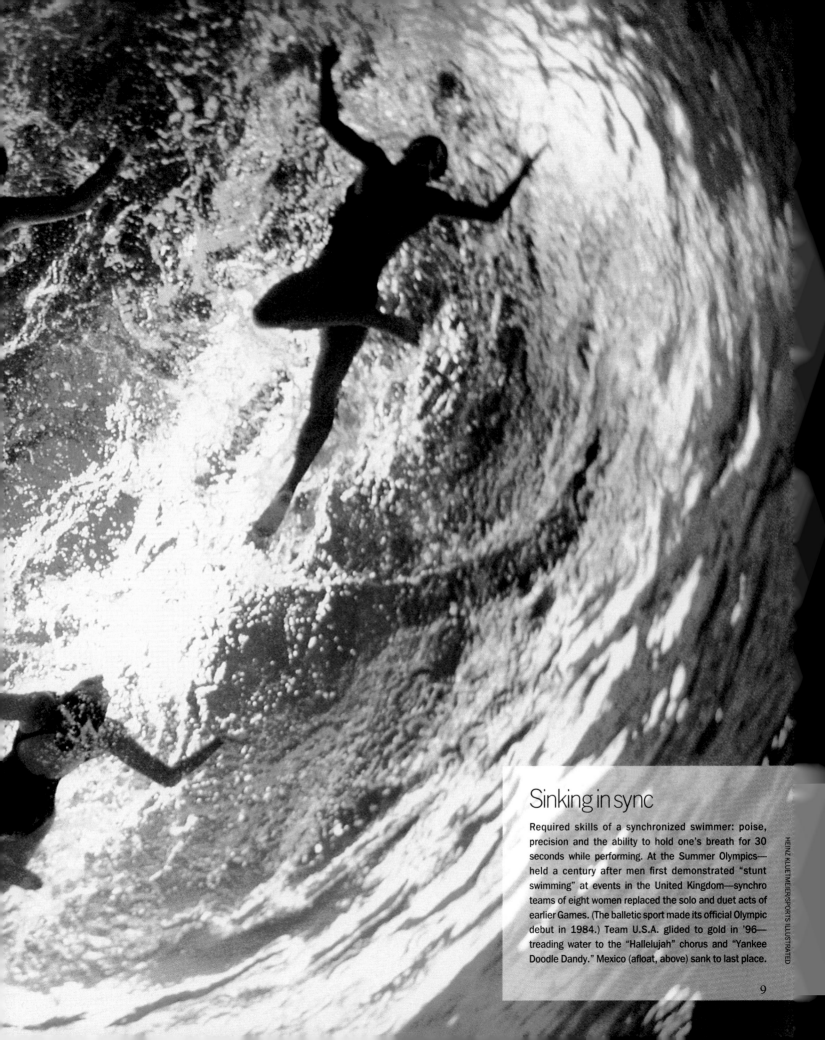

Sinking in sync

Required skills of a synchronized swimmer: poise, precision and the ability to hold one's breath for 30 seconds while performing. At the Summer Olympics— held a century after men first demonstrated "stunt swimming" at events in the United Kingdom—synchro teams of eight women replaced the solo and duet acts of earlier Games. (The balletic sport made its official Olympic debut in 1984.) Team U.S.A. glided to gold in '96— treading water to the "Hallelujah" chorus and "Yankee Doodle Dandy." Mexico (afloat, above) sank to last place.

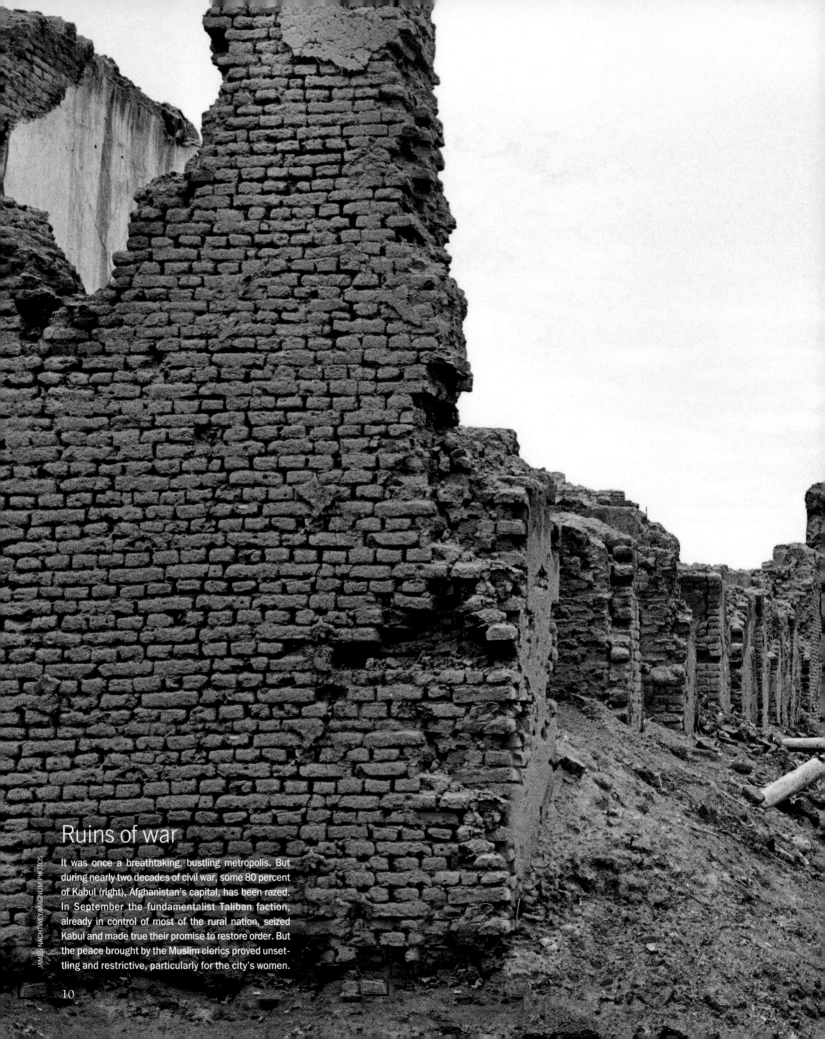

Ruins of war

It was once a breathtaking, bustling metropolis. But during nearly two decades of civil war, some 80 percent of Kabul (right), Afghanistan's capital, has been razed. In September the fundamentalist Taliban faction, already in control of most of the rural nation, seized Kabul and made true their promise to restore order. But the peace brought by the Muslim clerics proved unsettling and restrictive, particularly for the city's women.

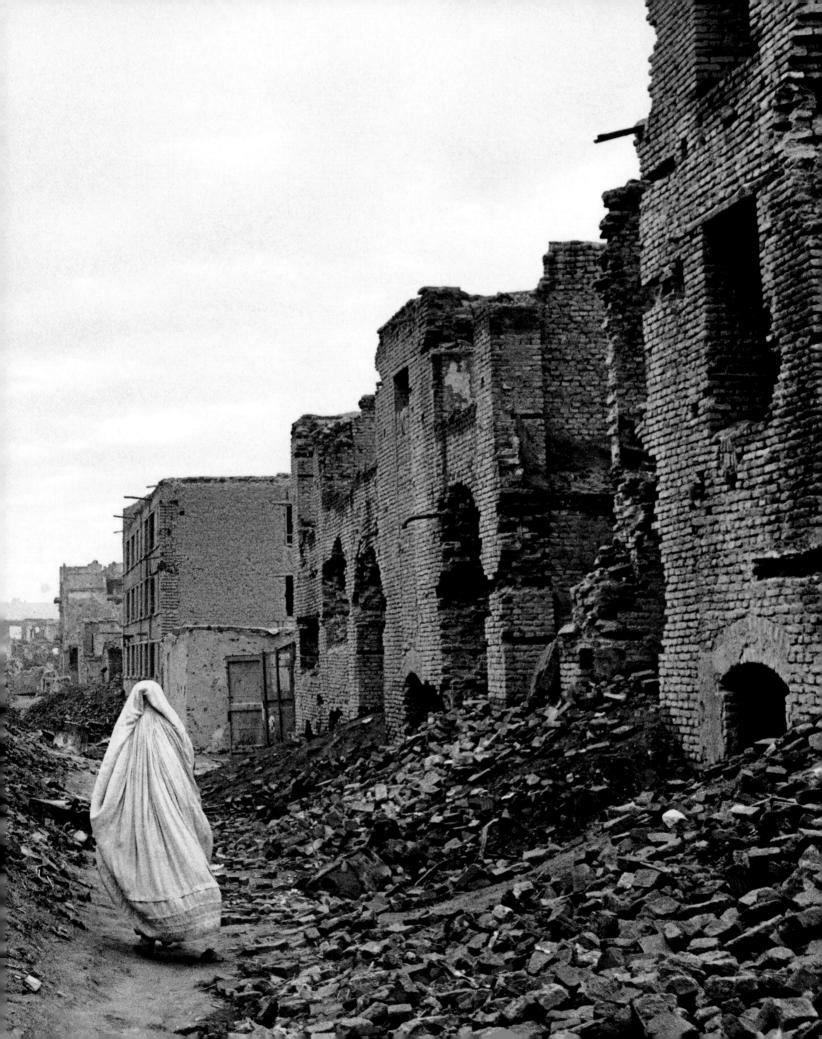

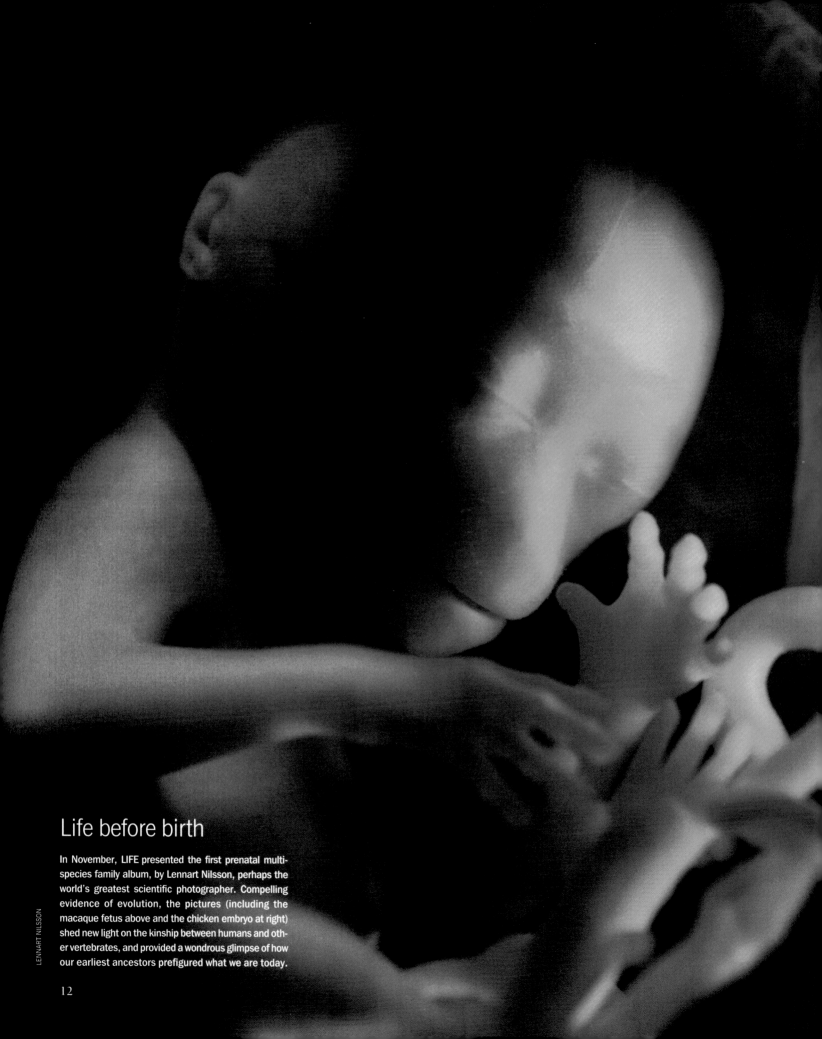

Life before birth

In November, LIFE presented the first prenatal multi-species family album, by Lennart Nilsson, perhaps the world's greatest scientific photographer. Compelling evidence of evolution, the pictures (including the macaque fetus above and the chicken embryo at right) shed new light on the kinship between humans and other vertebrates, and provided a wondrous glimpse of how our earliest ancestors prefigured what we are today.

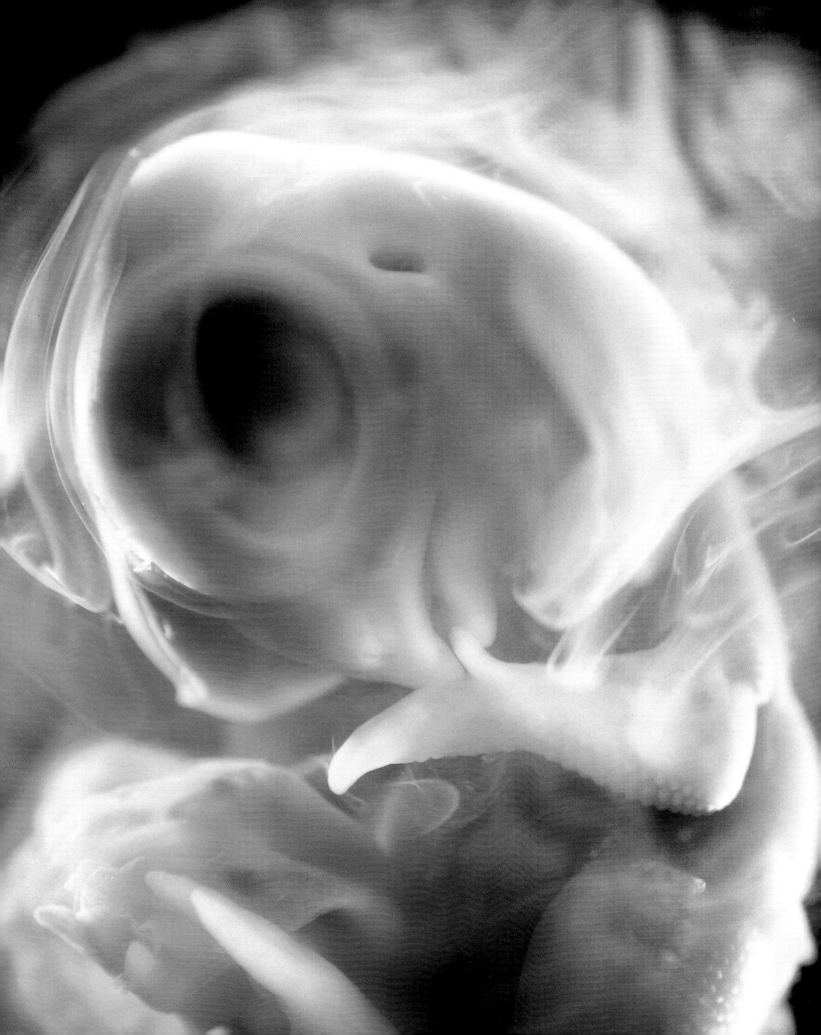

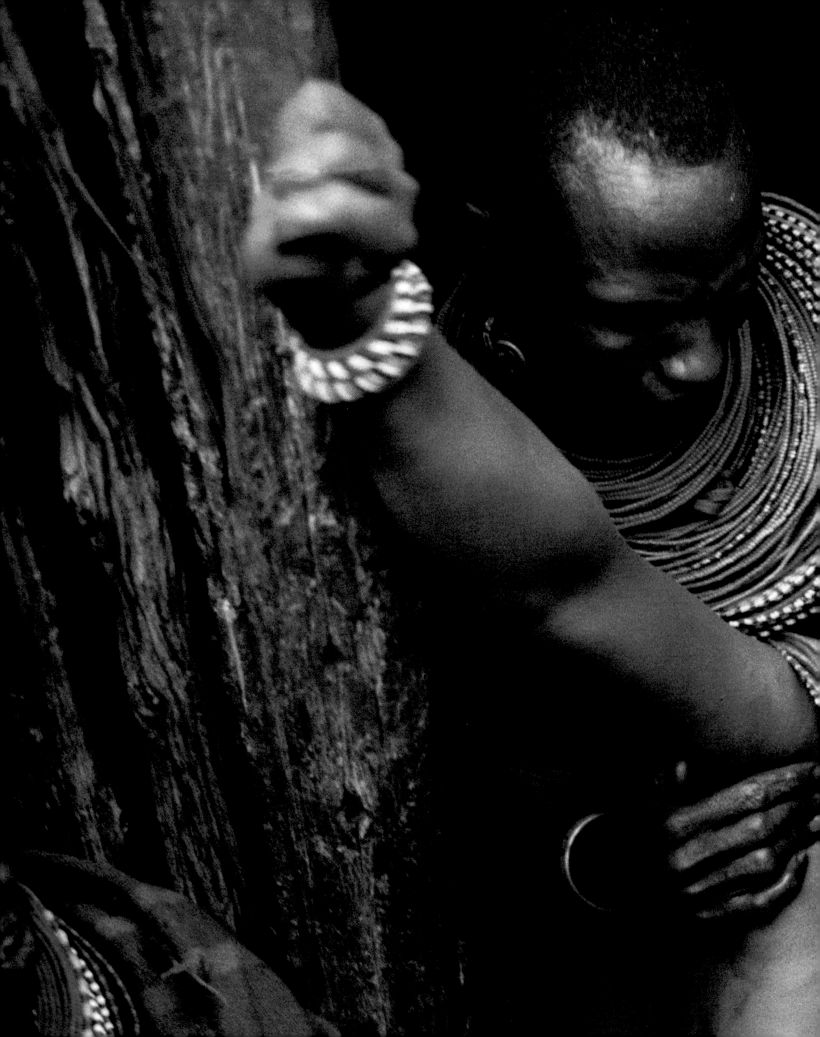

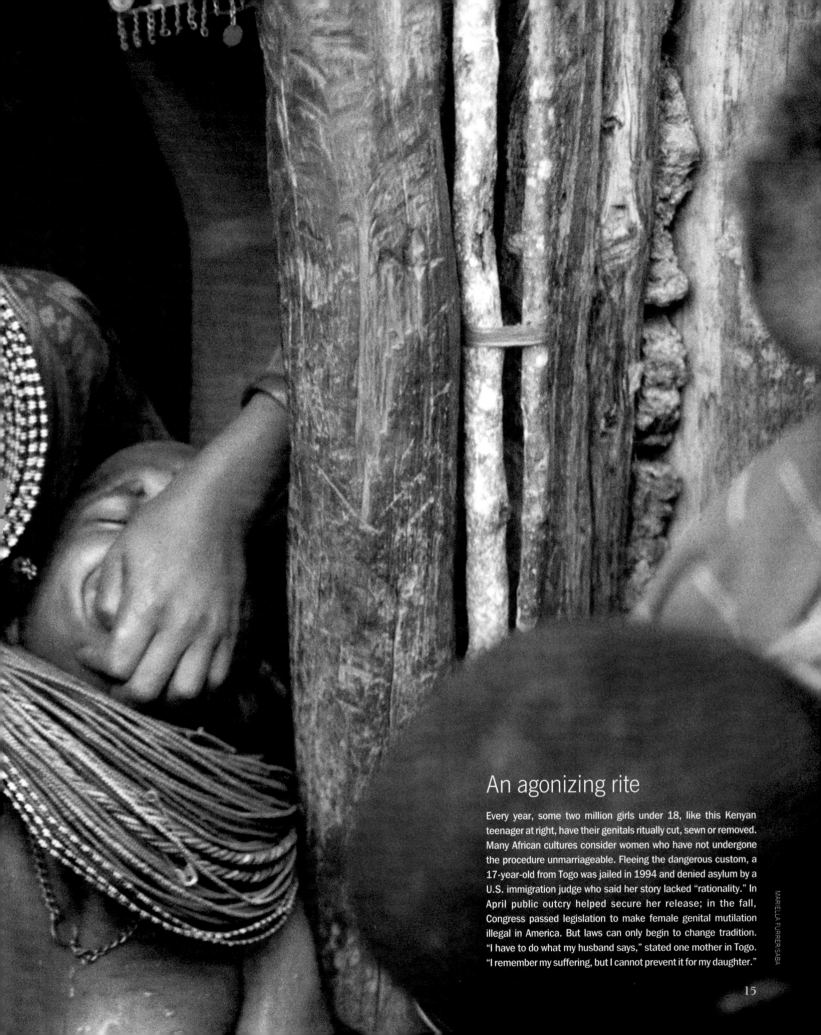

An agonizing rite

Every year, some two million girls under 18, like this Kenyan teenager at right, have their genitals ritually cut, sewn or removed. Many African cultures consider women who have not undergone the procedure unmarriageable. Fleeing the dangerous custom, a 17-year-old from Togo was jailed in 1994 and denied asylum by a U.S. immigration judge who said her story lacked "rationality." In April public outcry helped secure her release; in the fall, Congress passed legislation to make female genital mutilation illegal in America. But laws can only begin to change tradition. "I have to do what my husband says," stated one mother in Togo. "I remember my suffering, but I cannot prevent it for my daughter."

MARIELLA FURRER/SABA

15

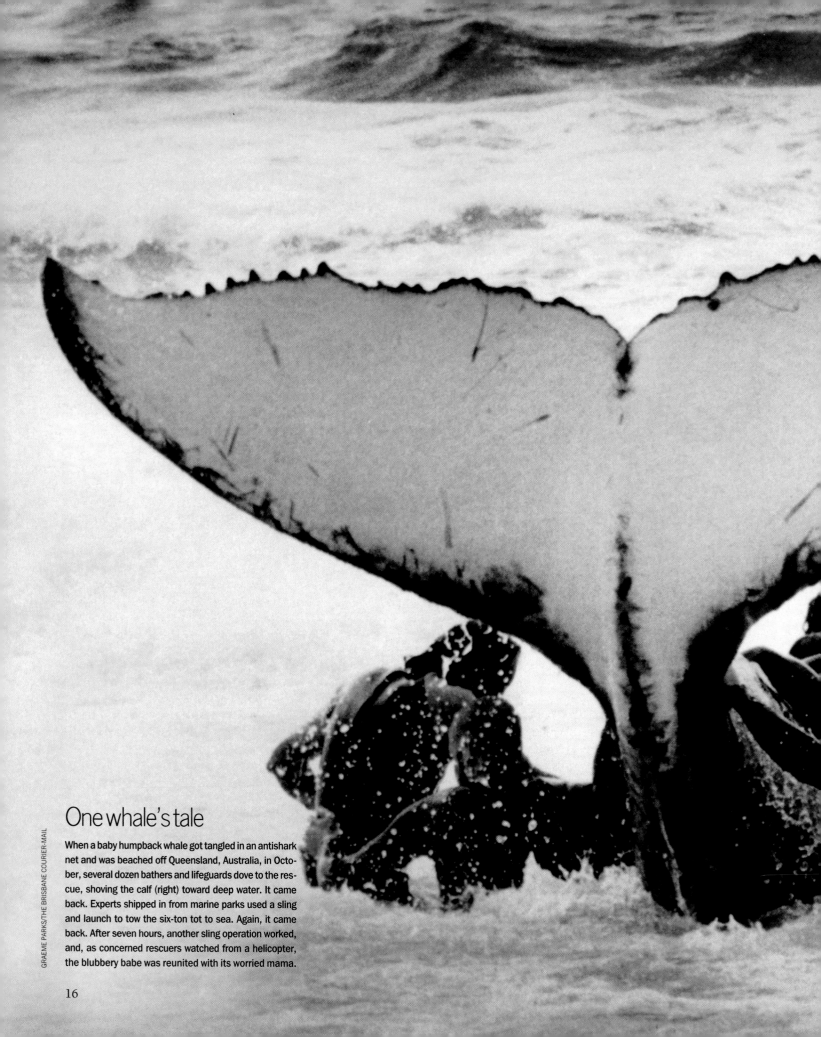

One whale's tale

When a baby humpback whale got tangled in an antishark net and was beached off Queensland, Australia, in October, several dozen bathers and lifeguards dove to the rescue, shoving the calf (right) toward deep water. It came back. Experts shipped in from marine parks used a sling and launch to tow the six-ton tot to sea. Again, it came back. After seven hours, another sling operation worked, and, as concerned rescuers watched from a helicopter, the blubbery babe was reunited with its worried mama.

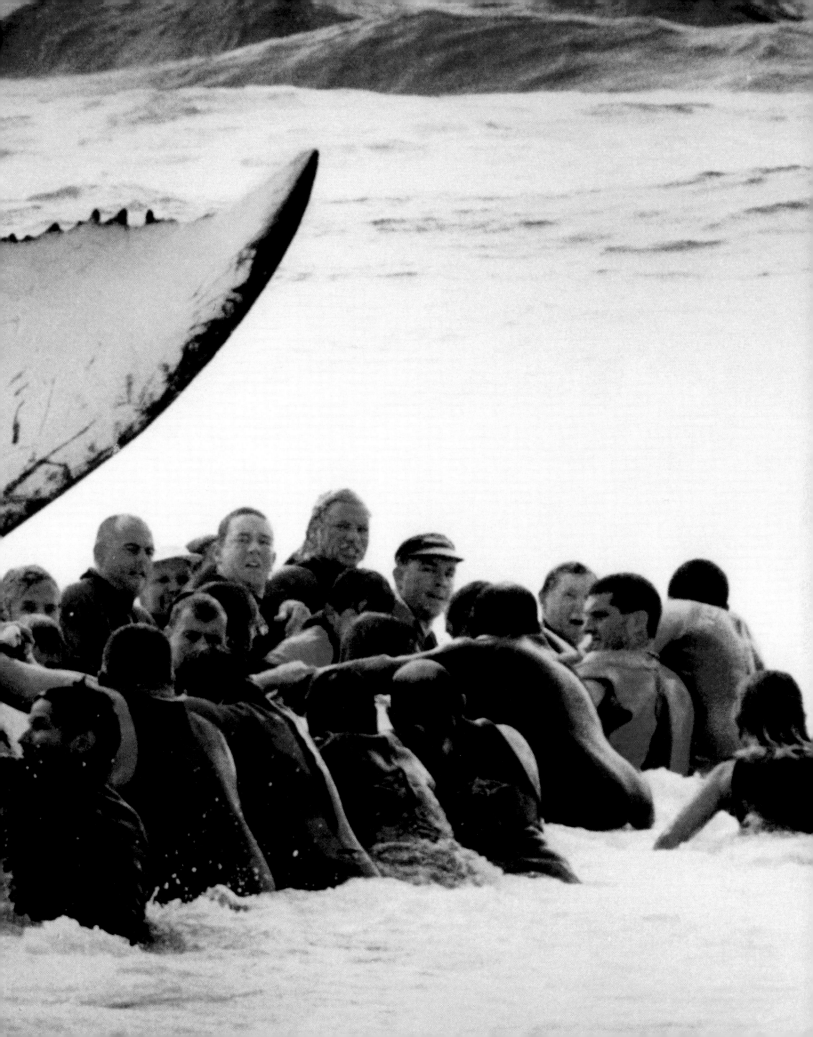

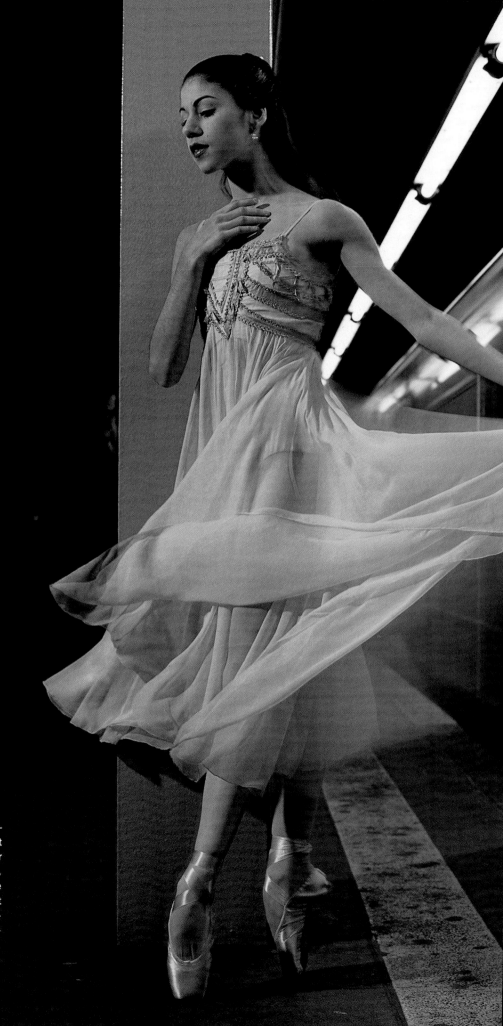

A modern classic

Onstage—and on a New York City subway platform (right)—Paloma Herrera, 20, the American Ballet Theatre's youngest prima ballerina, danced Juliet. On the big screen, in director Baz Luhrmann's *William Shakespeare's Romeo & Juliet*, rising star Claire Danes, 17, acted Juliet; her Romeo was the similarly skyrocketing Leonardo DiCaprio, 22. In that production, Juliet on the subway wouldn't have been far-fetched: The fair city of Verona was translated into the hyperkinetic Verona Beach, where the Montagues and Capulets, swords tossed aside, did battle with automatic weapons.

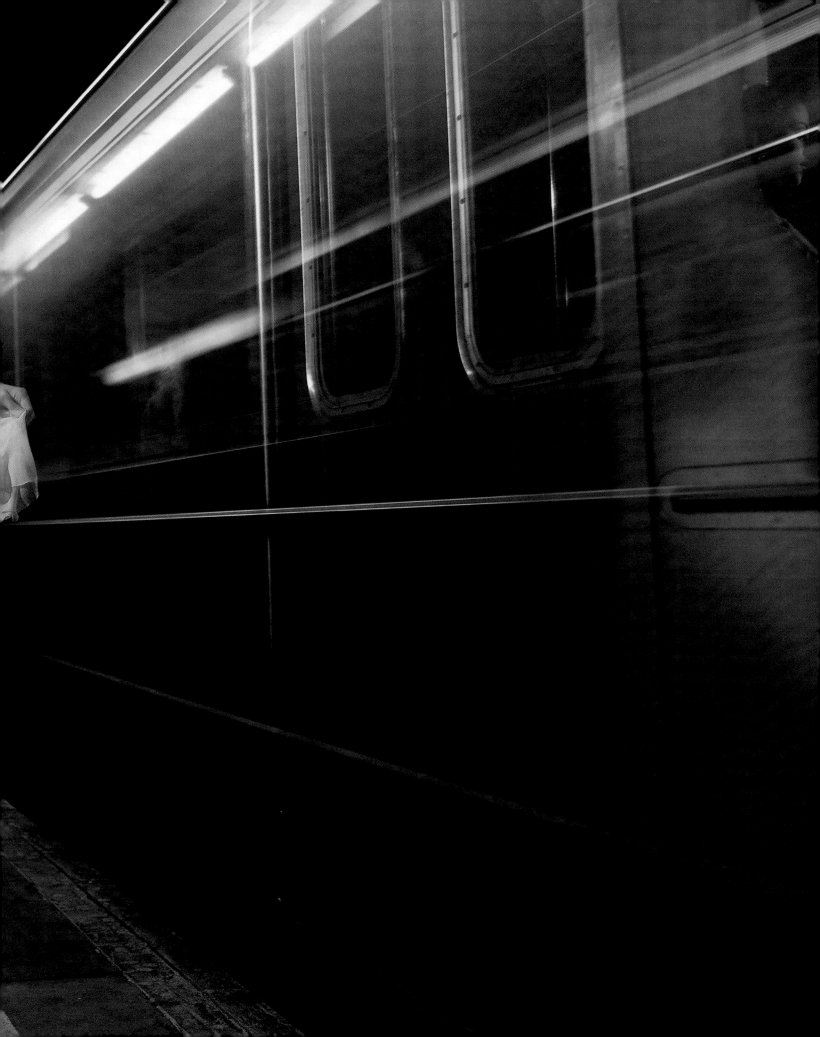

Lessons in cooperation

For conjoined twins Abigail and Brittany Hensel (opposite, at school), midwestern six-year-olds who share a single body, daily life requires extraordinary coordination and cooperation. Their singular doubleness raises fundamental questions about human nature: What is individuality? Does mental telepathy exist? But these smart and lively sisters, introduced to LIFE readers in April, do more than inspire philosophical musings—they conquer hearts. Britty wants to be a pilot, Abby a dentist. "Who knows?" says their father, Mike. "They can do just about anything."

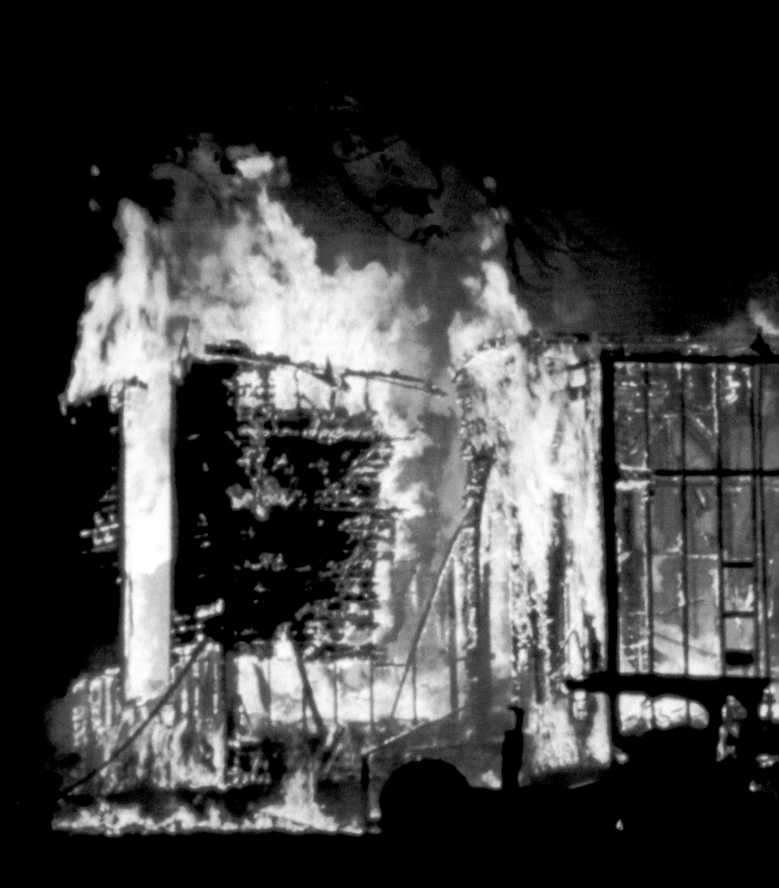

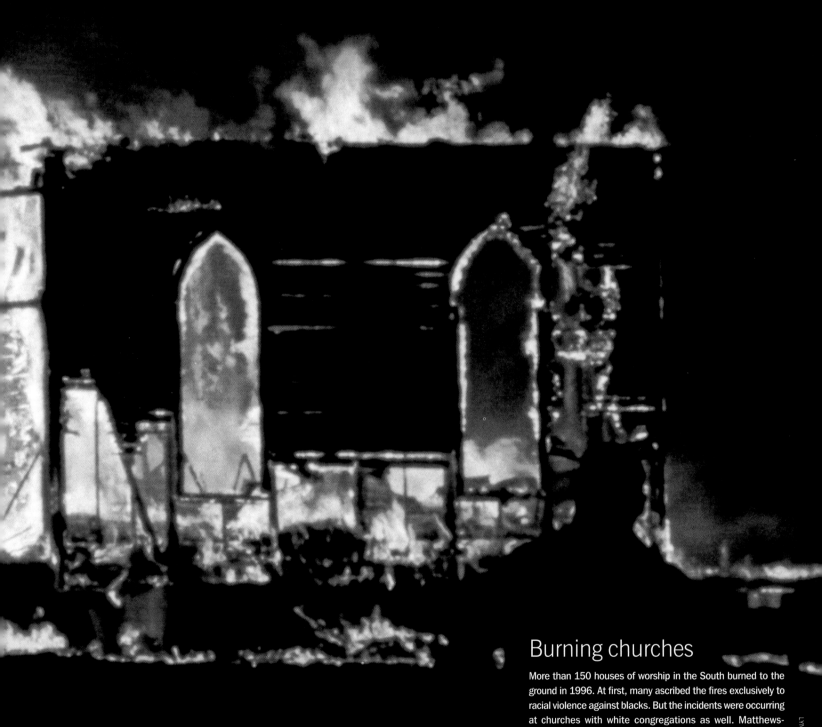

Burning churches

More than 150 houses of worship in the South burned to the ground in 1996. At first, many ascribed the fires exclusively to racial violence against blacks. But the incidents were occurring at churches with white congregations as well. Matthews-Murkland Presbyterian (above), a historic African American chapel in Charlotte, N.C., was destroyed in June by a 13-year-old white girl who was reportedly lashing out at religion.

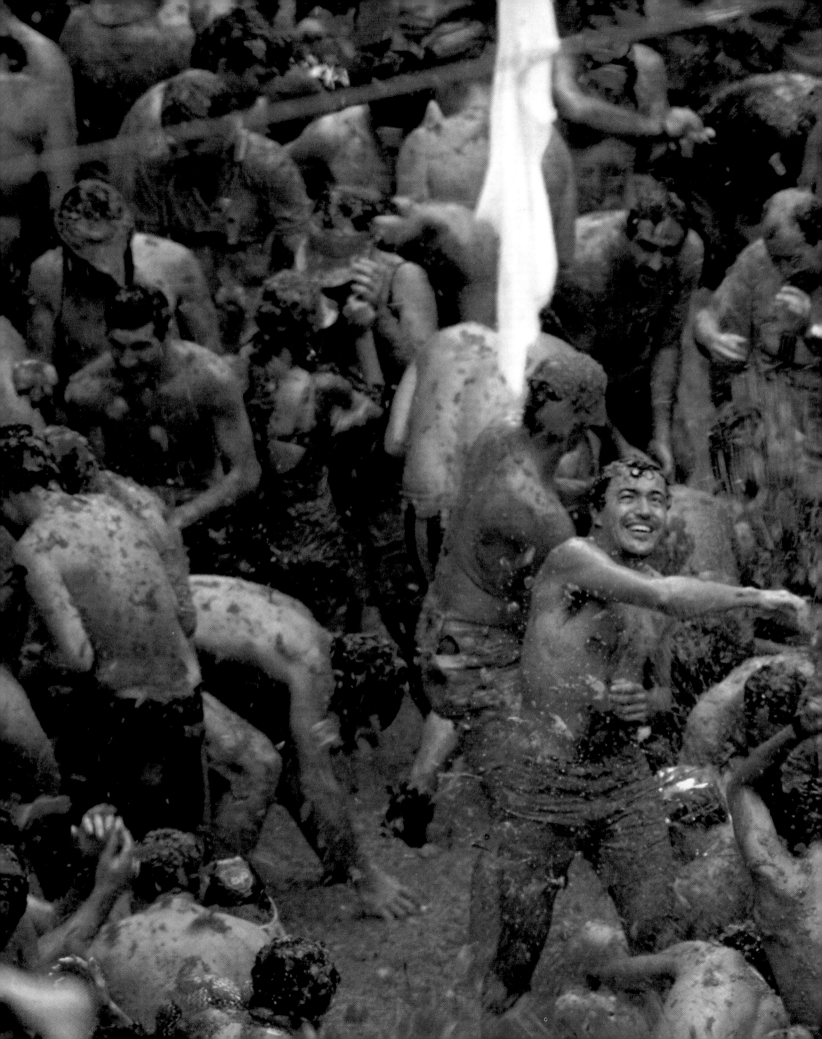

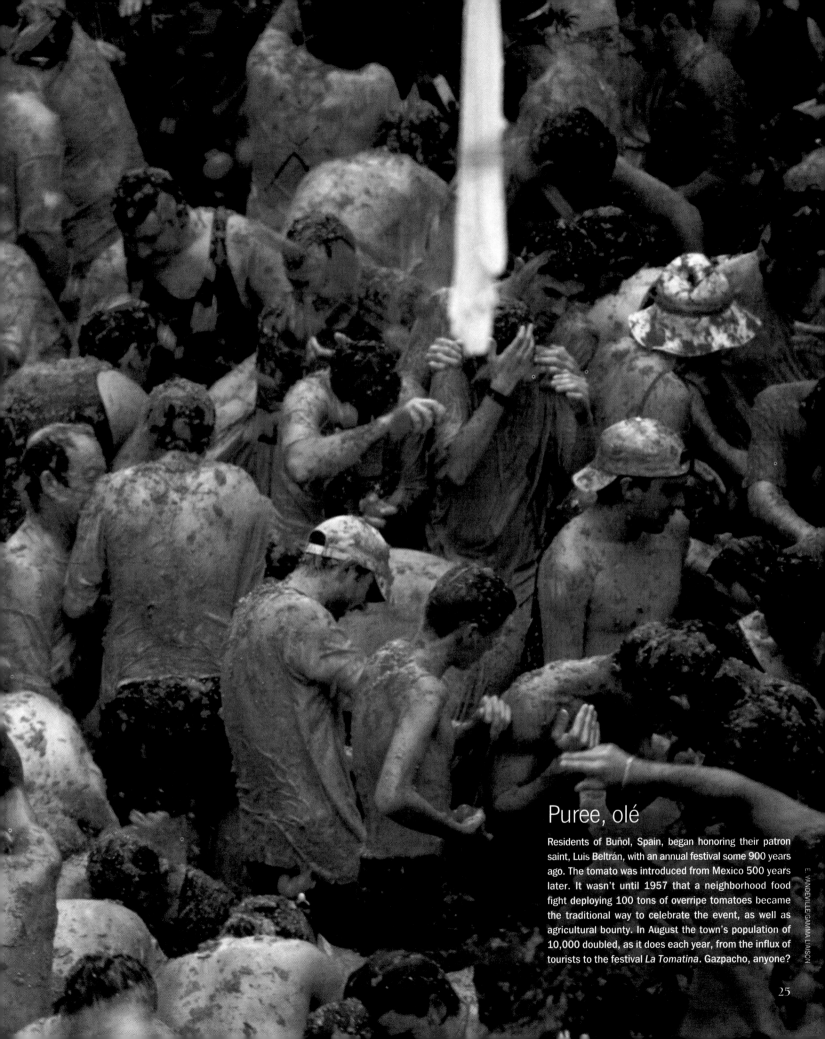

Puree, olé

Residents of Buñol, Spain, began honoring their patron saint, Luis Beltrán, with an annual festival some 900 years ago. The tomato was introduced from Mexico 500 years later. It wasn't until 1957 that a neighborhood food fight deploying 100 tons of overripe tomatoes became the traditional way to celebrate the event, as well as agricultural bounty. In August the town's population of 10,000 doubled, as it does each year, from the influx of tourists to the festival *La Tomatina*. Gazpacho, anyone?

Little old man

When Tibetan Buddhist monk Lama Deshung Rinpoche III was 81, he told his followers that he would be reincarnated in Seattle. He died in 1987. When Sonam Wangdu, the Seattle-born son of an American woman and her Tibetan husband, was two, he was enthroned as the fourth incarnation of the lama. In January, the little lama's mother (with him, right) took her son, newly four—and his duffel bag of action figures and cartoon videos—to the Tharlam Monastery near Kathmandu, Nepal. There the child will be schooled until the Rinpoche's followers believe that he is ready to become, again, their teacher.

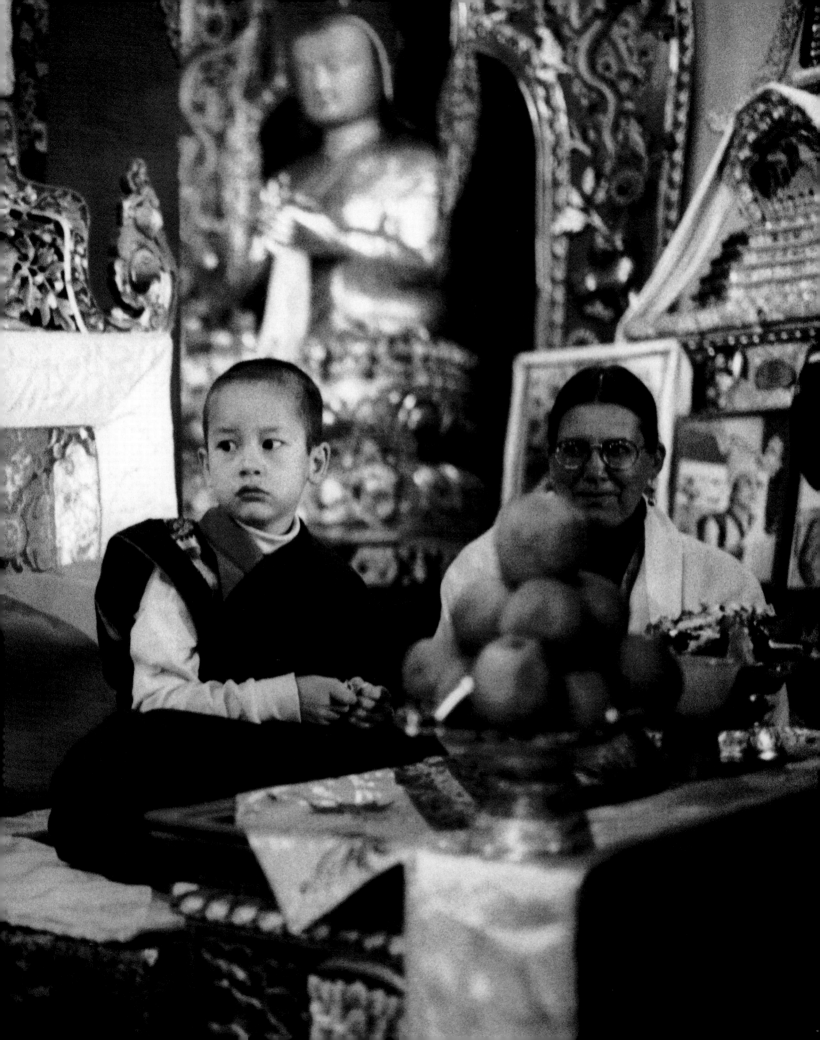

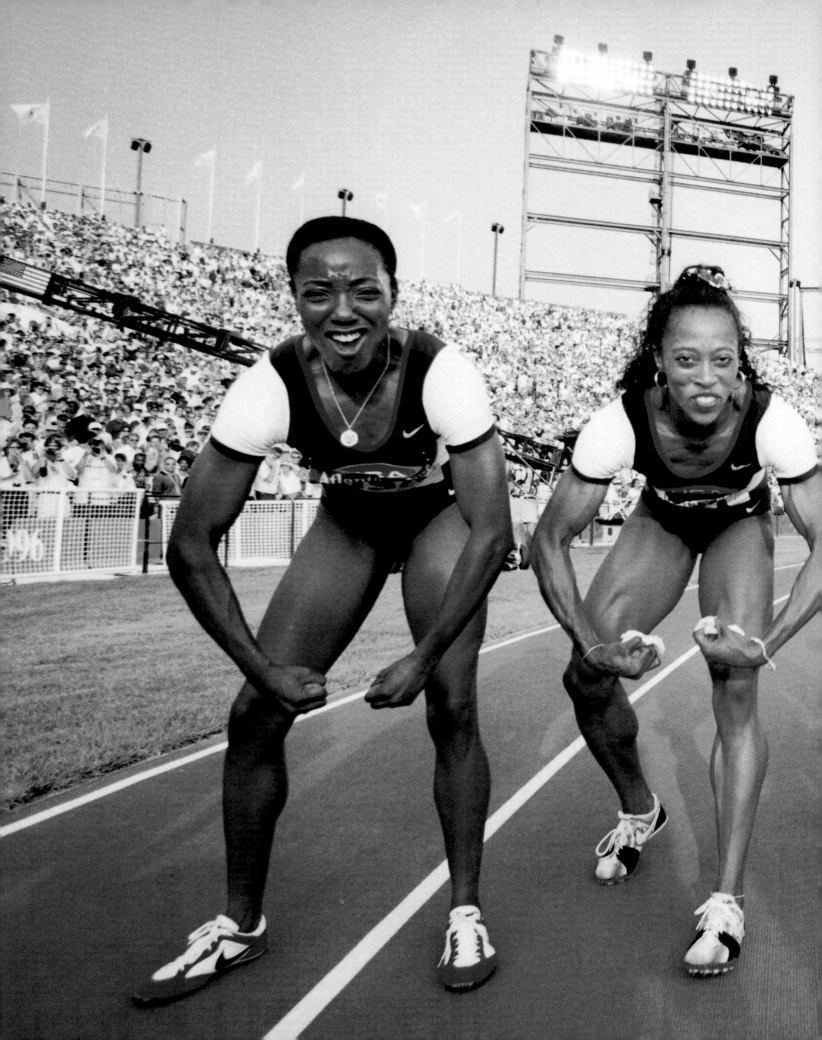

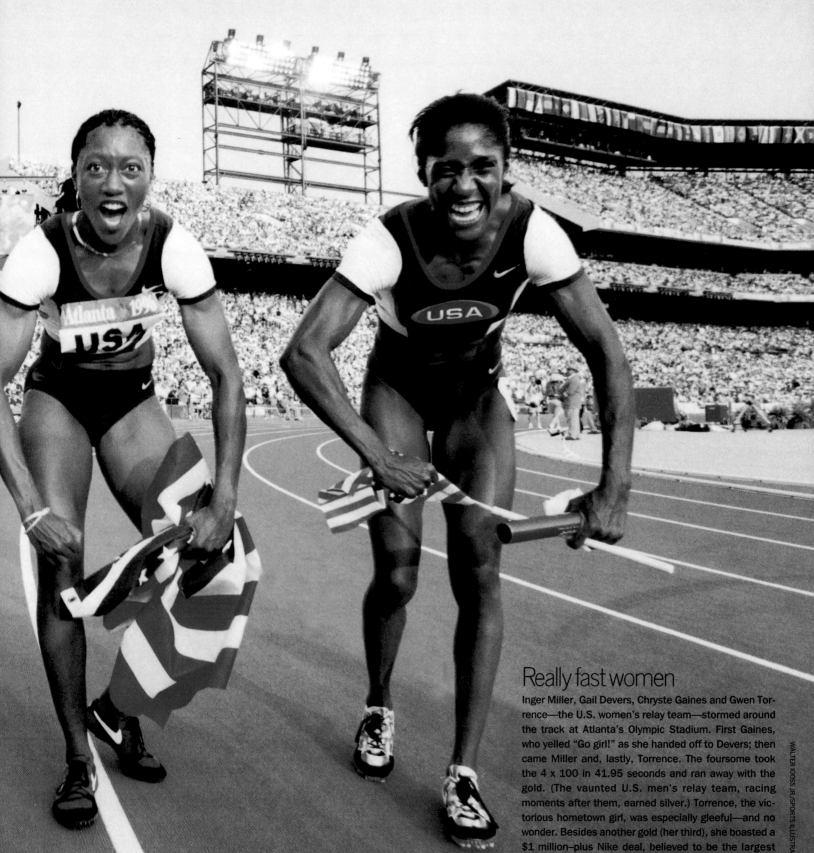

Really fast women

Inger Miller, Gail Devers, Chryste Gaines and Torrence—the U.S. women's relay team—stormed around the track at Atlanta's Olympic Stadium. First Gaines, who yelled "Go girl!" as she handed off to Devers; then came Miller and, lastly, Torrence. The foursome took the 4 x 100 in 41.95 seconds and ran away with the gold. (The vaunted U.S. men's relay team, racing moments after them, earned silver.) Torrence, the victorious hometown girl, was especially gleeful—and no wonder. Besides another gold (her third), she boasted a $1 million–plus Nike deal, believed to be the largest endorsement contract ever for a female athlete.

January

■ President Clinton signs a stop-gap budget measure on January 6, ending the **LONGEST GOVERNMENT SHUTDOWN IN U.S. HISTORY**—21 days. To break a stalemate with the Republican Congress, the President agrees to the GOP plan for balancing the federal budget by the year 2002. Clinton had proposed a balanced budget by 2005.

■ **AT&T** announces plans to eliminate 40,000 jobs—13 percent of its workforce—over the next three years. The proposed staff cut will be one of the largest ever made by an American corporation.

■ The United States–based Human Rights Watch, a nongovernmental humanitarian organization, accuses China of deliberately **STARVING AND NEGLECTING ORPHANS**—particularly baby girls and handicapped boys. The Chinese government, which has population control policies that restrict families to one child, denies the charges.

■ California becomes the first state to prohibit businesses from **CHARGING MEN AND WOMEN DIFFERENT PRICES** for the same services, such as haircuts and dry cleaning.

■ Pop star **JANET JACKSON** signs a four-album deal with Virgin Records for a reported $80 million, surpassing her brother Michael—and even Madonna—to land the most lucrative recording contract ever.

■ On the best-seller lists: First Lady **HILLARY RODHAM CLINTON**'s *It Takes a Village,* a treatise on rearing children in a troubled society, and *Primary Colors,* a keenly accurate roman à clef, by **ANONYMOUS**, about Bill Clinton's 1992 run for the White House. Among those suspected of being the scribe: Clinton campaign strategist Paul Begala, LIFE contributing editor Lisa Grunwald (whose sister, Mandy, worked on the campaign) and *Newsweek* political columnist Joe Klein. Each vehemently denies authorship, but in July, Klein confesses to the deed.

■ At the box office: **WHITNEY HOUSTON** and **ANGELA BASSETT** in *Waiting to Exhale,* a so-called chick flick based on **TERRY McMILLAN**'s best-selling novel about four black women and the men in their lives. And *From Dusk Till Dawn,* a gory biker-vampire movie starring director **QUENTIN TARANTINO** and TV heartthrob **GEORGE CLOONEY** of *ER.*

■ The **STATE OF THE UNION** address is broadcast on the Internet for the first time. To the nation's relief, President Clinton talks for just 61 minutes. (His 1995 speech, which clocked in at 81 minutes, was the longest State of the Union message in history.) Senate Majority Leader Bob Dole gives the Republican response. Talk time: 12 minutes.

■ The Dallas Cowboys defeat the Pittsburgh Steelers 27–17 to win **SUPER BOWL XXX**, played in Tempe, Ariz. The halftime show stars **DIANA ROSS**. Cornerback **LARRY BROWN** is named MVP.

■ After a two-day standoff with police outside his estate in Newton Square, Pa., reclusive millionaire and wrestling benefactor **JOHN E. du PONT**, 57, is arrested for murdering former Olympic wrestler **DAVID SCHULTZ**, 36. (In September, a judge declares the heir to the du Pont chemical fortune mentally incompetent and unfit to stand trial, ordering periodic psychiatric evaluations.)

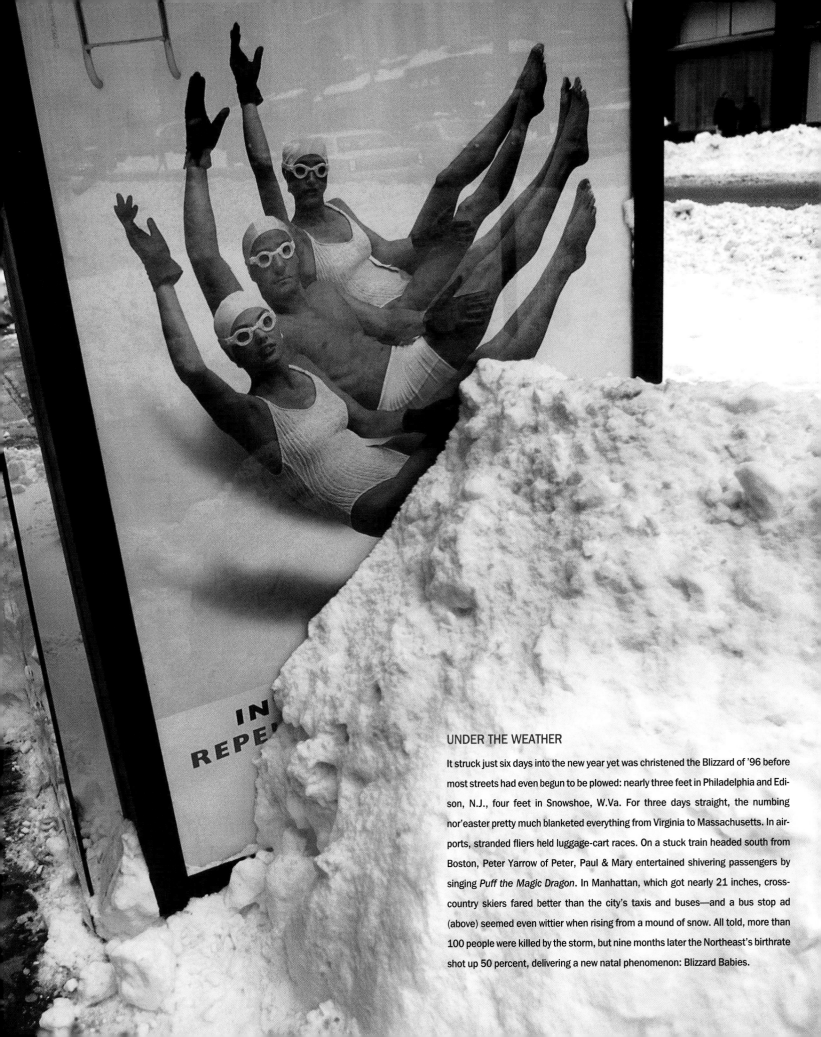

UNDER THE WEATHER

It struck just six days into the new year yet was christened the Blizzard of '96 before most streets had even begun to be plowed: nearly three feet in Philadelphia and Edison, N.J., four feet in Snowshoe, W.Va. For three days straight, the numbing nor'easter pretty much blanketed everything from Virginia to Massachusetts. In airports, stranded fliers held luggage-cart races. On a stuck train headed south from Boston, Peter Yarrow of Peter, Paul & Mary entertained shivering passengers by singing *Puff the Magic Dragon*. In Manhattan, which got nearly 21 inches, cross-country skiers fared better than the city's taxis and buses—and a bus stop ad (above) seemed even wittier when rising from a mound of snow. All told, more than 100 people were killed by the storm, but nine months later the Northeast's birthrate shot up 50 percent, delivering a new natal phenomenon: Blizzard Babies.

FAR FROM HOME

The Third Battalion, 325th Airborne (including Spec. John Pielli, 21, right, on patrol near Tuzla in January), had arrived in Bosnia on Christmas Eve, the first of 20,000 U.S. soldiers assigned to a NATO peace-keeping force. The mission: prevent Croats, Muslims and Serbs—who signed a peace agreement in 1995 after four years of civil war—from killing one another. The U.S. combat troops sent to Bosnia were specially trained to cope with snipers and hostile civilians, land mines (some three million lay hidden) and mothers begging to have their children evacuated. On January 13, President Clinton visited, bearing as gifts 200 cases of Coke and 5,000 Hershey bars. Three weeks later, the U.S. suffered its first casualty: Army Sgt. Donald Dugan, 38, of the 1st Cavalry, killed while trying to defuse a mine.

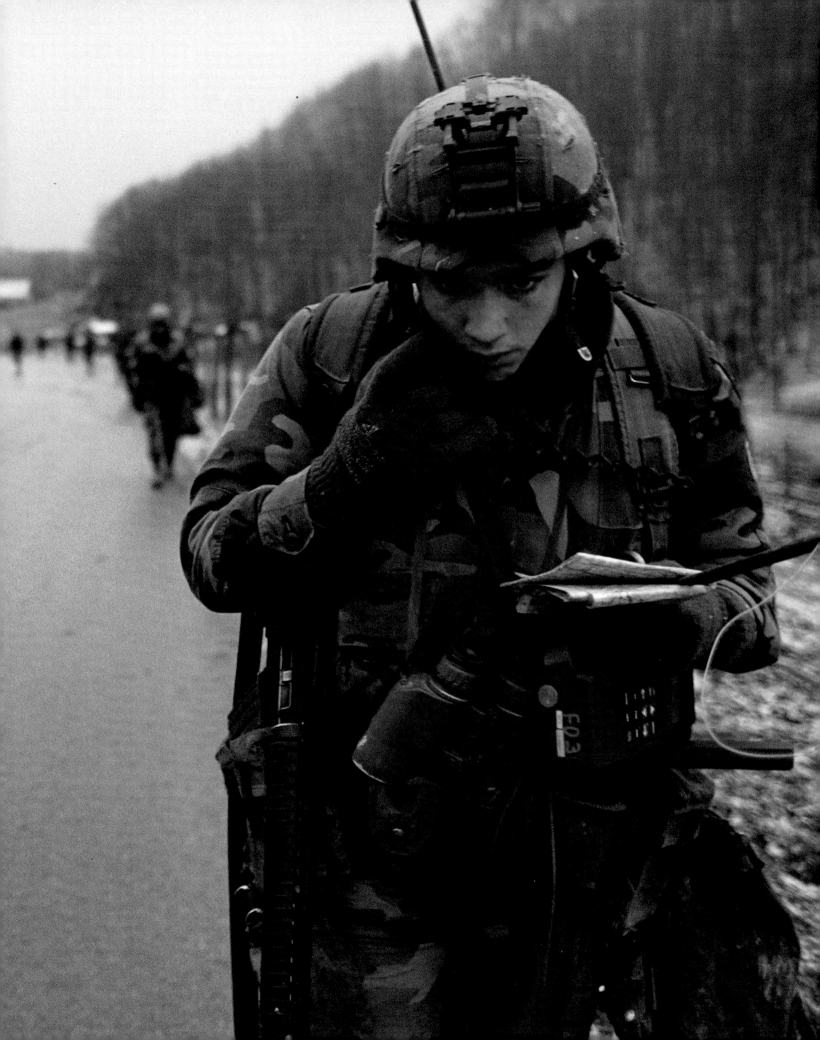

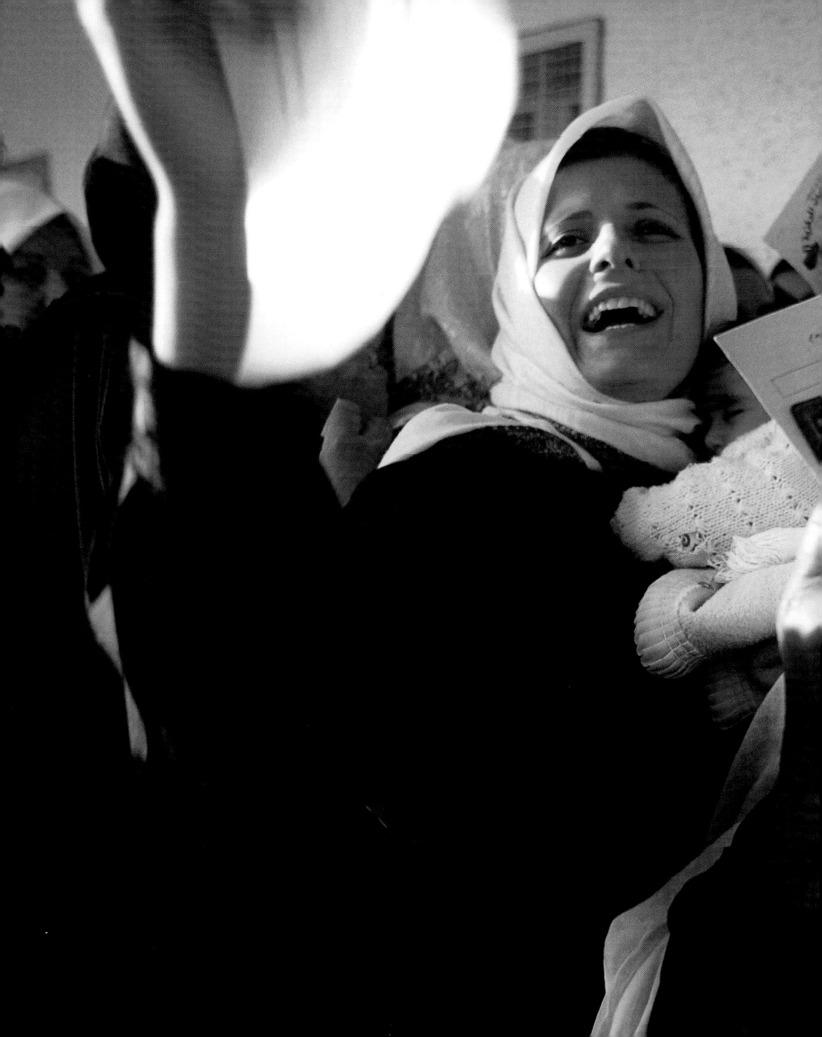

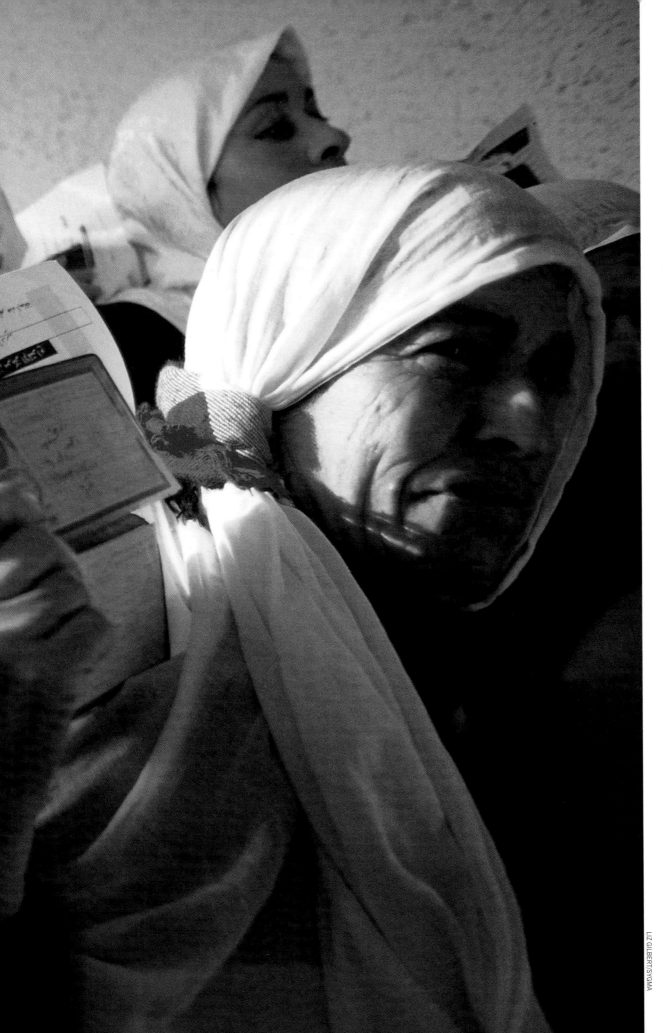

PALESTINIAN UPRISING

The women came in muted revolution, some laughing, some crying, a few still veiled even in their emancipation. Waiting outside polling places like this one at a refugee camp in Gaza (left), they displayed their national identification cards in order to vote. It was January 20, the day Palestinians in the West Bank, Gaza Strip and East Jerusalem cast ballots in their first general election. Voter turnout was a strong 70 percent despite intimidation by Israeli soldiers and a boycott by the Islamic resistance movement Hamas. PLO chairman Yasir Arafat, 66, predictably swamped his token opponent, social worker Samiha Khalil, a 72-year-old woman, to become president of the Interim Self-Government, the chosen leader of two million Palestinians. But renewed Palestinian-Israeli violence would bring home a cruel irony: Peaceful elections do not ensure peace.

HEAVYWEIGHT MATCH

Muhammad Ali was on a mercy mission, but as usual he packed a little punch. On a one-man charitable visit to donate $500,000 in medical supplies to Cuba, the former boxing champ (Ali, 54, suffers from Parkinson's disease) met Fidel Castro, 69, for the first time. During their hour-long meeting on January 22, Ali tossed a slo-mo at his host's chin. "Help me!" Castro implored Cuban heavyweight Teófilo Stevenson (behind him at right). Then Ali gave Cuba's president an autographed photo and did a magic trick, making a red handkerchief vanish into a hollow rubber thumb. (As a parting gift, he presented it to Castro.) A month later, America's relations with Cuba cooled considerably. Cuban MiGs downed two civilian planes from a U.S.-based anti-Castro group, killing both pilots, and President Clinton, who had previously opposed strengthening sanctions against the communist nation, signed a bill to tighten the U.S. embargo.

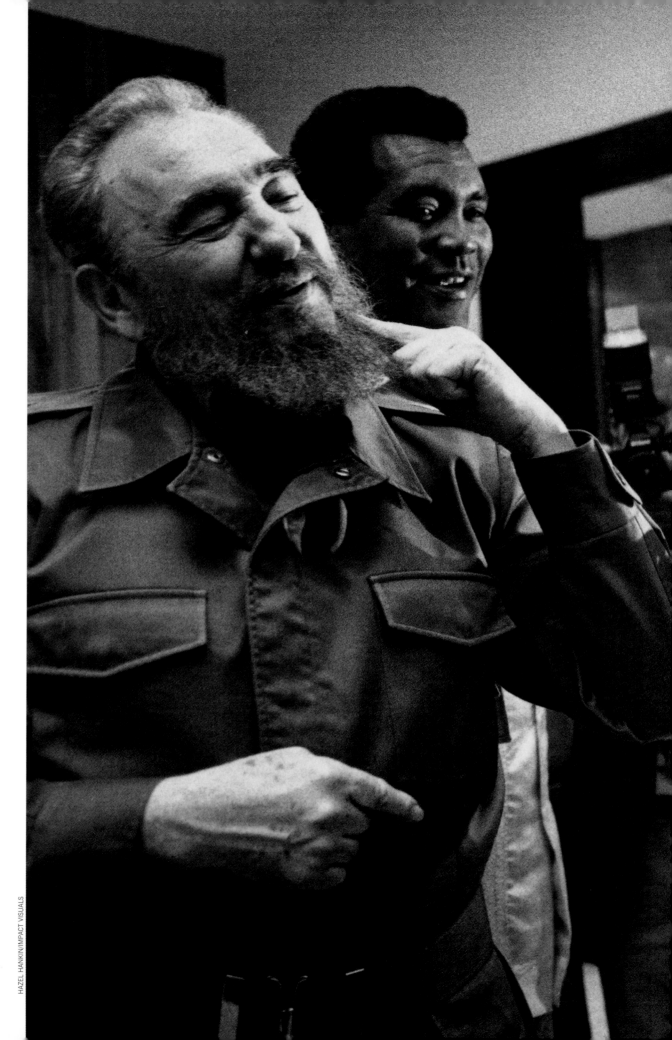

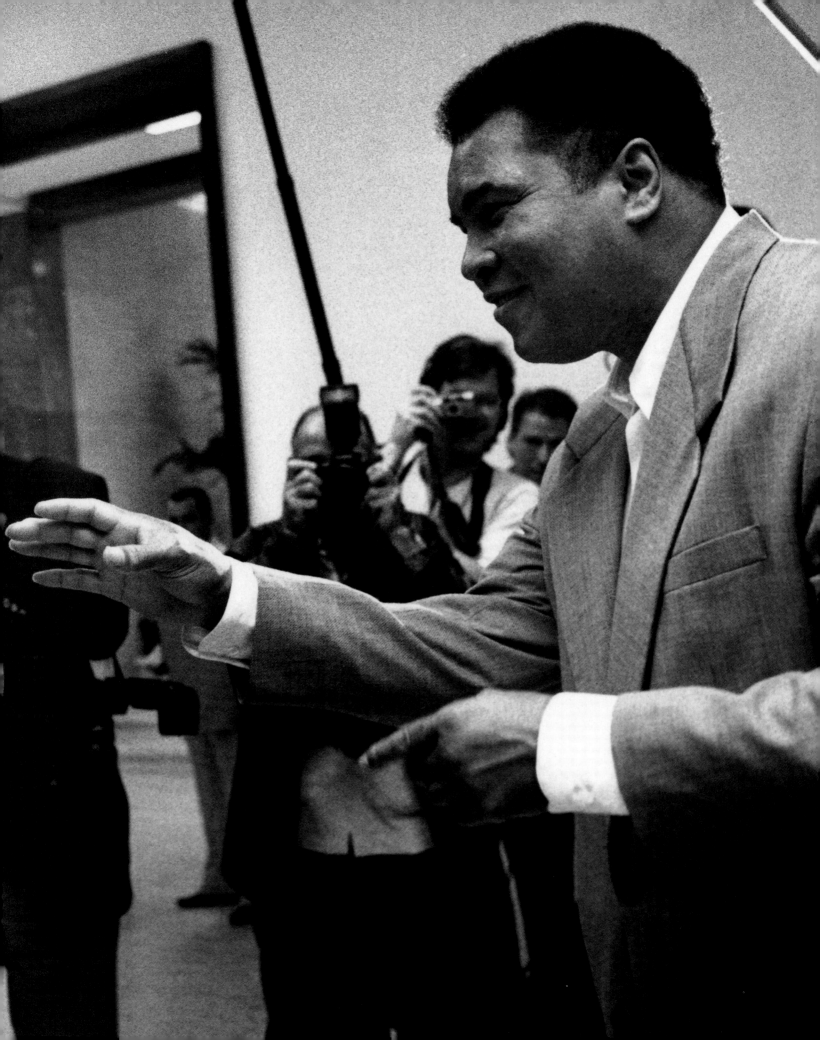

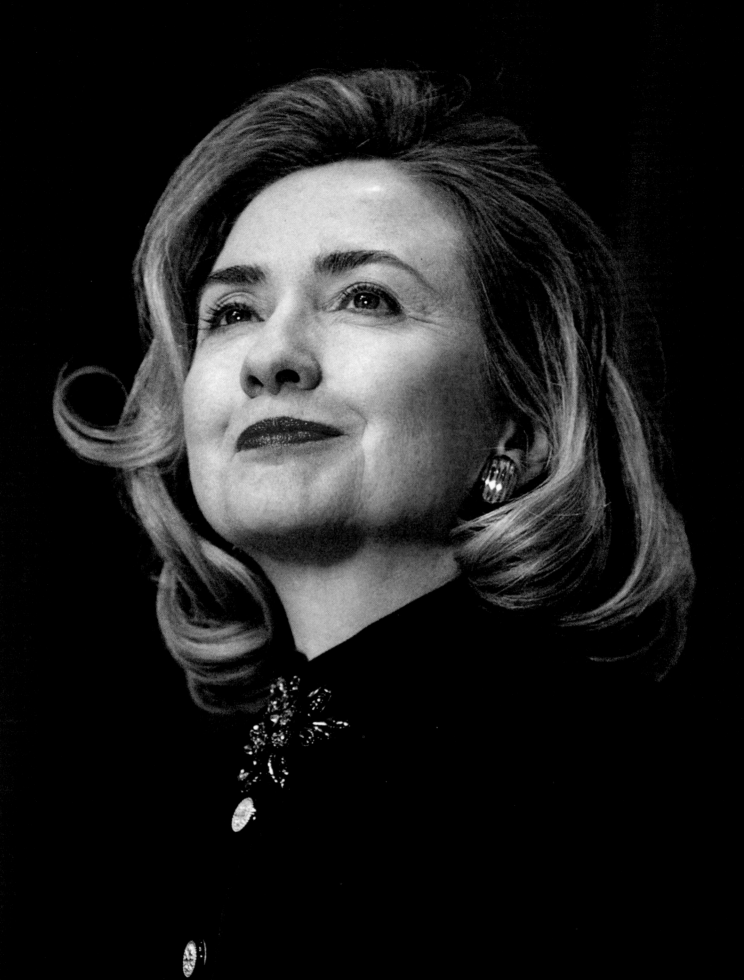

Hillary Rodham Clinton

O verall, the good news outweighed the bad for Hillary Rodham Clinton, but 1996 was a nonstop balancing act. The Good: In January her part personal, part pop-sociology treatise on child rearing, *It Takes a Village: And Other Lessons Children Teach Us*, became a national best-seller. The Bad: Days before Bill's State of the Union address, she became the first First Lady to be subpoenaed by a grand jury—and on January 26 testified under oath for four hours on issues relating to the discovery of long-lost Whitewater documents, which had recently surfaced in a storage room in the White House residence. Good: Just as she had done countless times for him, Bill stood firmly by his spouse. Hillary, he declared during his speech to the nation, "is a wonderful wife, a magnificent mother and a great First Lady." Bad: In June, when Hillary, 48, revealed that, with daughter Chelsea soon leaving for college, the First Couple had been talking about having a second child, she was accused of making a shameless election-year bid at softening her image. Soon after, journalist Bob Woodward asserted in his book *The Choice* that under the tutelage of a New Age adviser, the First Lady had engaged in imaginary conversations with Eleanor Roosevelt and Mahatma Gandhi. (Hillary claimed it was an "intellectual exercise.") Good: In August, Hillary made a pro-family speech at the Democratic convention, held in her hometown of Chicago, and received a four-minute standing ovation. Bad: She was frozen out of the campaign, forced to keep a low profile and feign indifference to matters of state. The Best: Bill Clinton was reelected on November 5, giving his wife a second term and—by presidential decree—a formal role in the administration's efforts at welfare reform.

February

■ On February 9, the day the **IRISH REPUBLICAN ARMY** announces an end to its 17-month cease-fire, a bomb explodes in an East London parking lot, killing two and wounding more than 100. Nine days later a second bomb goes off on a double-decker bus, wounding nine. The IRA claims responsibility for both attacks, accusing British Prime Minister **JOHN MAJOR** of "acting in bad faith" during peace efforts.

■ President Clinton signs legislation requiring television manufacturers to install **V-CHIPS** (the "V" stands for violence) in all new TV sets by 1998. The device is designed to enable parents to block access to shows they don't want their children to watch.

■ Deep Blue, a state-of-the-art **IBM** computer, defeats world chess champion **GARRY KASPAROV**, a 32-year-old human, in the first match of a six-game tournament. Kasparov, described by his coach as "devastated" by the loss, eventually proves victorious, with one loss, two draws and three wins.

■ Citing the potential for "great prejudice" in the jury pool of Oklahoma City, a federal judge moves the trial of **TIMOTHY McVEIGH** and **TERRY NICHOLS**, suspects in the April 1995 bombing of the Alfred P. Murrah Federal Building, to Denver.

■ The supertanker *Sea Empress* runs aground off the Welsh coast on February 15, leaking 70,000 tons of crude into the Celtic Sea. The **OIL SPILL** ranks as one of the 10 worst ever, causing twice the damage of the infamous Exxon *Valdez* spill off the Alaskan coast in 1989.

■ **PAT BUCHANAN**, ultraconservative political pundit, upsets Kansas senator **BOB DOLE**, the GOP's presumed presidential candidate, in the New Hampshire primary on February 20. **LAMAR ALEXANDER**, former Tennessee governor, comes in third. **MALCOLM FORBES JR.** (a.k.a. Steve), magazine magnate and promoter of a 17 percent flat tax, takes fourth place—but within the week wins both Delaware and Arizona.

■ Two of **SADDAM HUSSEIN**'s sons-in-law, who had defected to Jordan in 1995, go home to Baghdad with the Iraqi leader's promise of a pardon. They are killed three days after their return, reportedly by angry relatives.

■ **ALANIS MORISSETTE** wins four Grammy Awards—including best album of the year—for *Jagged Little Pill*. Also taking home Grammys: **SEAL**, for record and song of the year ("Kiss From a Rose"); **ANNIE LENNOX**, for best female pop vocal ("No More I Love You's"); and **FRANK SINATRA**, for best traditional pop album (*Duets II*).

■ Other winners: At the 37th annual **PILLSBURY BAKE-OFF**, Kurt Wait, baker of a macadamia fudge torte, becomes the first man to win the grand prize—an unprecedented $1 million in cash. At the 120th annual **WESTMINSTER KENNEL CLUB DOG SHOW**, Ch. Clussexx Country Sunrise (otherwise known as Brady), a four-year-old Clumber spaniel, takes Best in Show.

■ Hot books: *Rush Limbaugh Is a Big Fat Idiot and Other Observations*, a collection of anticonservative musings by comedian **AL FRANKEN**, and the relationship manual *Men Are From Mars, Women Are From Venus* by **JOHN GRAY**—still a best-seller after nearly three years.

▶ **THIS MAGIC MOMENT**

If Mount Rushmore could slam-dunk, it would look like this: Three of basketball's most super superstars, Dennis Rodman, Earvin "Magic" Johnson and Michael Jordan—on the court together for the first time since the NBA All-Star Game in February 1992. Magic had officially retired from the Los Angeles Lakers a few months earlier, after learning that he was HIV-positive. But this year the 36-year-old point guard decided to return to the game so that, he said, his three-year-old son, Earvin III, could see him play. In the February 2 matchup (right) between the Lakers and the Chicago Bulls, the second game of his comeback, Magic scored an honorable if wobbly 15 points. But Rodman bashed him around under the boards, pulled down 23 rebounds, and the soon-to-be 1996 NBA champion Bulls walked off with it 99–84. "Had no fun tonight," said Magic. In May he retired again.

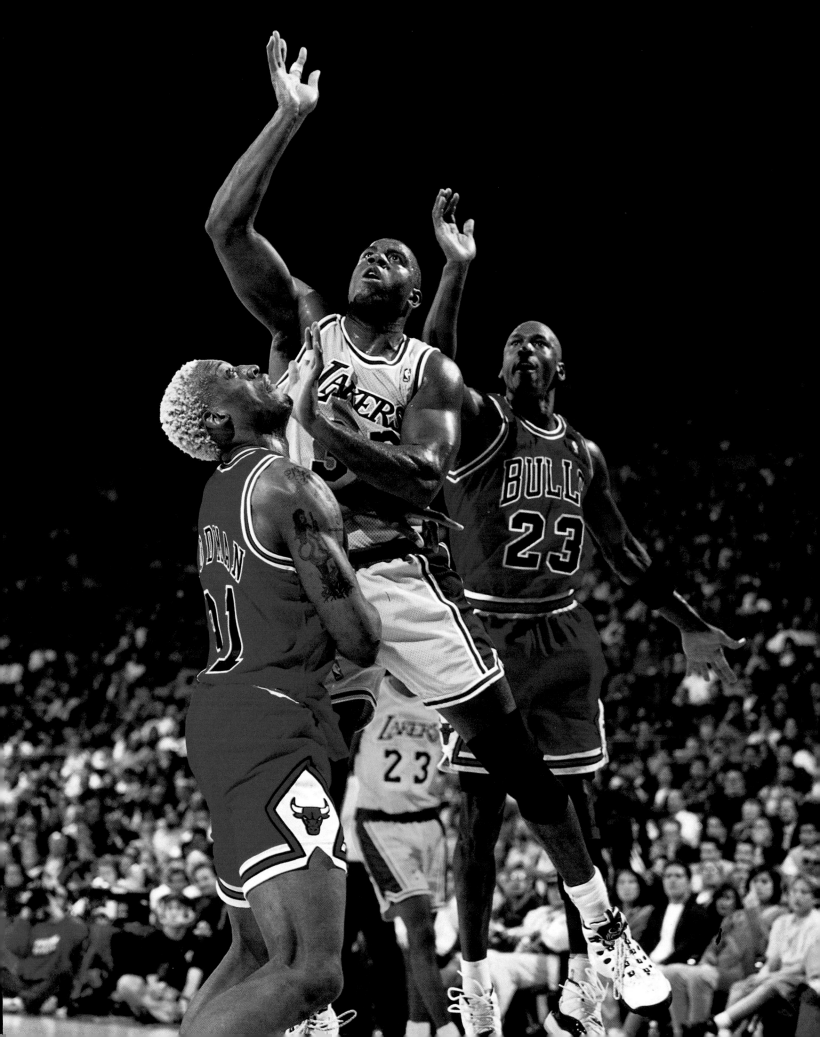

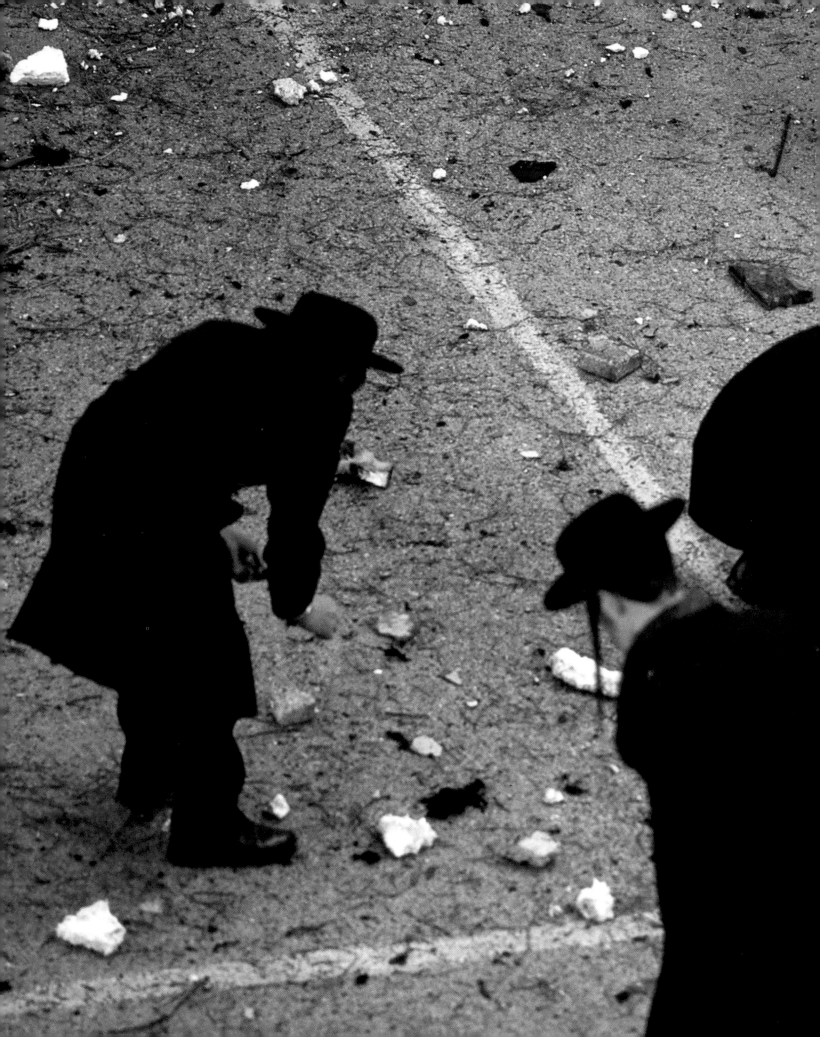

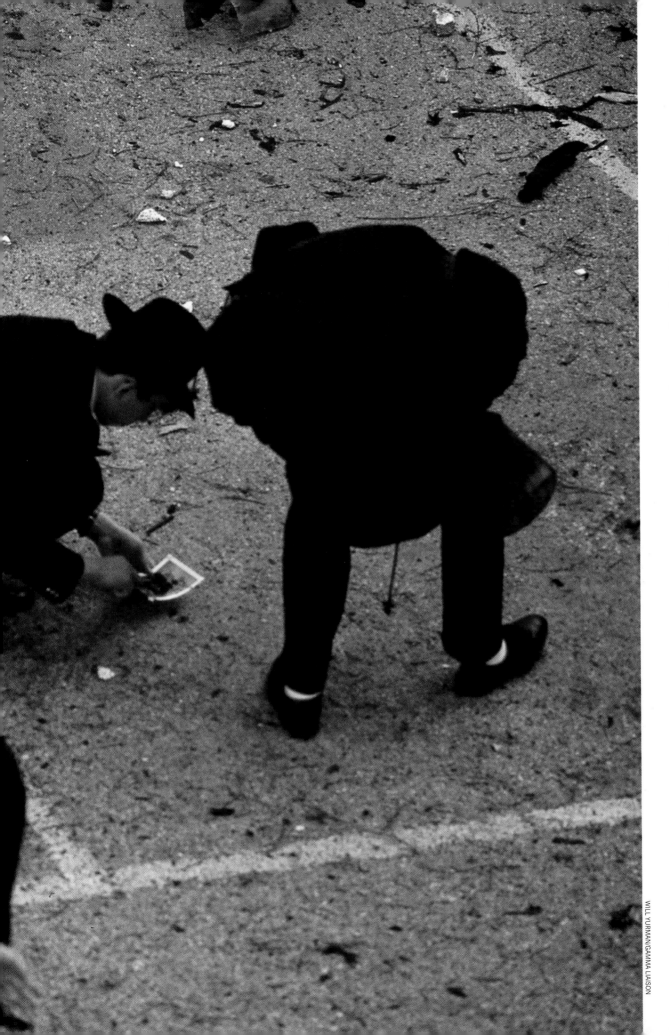

SHATTERED PEACE

In a nightmarish ritual, Orthodox Jews (left) scavenged sidewalks for pieces of bodies after a suicide bombing blew apart a bus and its passengers in Jerusalem on February 25. Under Jewish law, all the remains of the dead must receive a proper burial— even drops of blood may be chiseled from the pavement. Within nine days, three more bombings brought the toll to some 60 dead and 200 injured, savagely ending six months of calm. All were the work of a militant wing of Hamas, the newly splintered Palestinian group opposing peace with Israel. The faction claimed retaliation for the January killing of Hamas bombmaker Yahiya Ayyash, which was attributed to Israeli agents. The peace process was another casualty of the bombings. Like one woman who waited for forensic experts to match the DNA of the victims, the world could only ask, "Why, why, why?"

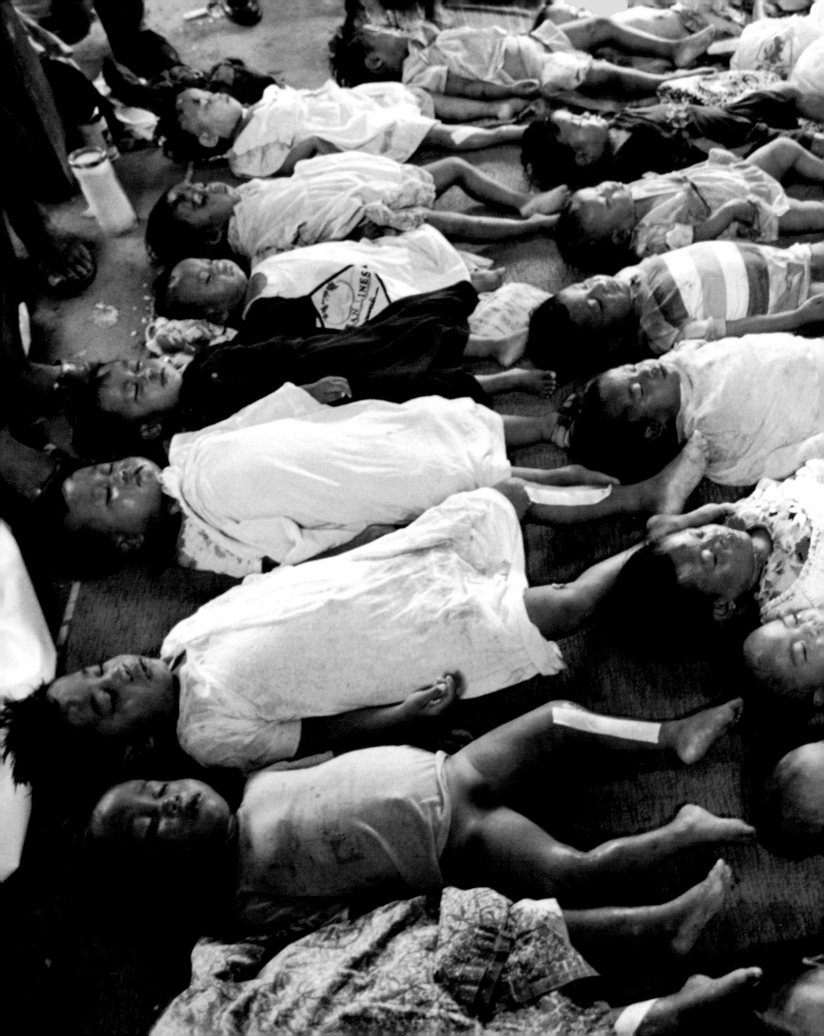

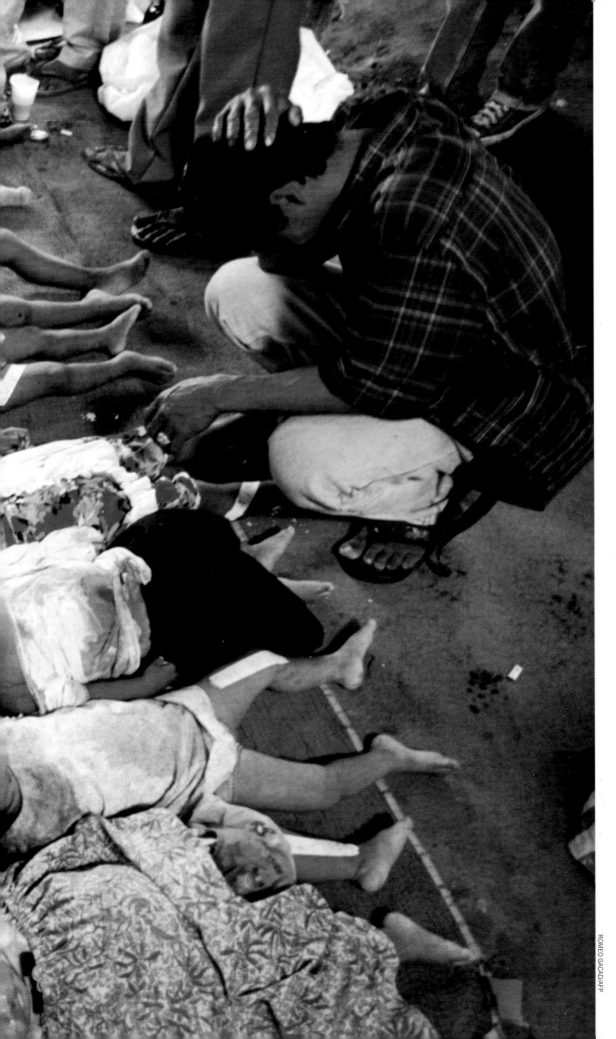

A TRAGIC PASSAGE

The 205 passengers on the *ML Gretchen 1* were a third of a mile from the end of their two-hour trip when nature and neglect caught up with them. The ferry, one of many that link the 7,000 islands of the Philippines, had been ordered out of service the previous week but sailed anyway. Its hull was rotten, its radio was broken, its captain had no formal maritime training, and it was badly overloaded—at almost double the legal capacity. Most fateful of all, the ship had left Bantayan island eight hours late and was forced to lie outside the shallow port of Cadiz on the island of Negros, awaiting high tide. When the storm hit, it was dark. Panicked passengers rushed to one side, and the ferry capsized. Jean Nunez, six, was one of the 31 children and 23 adults who drowned. Her father, Joseph (left), grieved at Cadiz's largest funeral parlor, which had run out of coffins.

45

THE Hip & THE Hot

The object of Six Degrees of Kevin Bacon, the mind-game rage on college campuses and the Internet: to connect the 38-year-old actor, veteran of some 30 movies, to other Hollywood stars via six films or less (right). The object of Scott Adams's comic strip *Dilbert* (above, the title character and his pet Dogbert): to tell the awful truth about the corporate workplace. The object of the year's most popular how-to book, *The Rules*: to, well, the subtitle—*Time-tested Secrets for Capturing the Heart of Mr. Right*—says it all. The object of *the* dance at the year's weddings, proms and most every other danceable event (Hey, Macarena!): to, hmm, that's a tough one. But comedian Janeane Garofalo (herself very hot since starring in the summer sleeper *The Truth About Cats and Dogs*) gave it some thought. Observed she: "You can tell a lot about a person by how excited they are to do the Macarena."

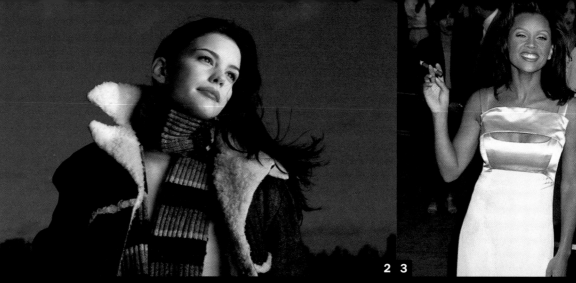

1

2 3

6

1. In need of fresh beefcake (Brad Pitt won't play along anymore), Hollywood nominated Texan Matthew McConaughey, 26—leading man, opposite the once superhot Sandra Bullock, in *A Time to Kill*—for movie hunkdom. 2. With turns in the erotic *Stealing Beauty* and director Tom Hanks's giddy *That Thing You Do,* the year's hottest actress turned out to be Liv Tyler, the 19-year-old daughter of Aerosmith front man Steven Tyler. 3. What's in and out of style? Very In: rainbow hues—pastel, candy or citrus colors. Check out Vanessa Williams (in minty blue, smoking a still quite fashionable stogie) and the frosty nail polish (right). Becoming In: basic brown. Quite Out: basic black. 4. The overall strategy propounded by *The Rules:* Play hard to get. (Other retro trends: the hippie look, yellow smiley faces, *Kiss* concerts and, dangerously, heroin. 5. Regis Philbin attempts steps two through five (there are seven) of the Macarena. (See Janeane Garofalo's theory, opposite.) 6. The pups in Disney's *101 Dalmatians* helped make anything spotted a must-have among the kiddie set.

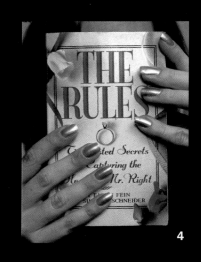

4

5

March

■ World leaders unite in Egypt for a **SUMMIT OF PEACEMAKERS**—a gathering to denounce terrorism and reaffirm support for the tenuous Middle East peace process. Among the 28 leaders in attendance: Bill Clinton, Yasir Arafat and Israeli Prime Minister Shimon Peres. Notably absent: Syrian President Hafez al-Assad.

■ On March 8, Sen. **STROM THURMOND** (R–S.C.) turns 93 years and 94 days old, breaking the record set by Theodore F. Green (D–R.I.) in 1956 to become the oldest senator in American history. Thurmond joined the Senate in 1954.

■ In Dunblane, Scotland, on the morning of March 13, Thomas Hamilton, a 43-year-old loner, **OPENS FIRE ON AN ELEMENTARY SCHOOL CLASS**. He then kills himself. Sixteen kindergartners and their teacher are slain; 12 other children are wounded. Mourners worldwide send several hundred bouquets and teddy bears to Dunblane.

■ **LYLE MENENDEZ**, 28, and his brother, **ERIK**, 25, are convicted of first-degree murder for the 1989 slayings of their parents. (Their first trials resulted in hung juries.) The brothers get life without parole—to be served in separate prisons.

■ Shock jock **DON IMUS** is assailed for his performance as host of the Radio & TV Correspondents' Dinner, attended by the President and First Lady. Among the comments the audience did not find amusing: quips about Bill Clinton's alleged womanizing; Hillary Clinton's legal tangles; House Majority Leader Newt Gingrich's gay half-sister; and Nebraska Sen. Bob Kerrey's artificial leg.

■ **GENERAL MOTORS** ends a 16-day strike at two of its brake factories in Dayton, on March 21. The shutdown, the biggest auto strike in a generation, all but halted car production in North America.

■ Taiwan holds its first democratic presidential election—which is also the first time in China's history that a head of state is popularly elected. The winner: **LEE TENG-HUI**, Taiwan's leader since 1988.

■ The **LIGGETT GROUP**, the smallest of the five major U.S. tobacco companies, breaks a long history of industry stonewalling and settles six lawsuits brought by smokers and state governments. Among the terms: Liggett must finance antismoking programs and discontinue advertising geared toward children.

■ On March 26, **BOB DOLE**—having gotten more than the 996 delegates needed to secure his party's backing—clinches the GOP presidential nomination. Lamar Alexander bowed out on March 6; Steve Forbes soon followed. Pat Buchanan vows to keep campaigning.

■ The Federal Reserve releases a **REDESIGNED $100 BILL**, created to foil counterfeiters. On the new C-note, Ben Franklin's face is larger than on the old bill and is placed left of center.

■ The U.S. Census Bureau reports that the **AVERAGE AGE AT MARRIAGE** is at an all-time high: 26.7 for men; 24.5 for women.

■ Tops at the box office: *The Birdcage,* a remake of the French farce *La Cage aux Folles,* starring **NATHAN LANE** as a middle-aged drag queen and **ROBIN WILLIAMS** as his longtime companion.

► THE BRIDES WORE WHITE

It was a revolutionary rite performed the old-fashioned way. Couples wore tulle or tuxes. There was organ music. As artist Maxine Kincora, 40 (right, smiling), and writer Jan Stafford, 45, walked down the aisle together, Jan accidentally stepped on Maxine's train. On March 25, San Francisco Mayor Willie Brown and members of the city's Board of Supervisors pronounced 163 gay couples "lawfully recognized domestic partners." The civil ceremonies, witnessed by loved ones and 84 reporters, were part confirmation, part protest: Hawaii's courts were preparing to hear a case legalizing same-sex unions; several states, along with Congress, were scrambling not to recognize them. For Kincora and Stafford, the event was personal as well as political. "Maxine always felt ripped off that she didn't have the big wedding with the dresses and everything," said Stafford, her partner of 12 years. "It was surprisingly touching, once we got past the reporters."

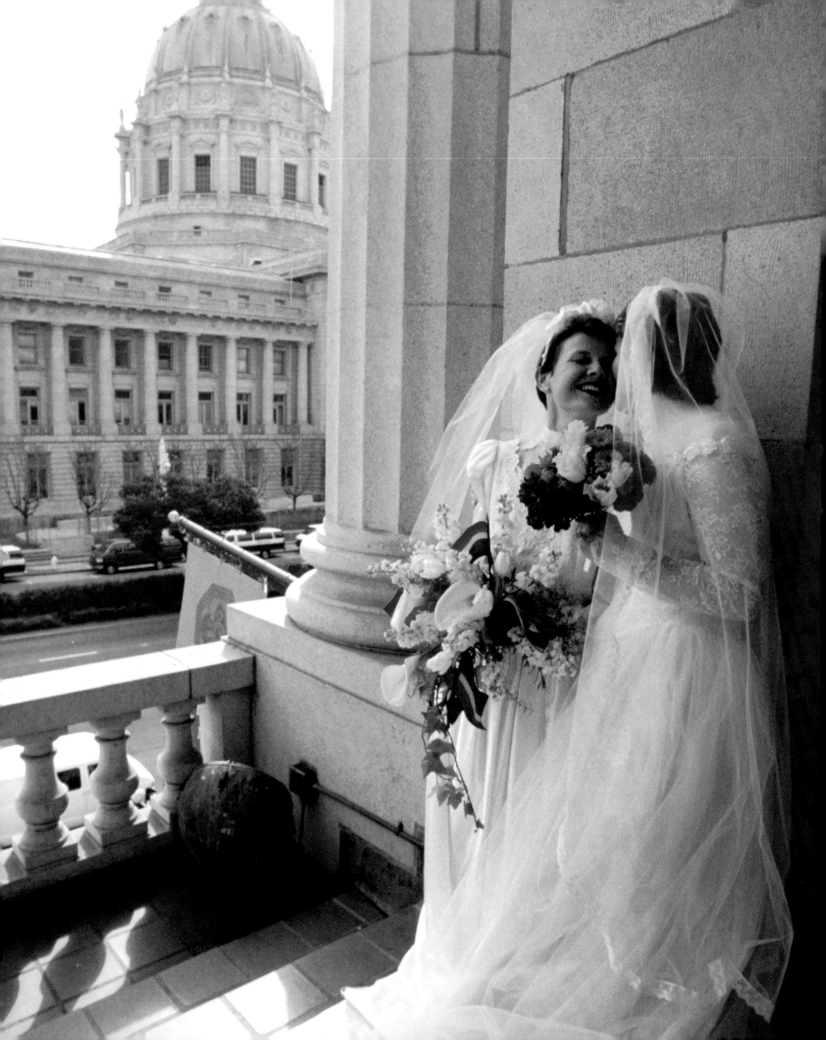

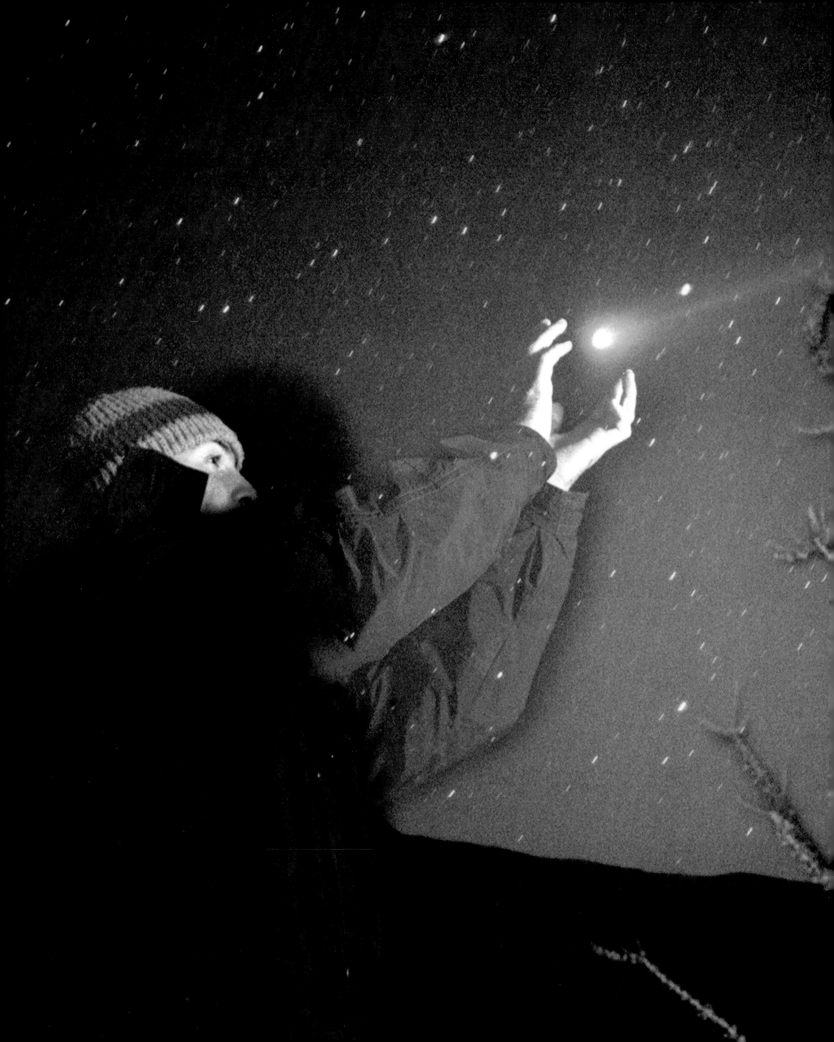

COSMIC OUTFIELDER

In reality it is hundreds of thousands of miles across. But from Earth, the brightest comet in 20 years appeared as insubstantial as a dandelion puff. Astronomers worldwide, both amateur and professional, attempted to catch Hyakutake—with the naked eye, with binoculars (as did Japanese photoengraver Yuji Hyakutake when he discovered it in January) or with the superpower of the Hubble Space Telescope. And in the dark of the desert near San Diego on March 23, Jay Bartletti, 19 (left), caught this remnant of the solar system's birth with his bare hands, preserving a moment that won't occur again for 18,000 years.

BOVINE MADNESS

"Mad cow disease" may have been a laughingstock elsewhere (one suggestion for how to eradicate it: Use Britain's 11 million cows to detonate Cambodia's 11 million land mines), but for the U.K. and John Niven Sr. (right) of Gloagburn Farm in Scotland, it was no joke. Perhaps transmitted by sheep remains in cattle feed, the bovine disease posed no threat to humans, British health officals had long insisted. But in March a study warned of a suspected link between eating beef and developing a rare human brain disease that had recently killed eight people in Britain. The European Union barred the nation's beef, and Britons themselves agonized over food safety. For reassurance, officials ordered the destruction of all cattle over 30 months—the disease seemed to strike older animals. The Nivens lost 14 of their 120 head, and John Jr. says the cull was political, er, bull: "A waste of good beef."

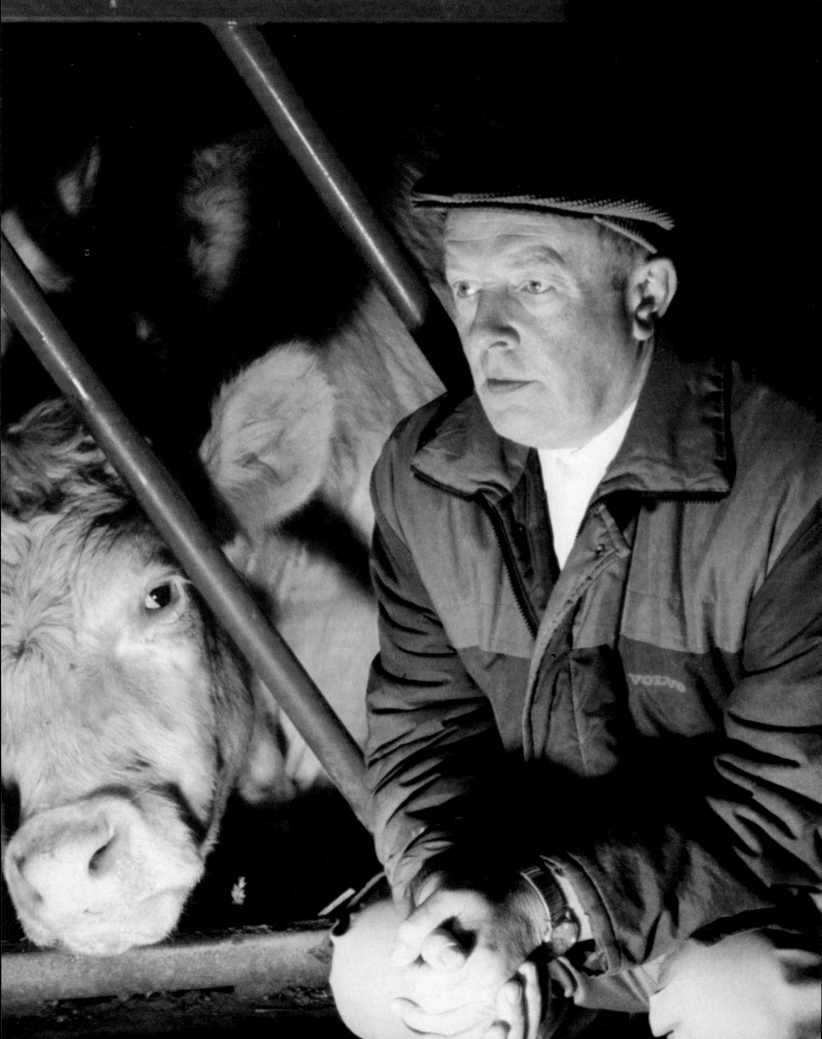

Oscar Night

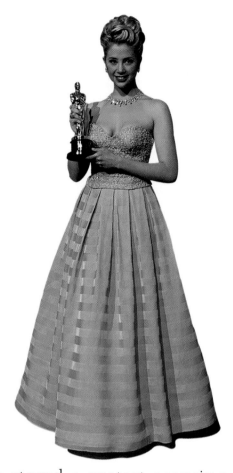

Outside, Jesse Jackson staged a protest accusing Hollywood—and the 68th Annual Academy Awards in particular—of ignoring the talent of African Americans. Inside, host Whoopi Goldberg kept the three-hour-and-39-minute show hopping, Christopher Reeve made his first live TV appearance since the riding accident that left him a quadriplegic, and the big screen's brightest stars, including the evening's Cinderella, Mira Sorvino (above), thanked and thanked and thanked the Academy for honoring them with the Oscar—or, as presenter Jim Carrey dubbed the golden statuette, "the Lord of all Knickknacks, the King of all Tchotchkes."

AND THE WINNER IS ...

Picture *Braveheart*
Director Mel Gibson, *Braveheart*
Actor Nicolas Cage, *Leaving Las Vegas*
Actress Susan Sarandon, *Dead Man Walking*
Supporting Actor Kevin Spacey, *The Usual Suspects*
Supporting Actress Mira Sorvino, *Mighty Aphrodite*
Original Screenplay Christopher McQuarrie, *The Usual Suspects*
Screenplay Adaptation Emma Thompson, *Sense and Sensibility*
Original Song "Colors of the Wind," *Pocahontas*
Foreign Language Film *Antonia's Line* (The Netherlands)

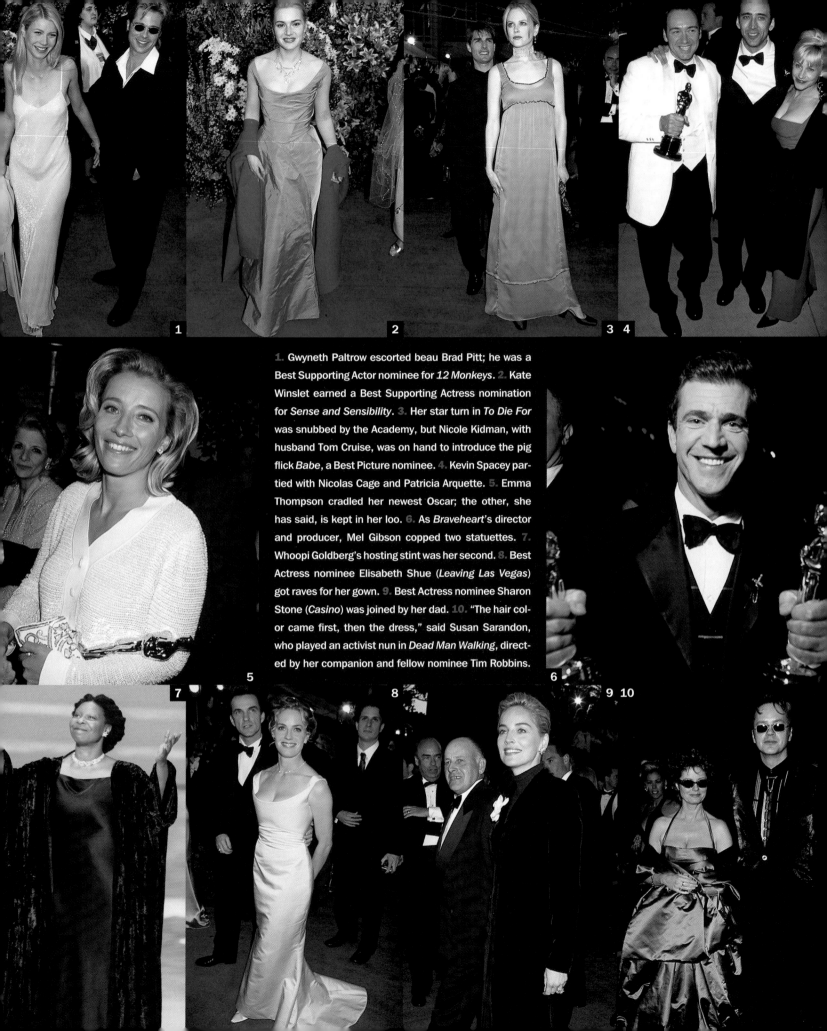

1. Gwyneth Paltrow escorted beau Brad Pitt; he was a Best Supporting Actor nominee for *12 Monkeys*. 2. Kate Winslet earned a Best Supporting Actress nomination for *Sense and Sensibility*. 3. Her star turn in *To Die For* was snubbed by the Academy, but Nicole Kidman, with husband Tom Cruise, was on hand to introduce the pig flick *Babe*, a Best Picture nominee. 4. Kevin Spacey partied with Nicolas Cage and Patricia Arquette. 5. Emma Thompson cradled her newest Oscar; the other, she has said, is kept in her loo. 6. As *Braveheart*'s director and producer, Mel Gibson copped two statuettes. 7. Whoopi Goldberg's hosting stint was her second. 8. Best Actress nominee Elisabeth Shue (*Leaving Las Vegas*) got raves for her gown. 9. Best Actress nominee Sharon Stone (*Casino*) was joined by her dad. 10. "The hair color came first, then the dress," said Susan Sarandon, who played an activist nun in *Dead Man Walking*, directed by her companion and fellow nominee Tim Robbins.

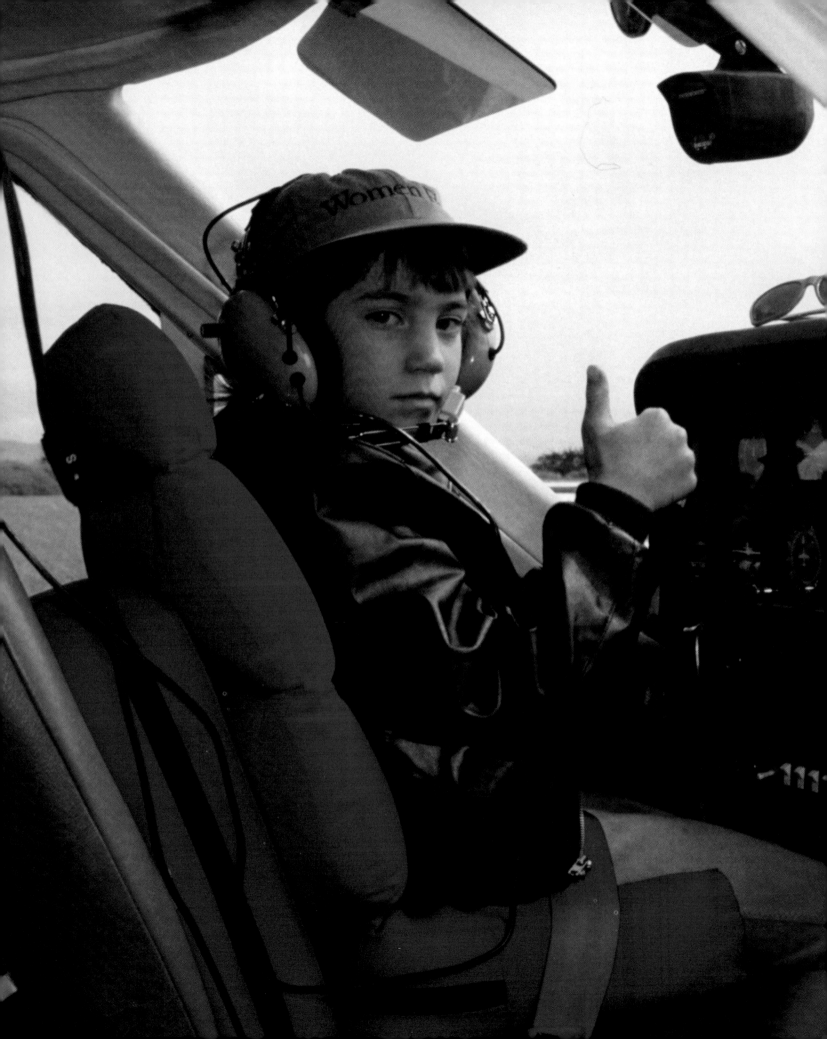

SAM SARGENT/GAMMA LIAISON

◀ THE SKY WAS THE LIMIT

Jessica Dubroff, four foot two inches tall, seven years old, requiring a booster chair so she could see and pedal extenders so her feet could reach, was trying to become the youngest pilot to fly coast to coast. A sunny child, she lived in California with her mother, who believed that children didn't need toys, but dreams. Inspired by Amelia Earhart, Jessica (left, the day before her departure) learned to fly. She took off for the first leg of her cross-country flight on April 10 with her father, Lloyd Dubroff, and instructor Joe Reid, who could instantly take over the controls. The next morning, in Cheyenne, Wyo., there were ugly thunderstorms and sleet, but Jessica was excited. "Do you hear the rain?" she asked her mom by phone. "Do you hear the rain?" Then, buffeted by winds, the Cessna 177B took off, stalled and dove into a street, killing all on board. In the tragedy's aftermath, many blamed Jessica's parents—and the press for hyping the attempt. But piloting, said her mother, Lisa Blair Hathaway, was the child's greatest joy. "I'm going to fly 'til I die," Jessica had said.

April

■ Saying that the use of a **LATE-TERM ABORTION** technique—dubbed "partial birth" by antiabortion activists—must remain an option for women who face serious health risks by continuing a pregnancy, President Clinton vetoes a bill outlawing the procedure. Had the law passed, it would have been the first to criminalize a specific abortion method. Congress fails to override the veto. Legislation Clinton does sign: a bill granting the President a line-item veto.

■ Golf's Great White Shark **GREG NORMAN**—who has a reputation for choking during big matches—loses the Masters Tournament to steel-nerved Brit **NICK FALDO**. Says Norman: "I let another one slip away."

■ Kenya speeds past the competition at the **100TH BOSTON MARATHON**. Moses Tanui, Ezekial Bitok and Cosmas Ndeti place first, second and third; Tegla Loroupe takes first in the women's race.

■ The Chicago Bulls become **THE FIRST TEAM IN THE NBA TO WIN 70 GAMES** in regular season play. Former recordholders: the 1971-72 Los Angeles Lakers.

■ The Equal Employment Opportunity Commission files a **SEXUAL HARASSMENT** suit on behalf of nearly 700 women, who claim that Mitsubishi motors condoned sexual harassment on an "outrageous scale" at its factory in Normal, Ill. Mitsubishi denies the charges but says it will investigate.

■ Sotheby's auction of **JACQUELINE KENNEDY ONASSIS'S ESTATE**, a four-day event initiated by Jackie's children, John Jr. and Caroline, rakes in $34.5 million (Sotheby's pre-auction estimate: $5 million). Among the 5,914 items sold: a fake-pearl necklace (valued at $600, sold for $211,500); a set of JFK's golf clubs (to Kennedy clan in-law Arnold Schwarzenegger, $772,500); a humidor given to the President by Milton Berle ($574,500). Priciest memento: The 40-carat diamond engagement ring from Aristotle Onassis, valued at $500,000, sold for $2.5 million.

■ *In Contempt*, by O.J. Simpson prosecutor **CHRISTOPHER DARDEN**, tops the best-seller lists. "At night, when your lawyers aren't around to convince the world that you didn't do it," Darden writes, in an imagined confrontation with the defendant, "I'll bet you ache a little bit."

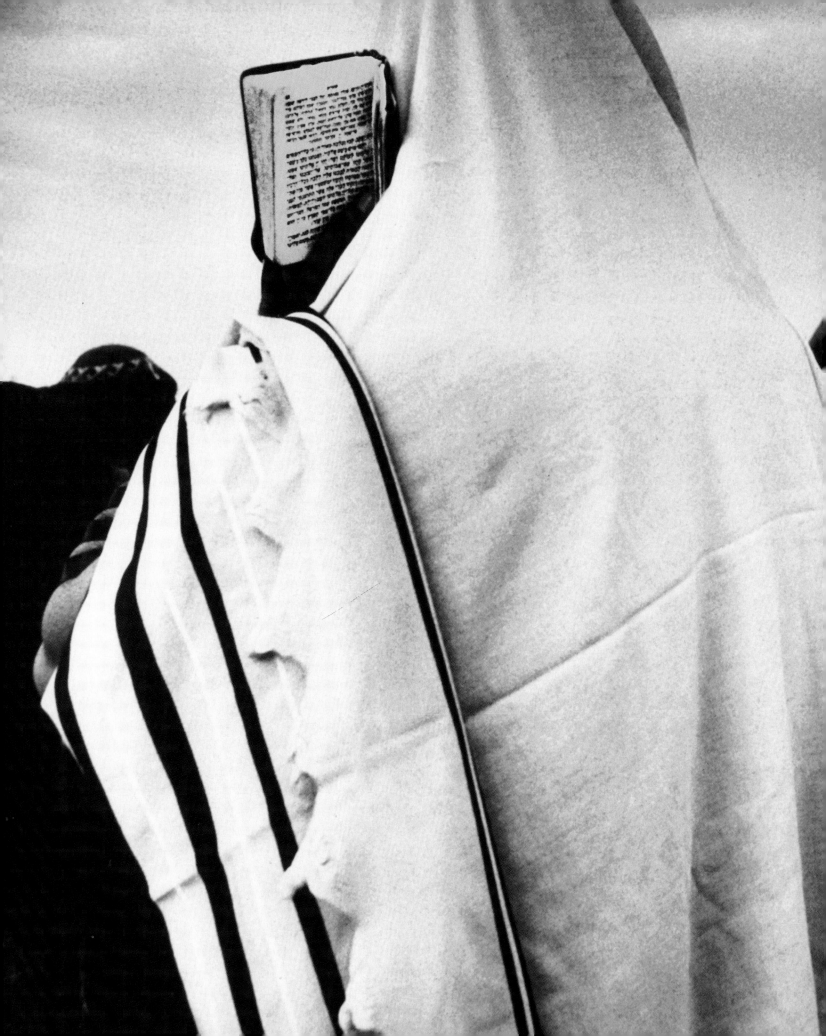

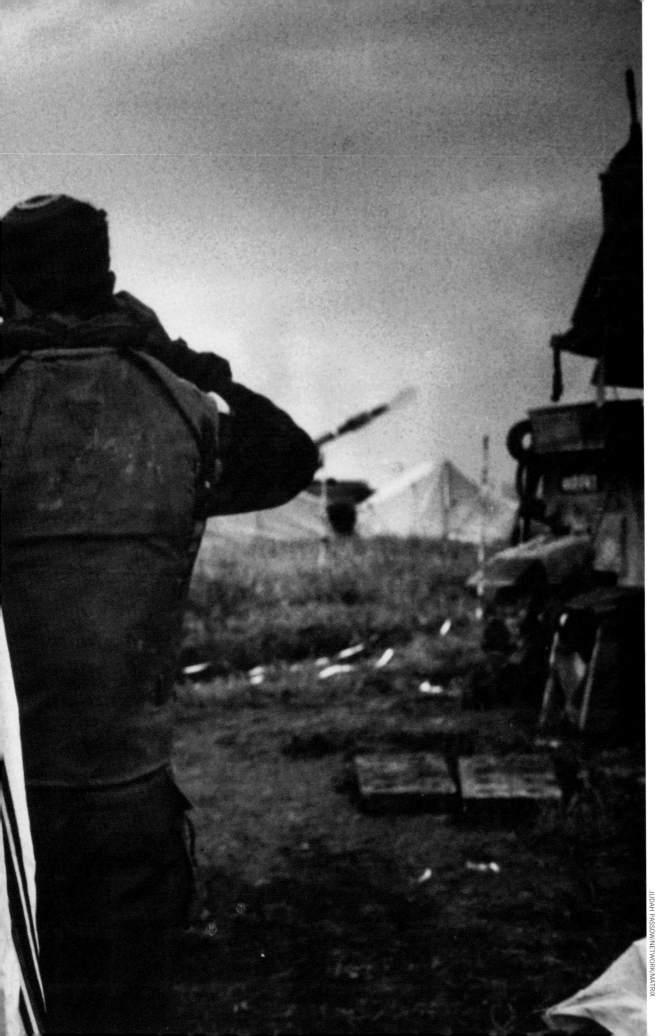

HOLY WAR

At an Israeli artillery outpost (left), a soldier in a prayer shawl does morning devotions while Israeli guns shell targets inside southern Lebanon, nine miles away. Israel's 16-day Operation Grapes of Wrath was aimed at the Iranian-backed guerrillas of Hizballah, or Party of God, in retaliation for rockets fired into northern Israel. Starting on April 11, Israel hit Hizballah positions hard and sent 400,000 forewarned Lebanese civilians fleeing north, where some sought shelter with United Nations troops. But while aiming at Hizballah guns near a U.N. compound, Israel hit the camp itself 13 times, killing more than 100 refugees. Said Israeli Prime Minister Shimon Peres of the carnage: "It came to us as a bitter surprise." Despite taking the offensive, the Nobel peacemaker was still not hard-line enough for supporters of the hawkish Benjamin Netanyahu, who in May narrowly defeated him to become Israel's leader.

CAPTURED

This is what the most wanted man in America proved to look like. Theodore J. Kaczynski, 53, lived in a 10-by-12-foot tar paper shack outside Lincoln, Mont. Local folks knew that the taciturn loner grew his own food, hunted deer and pedaled his beat-up bike to town for stone-ground flour. They didn't know that he was Harvard class of '62, a former math professor—or that, according to federal agents, he hoarded explosives and loose-leaf binders full of bomb diagrams. Alerted by his brother, David, who had become suspicious after reading a Unabomber tirade in *The Washington Post,* the FBI surrounded Kaczynski's hideaway and escorted him to the county jail in Helena (right). He was later charged with all three of the deaths and many of the blasts that, over nearly two decades, had been linked to the Unabomber (so called because early targets were universities and airlines). One damning entry in Kaczynski's journal: "I mailed that bomb."

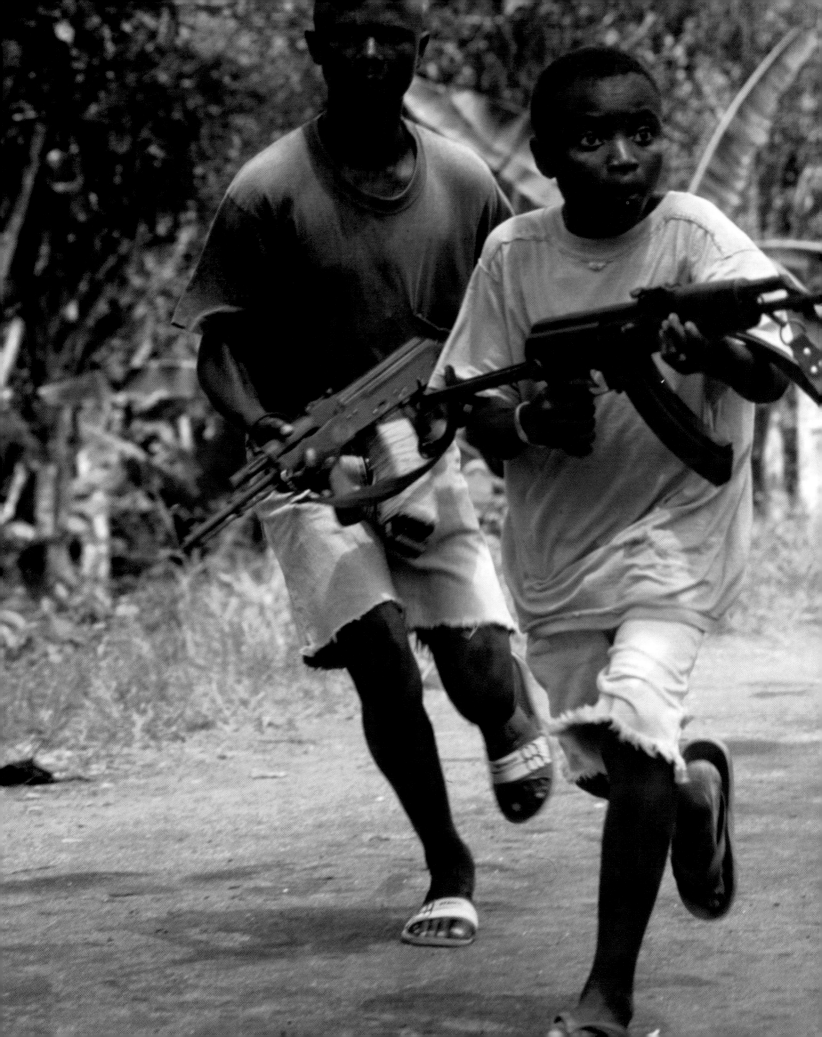

THE LOST BOYS

There are children in Liberia with names like Captain Killing Machine and Sudden Death. They're often stoned on cannabis, alcohol and amphetamines. They've cut open the abdomens of pregnant women, chopped off heads, bayoneted more people than they can count. And they're as young as eight. Led by American-educated warlord Charles Taylor, the Small Boy Units, some 15,000 strong (including these unidentified boys, whose crimes, if any, are not known), were but the most horrifying symptom of chaos in this West African nation. Since 1989, 150,000 have died and a million have lost their homes in civil strife. When fighting re-erupted in early April, U.S. helicopters began to evacuate almost 2,500 foreigners, including 461 Americans. At month's end, a U.S. delegation extracted a cease-fire from the warlords. A chief stipulation: Withdraw the marauding children who had taken over Monrovia, the capital.

Wedding Bells

Without question, the stealth marriage ceremony of John F. Kennedy Jr. and Carolyn Bessette (see page 114) was *the* Wedding of the Year—but there *were* others. Amy Carter, another child of the White House, also tied the knot without fanfare in Georgia. Olympic gymnasts Nadia Comaneci (gold for Romania in '76 and '80) and Bart Conner (gold for the U.S. in '84) wed like royalty in Bucharest. The Artist Formerly Known as Prince and dancer Mayte Garcia (above) married on Valentine's Day. And many *remarried.* Giving it a second shot: Paula Abdul, Sean Penn, Jim Carrey and a rebounding Michael Jackson, dumped in January by Lisa Marie Presley. Trying yet again: Christie Brinkley and Melanie Griffith each took Walk No. 4 down the aisle—the latter to the just-divorced Antonio Banderas.

. . . and BREAKUPS . . .

Officially separated: Designer Calvin Klein and wife Kelly (after 10 years of marriage); actors Parker Stevenson and Kirstie Alley (13 years); actor Charlie Sheen and model Donna Peele (five months); actress Halle Berry and Atlanta Braves outfielder David Justice (three years). *Finally divorced:* Nelson and Winnie Mandela (married 38 years); Prince Charles and Princess Diana (15 years); Prince Andrew and the former Sarah Ferguson (10 years); Elizabeth Taylor and seventh spouse Larry Fortensky (four years)

. . . and BUNDLES OF JOY

Born: Brandon, to Pamela (*Baywatch* lifeguard) and Tommy (Mötley Crüe drummer) Lee; Daniel, to actors Natasha Richardson and Liam Neeson; Jennifer, to Mr. and Mrs. Microsoft, Bill and Melinda Gates; Sophia, to Sylvester Stallone and girlfriend Jennifer Flavin; Matthew, to figure skater Nancy Kerrigan and hubby-manager Jerry Solomon; Destry, to director Steven Spielberg and wife Kate Capshaw; and Heavenly Hiraani Tigerlily, to INXS rocker Michael Hutchence and his love Paula Yates

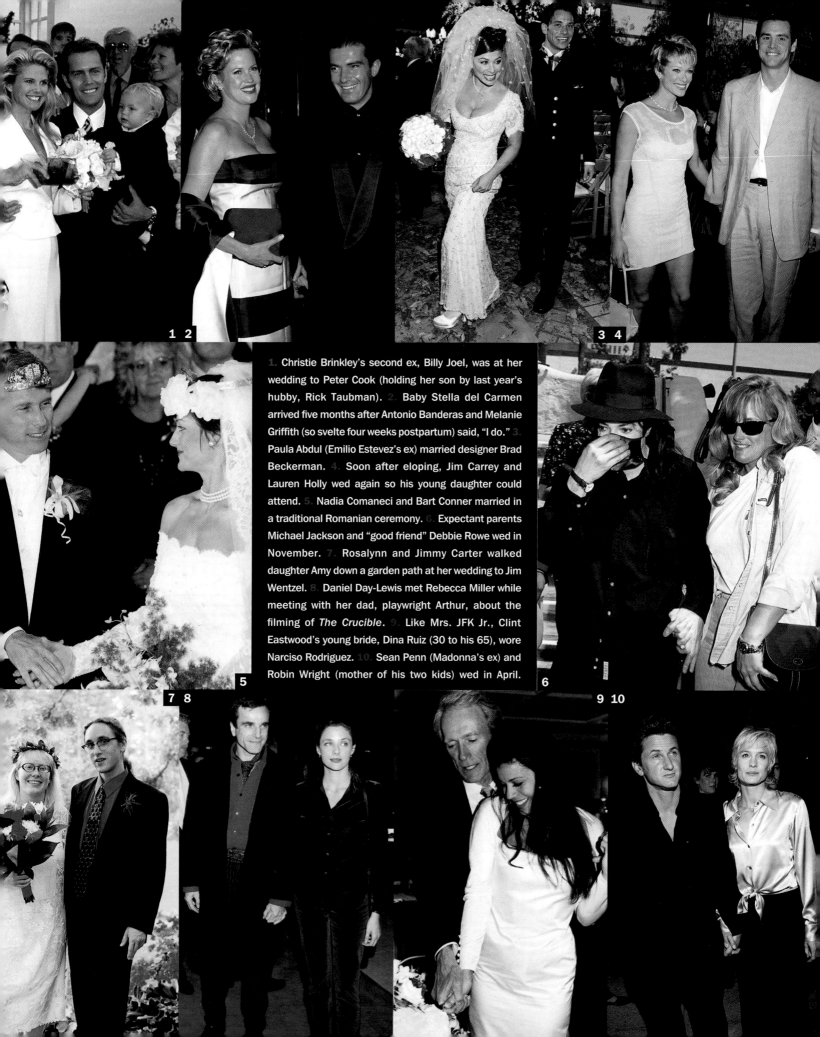

1. Christie Brinkley's second ex, Billy Joel, was at her wedding to Peter Cook (holding her son by last year's hubby, Rick Taubman). 2. Baby Stella del Carmen arrived five months after Antonio Banderas and Melanie Griffith (so svelte four weeks postpartum) said, "I do." 3. Paula Abdul (Emilio Estevez's ex) married designer Brad Beckerman. 4. Soon after eloping, Jim Carrey and Lauren Holly wed again so his young daughter could attend. 5. Nadia Comaneci and Bart Conner married in a traditional Romanian ceremony. 6. Expectant parents Michael Jackson and "good friend" Debbie Rowe wed in November. 7. Rosalynn and Jimmy Carter walked daughter Amy down a garden path at her wedding to Jim Wentzel. 8. Daniel Day-Lewis met Rebecca Miller while meeting with her dad, playwright Arthur, about the filming of *The Crucible*. 9. Like Mrs. JFK Jr., Clint Eastwood's young bride, Dina Ruiz (30 to his 65), wore Narciso Rodriguez. 10. Sean Penn (Madonna's ex) and Robin Wright (mother of his two kids) wed in April.

May

■ Grindstone wins the **KEN-TUCKY DERBY** by passing favorite (and half brother) Unbridled's Song and then edging ahead of Cavonnier by about four inches. It's the tightest Derby finish in 37 years.

■ A Pentagon study finds that roughly one in five U.S. soldiers **DRINKS, SMOKES AND EATS** far too much.

■ South Africa ratifies a new constitution by a vote of 421 to 2, with 10 abstentions. The 140-page document, which took two years to draft, rejects racism and guarantees rights that include freedom of speech and political action. Declares President **NELSON MANDELA**: "South Africa today undergoes her rebirth, cleansed of a horrible past."

■ **VALUJET AIRLINES** Flight 592 from Miami to Atlanta **CRASHES INTO THE EVERGLADES** on May 11, killing the 105 passengers and five crew members on board. Only 65 of the dead can be recovered from the muddy swamp. The suspected cause of the crash: oxygen generators, wrongly carried in the plane's cargo bay, exploded midflight. ValuJet, later grounded by the FAA for nearly four months, claims the oxygen had been mislabeled.

■ In an emotional announcement before his Capitol Hill colleagues, **BOB DOLE**, the GOP's longest-serving Senate leader, says he will resign from Congress after 35 years to focus on his presidential campaign. Dole declares he has "nowhere to go but the White House or home."

■ President Clinton signs legislation requiring local authorities to notify the public when a convicted sex offender moves into a community. The bill is modeled on New Jersey's **MEGAN'S LAW**, named for seven-year-old Megan Kanka, who was killed in 1994 by a convicted pedophile.

■ The **U.S. SUPREME COURT** rejects Colorado's Amendment 2, a 1992 voter referendum banning guarantees of equal rights and discrimination protection for gays and lesbians. Writing for the 6–3 majority, Justice Anthony Kennedy asserts that the amendment to the state's constitution put homosexuals into a "solitary class," and was clearly motivated by "animus."

■ The FDA approves **CONFIDE**, the first home-screening mail-in test for HIV. Cost: about $40. Results: in one week. Telephone counseling available.

■ Hello Gorgeous!!, a museum dedicated to **BARBRA STREISAND**, opens in San Francisco. On display are artifacts celebrating the singer-actress-director's career. Also offered: makeovers that allow fans to *be* Barbra, with the help of a fake proboscis and wig.

■ **ASTEROID 1996JA1** misses Earth by just 280,000 miles—a close call in space. The asteroid was the largest object ever to come so near. If 1996JA1 had hit, one astronomer noted, the explosion would have been akin to "taking all of the U.S. and Soviet nuclear weapons and blowing them up."

■ Buddy Lazier wins the **INDIANAPOLIS 500**. His average speed: 148 mph.

■ A Little Rock jury convicts President Clinton's former business partners, James McDougal and his ex-wife, Susan, of conspiracy—and assorted other offenses—in the first trial of the **WHITEWATER INVESTIGATION**. Also convicted, Arkansas Gov. Jim Guy Tucker, who resigns in July. The President had testified (via videotape) on behalf of all three.

■ At the movies: *Twister,* starring TV's **HELEN HUNT** as a tornado-chasing scientist, and **TOM CRUISE**'s *Mission: Impossible.*

▶ **DEATH ON THE MOUNTAIN**

The world's highest high, Mount Everest (29,028 feet), claimed more lives in one climbing season—11 this spring—than ever in its history. On May 10 (right), expedition leaders Scott Fischer, 40, of Seattle, and Rob Hall, 35, a New Zealander, guided their teams of paying clients in a final push to the summit. They had a few minutes on top of the world—looking below into Nepal and Tibet—before heading down into a snowstorm. With temperatures of –40° and 70-mph winds, the climbers began to fail from cold and lack of oxygen. Eight people, including the two leaders, never made it back to camp. Since 1953, when Sir Edmund Hillary and Tenzing Norgay Sherpa became the first to reach the Himalayan summit, 145 people have died in the attempt. One survivor of May's disaster said sadly, "The mountain always wins."

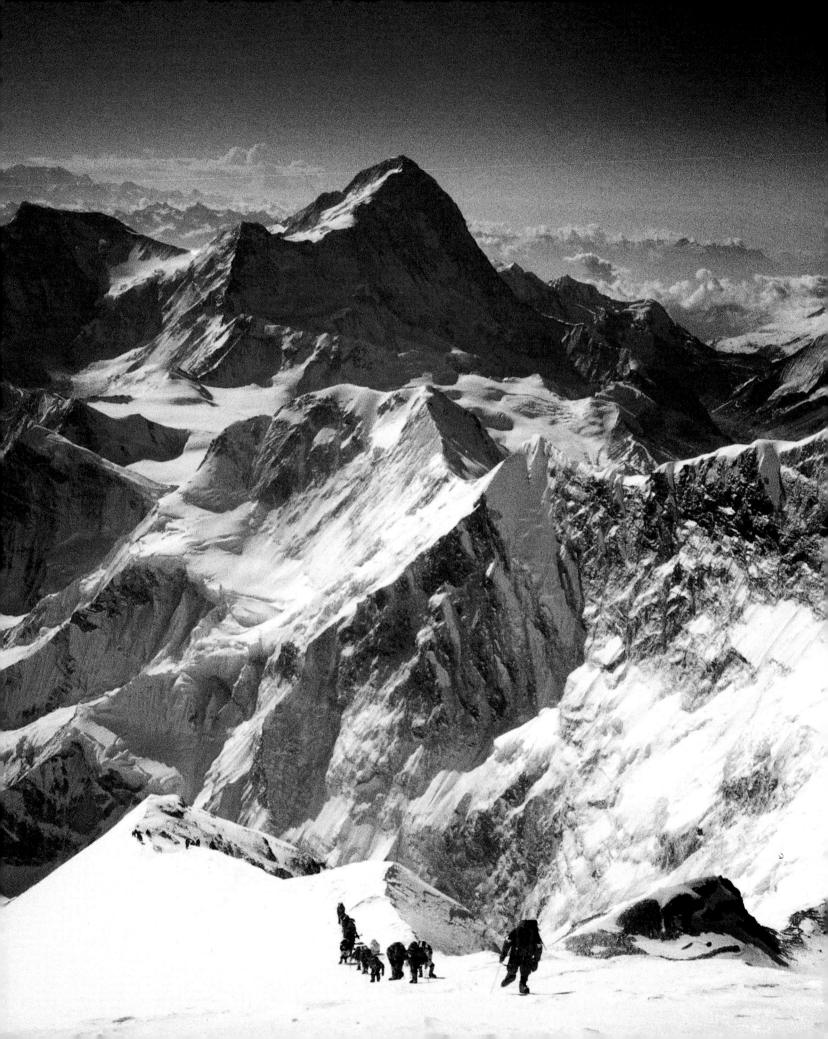

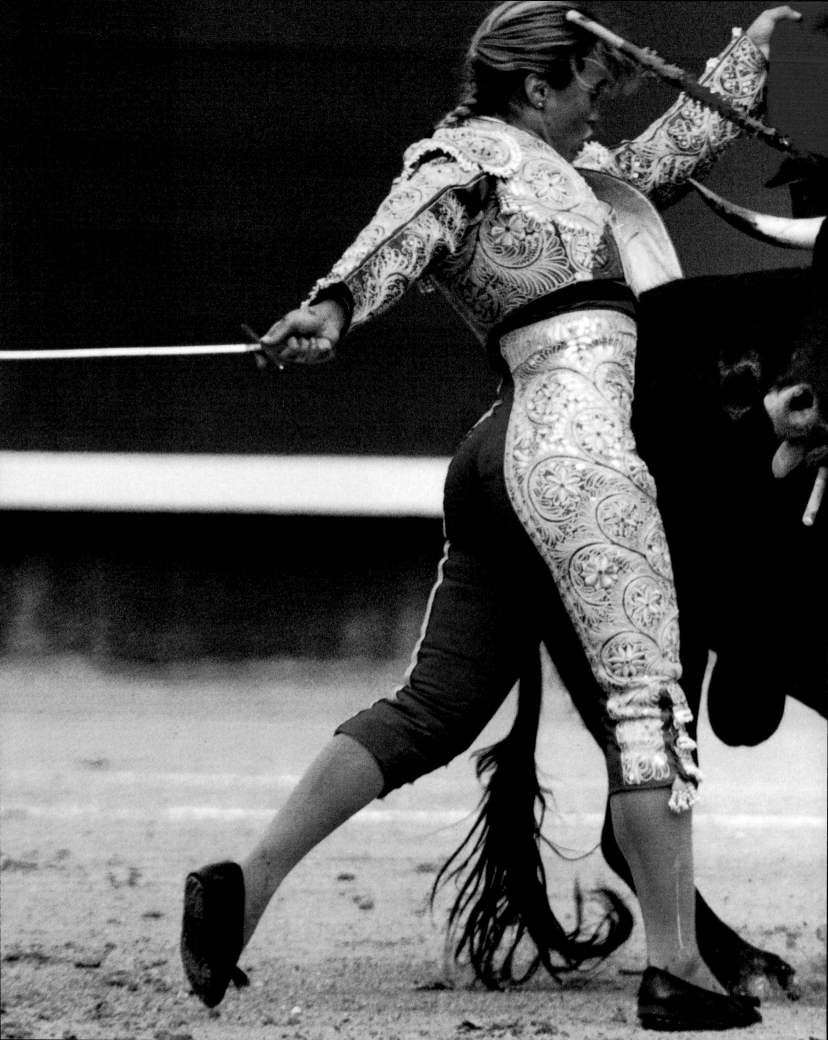

BEAUTY AND THE BEAST

"I want to make the *machistas* eat their words," bullfighter Cristina Sanchez, 24, used to say. *Machistas* are the most incorrigibly macho men in Spain, the country where machismo was invented. For years, they did everything in their power to drive Sanchez loco, bellowing insults and taunting her as she made her way through bullfighting's bush leagues. There had been other female bullfighters, but none had shown Sanchez's promise—she was first in her class at Madrid's vaunted bullfighting academy. For five years Sanchez (left, at the San Isidro festival in Madrid) advanced, dispatching more than 150 bulls. Then, on May 25, at the ancient Roman arena in Nîmes, France, Sanchez met a half-ton foe named Pocabarbas, a mightier animal than she had ever faced. On that day, she performed three feats: She sent Pocabarbas to his death, she became the first woman ever to reach the rank of *matador de toros* on European soil—and she silenced those *machistas* for good.

MAIDEN OF THE ICE

A red feather was the tip-off. Peruvian mountaineer Miguel Zarate and American archaeologist Johan Reinhard spotted the headdress poking through the snows of 20,700-foot Mount Ampato in Peru. Nearby was the frozen body of a young girl who had lain in ice for some 500 years until exposed by the heat of a recent volcanic eruption. By backpack, burro and bus, Reinhard got "Juanita" to his research center in nearby Arequipa. About 13 years old when she was sacrificed by Inca priests, the girl was clad in fine woolens and surrounded by ceremonial offerings. In May she traveled to Baltimore's Johns Hopkins University for tests and scans that revealed she'd probably been given drugs and killed with a blow to the head. Juanita then went public at the National Geographic Society in Washington, D.C., where President Clinton was among those impressed with her state of preservation: "That's a good-looking mummy," he said.

STOLEN CHILDHOOD

In Pakistan, where some 80 percent of the soccer balls sold in the U.S. are made, 11 million children like eight-year-old Kafayat (right) work 60-hour weeks. The pervasiveness of child labor worldwide was brought home in May when entertainer Kathie Lee Gifford responded to charges that clothing sold under her name by Wal-Mart was sewn by children in Honduras. Gifford tearfully defended herself on her morning show, *Live with Regis & Kathie Lee,* but she and other Americans were forced to face the fact that many goods—teddy bears, scissors, rugs, tweezers, celebrity-endorsed sneakers (among them Michael Jordan's line for Nike)—are made abroad by enslaved children. Two months later, Gifford testified before Congress against such sweatshop labor, giving proposed regulation a high-profile advocate. "These young children," she said, "are denied the basic right to be kids, to *play* with a ball."

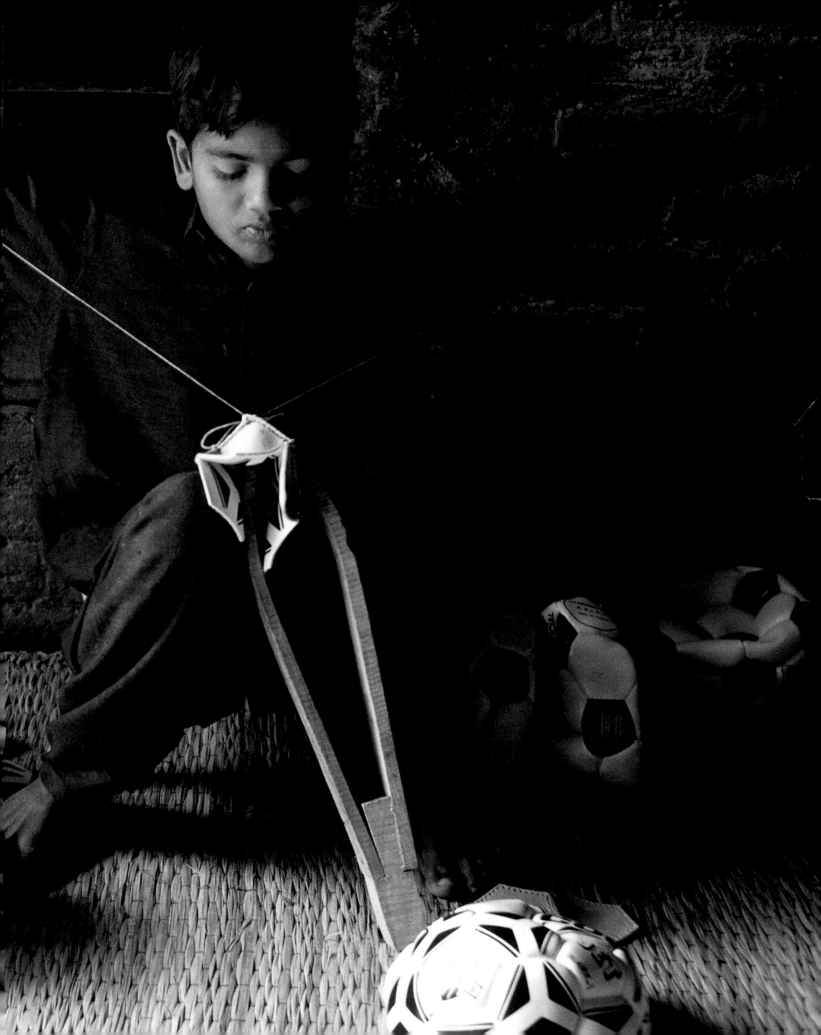

S

Rosie O'Donnell

omewhere in America there is a little girl who wants to be Rosie O'Donnell when she grows up. She has brothers and sisters from whom she needs to distinguish herself by being "the funny one." She's maybe not as conventionally pretty as her peers. She's sharp, never mean, and a little starstruck. She dreams of going to work on an amusement park set, of singing songs and telling jokes and having everyone say how fun and smart and sweet she is—everyone from Mel Gibson (the movie star) to Fergie (the Duchess of York) to Elmo (the Muppet). And until she grows up, she'll pretend she's on television by talking into her hairbrush in front of the mirror. In fact, she's a lot like Rosie herself was when she was a girl in Commack, N.Y., watching Mike Douglas and Merv Griffin in the afternoon and Johnny Carson at night, and making up talk-show banter while examining her teenage skin in the bathroom. All those hours in front of the tube and mirror paid off: 1996 was a big year for O'Donnell, 34, who had already been second banana in a number of hit films (like *A League of Their Own* and *Sleepless in Seattle*) but came center stage in June with the debut of her own daytime TV talk fest, *The Rosie O'Donnell Show*. Not snide like Letterman or sensational like Geraldo or squishy like Oprah, she found a niche with what was a radical attitude: She was nice. Nice, yes, but no pushover. When Donny Osmond made a fat joke at her expense, the host who never forgets a moment in pop-culture history sought justice by making him sing his 1973 hit "Puppy Love" in a dog suit. Who will her toddler, Parker, want to be when he grows up? Well, maybe not Rosie O'Donnell, but Mom will want him to go for it, whatever *it* is. Says she, "I've achieved so much of what I dreamed of as a child."

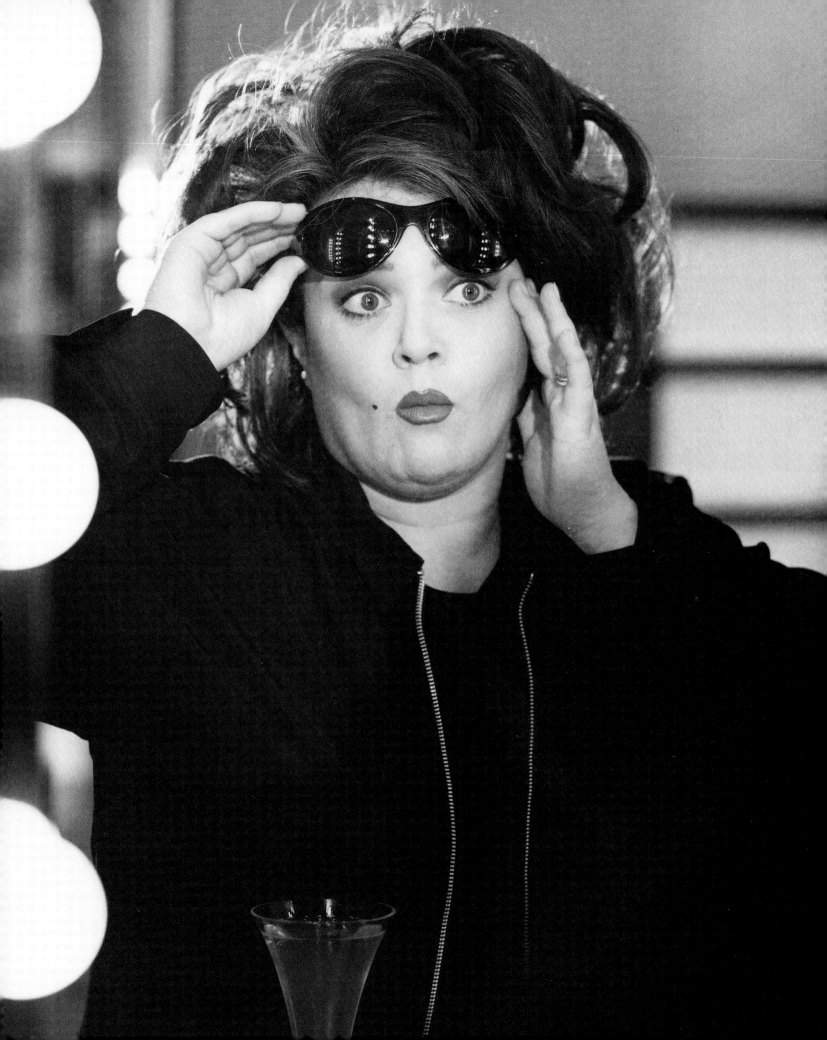

June

At the 50th annual **TONY AWARDS**, *Master Class*, **TERRENCE McNALLY**'s homage to Maria Callas, wins three Tonys, including Best Play and star **ZOE CALDWELL**'s award for Best Actress in a Play. *Rent*, the rock-opera sensation based on *La Bohème*, grabs four awards, including Best Musical. **NATHAN LANE** wins Best Actor in a Musical (*A Funny Thing Happened on the Way to the Forum*), and **DONNA MURPHY** takes home a Tony for Best Actress in a Musical (*The King and I*), an award expected to go to *Victor/Victoria* star **JULIE ANDREWS**, who, upset that the show received only one nomination—hers—rejected the honor and boycotted the ceremony.

On June 13, 16 members of the antigovernment militia group **THE FREEMEN**—holed up in Justus Township, their Jordan, Mont., ranch—surrender to the FBI after an 81-day standoff.

The Colorado Avalanche trounces the Florida Panthers in a four-game sweep (the last in triple overtime by a 1–0 score) to win the **STANLEY CUP**.

Unicef reports that 585,000 women worldwide die each year in **CHILDBIRTH**. The main cause: a dearth of trained midwives and obstetricians.

A truck bomb explodes at a U.S. military complex near Dhahran, Saudi Arabia, on June 25, killing 19 and injuring 300. It is the **WORST TERRORIST ATTACK** against Americans abroad since 1983, when a bomb at a Marine barracks in Beirut killed 241.

A United Nations court indicts eight Bosnian Serb officers for the organized rape of Muslim women. The indictment marks the first time rape and sexual assault, traditionally tolerated as part of soldiers' violent behavior, are treated as distinct **WAR CRIMES** against humanity.

While campaigning in Kentucky and Alabama, **BOB DOLE** tells tobacco farmers—angered by Clinton administration efforts to label nicotine a drug—that he's not sure cigarettes are addictive. "To some people, smoking is addictive; to others, they can take it or leave it," says Dole. "We know it's not good for kids. But some would say milk's not good."

HE'S A DANCING MACHINE

The history of black America in his size 12 ½ EE shoes, Savion Glover, 22, taps like a machine gun, dangles on the edge of a foot, balances on his heels and toes—and, without saying a word, tells of slavery, lynchings, Harlem, riots, gospel, dancing and freedom. In flappy T-shirt and pants or bare-chested, the star and choreographer of *Bring in 'Da Noise, Bring in 'Da Funk* danced off with a Tony Award for choreography on his second nomination—he earned one at age 15 for acting in *Black and Blue*. The raw, urban tap/rap he calls "hitting" brought exuberant originality back to Broadway. Gregory Hines, who starred with him in *Jelly's Last Jam*, says, "Savion is the best tap dancer that ever lived." It is not without cost: Glover, who began tap at seven, never dances without back pain. But he eschews advice about preventing early arthritis. "You're going to feel it when you're twenty-five," he's been warned. He shrugs. "I say, when I'm twenty-five, I'll feel it."

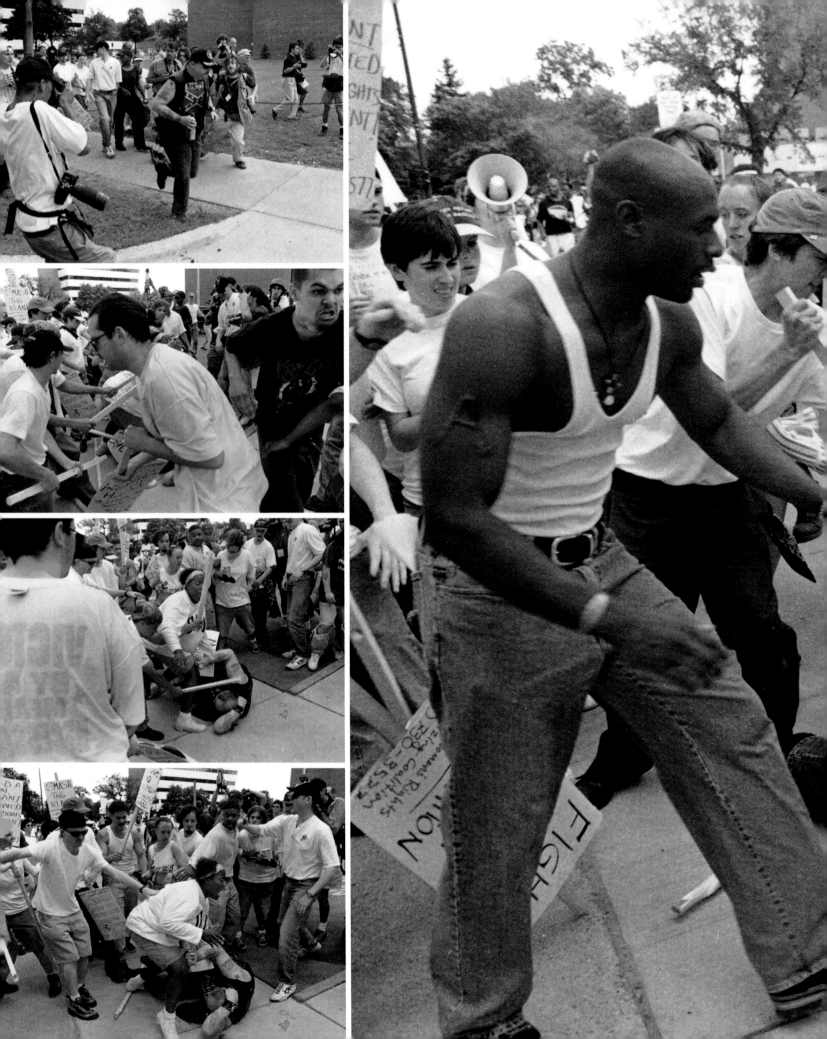

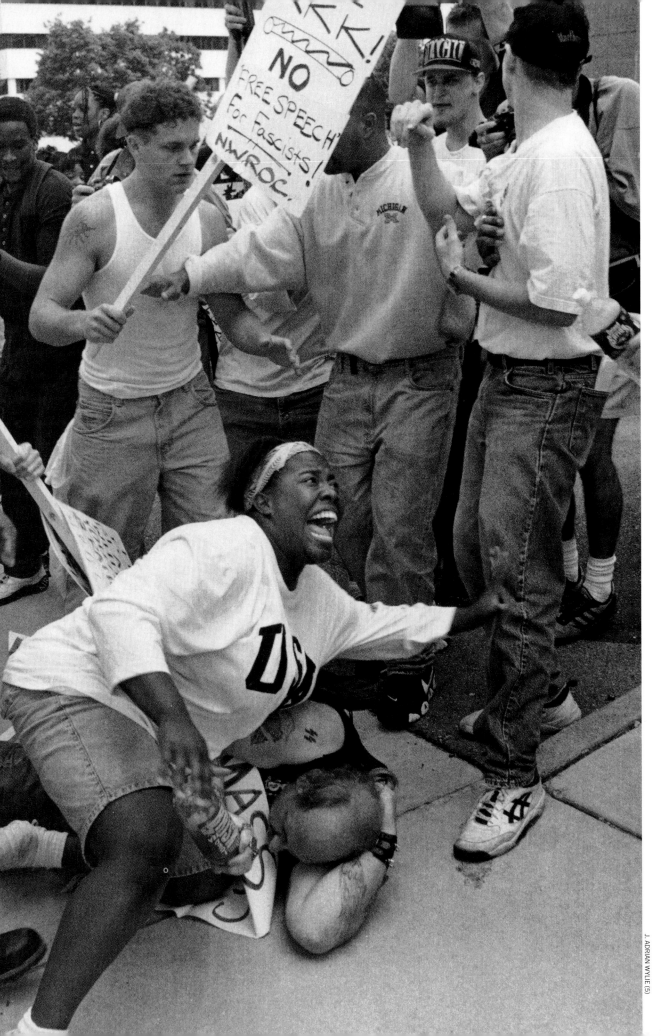

A HUMAN SHIELD

"What did I ever do to you?" That's the question Keshia Thomas, 18, would have liked to ask the man in the Confederate flag T-shirt with the slogan "You wear your X and I'll wear mine." The high school senior wanted to make her adversary *think,* but some of her fellow demonstrators at a Ku Klux Klan rally in front of city hall in Ann Arbor, Mich., were intent on making him *feel.* As they surged forward, beating bystander Albert McKeel Jr. to the ground, Thomas rushed into the melee. To everyone's surprise, she threw herself on McKeel, protecting him from harm (left). "Stop, stop, stop!" she yelled. The police moved in; the crowd retreated. Even an imperial wizard of the Klan was impressed, saying, "We bless her. Tell her thanks." For Thomas, the June 22 act was one not of heroism but of simple humanity. "He's still somebody's child," she later said. "My parents taught me that you shouldn't resort to violence."

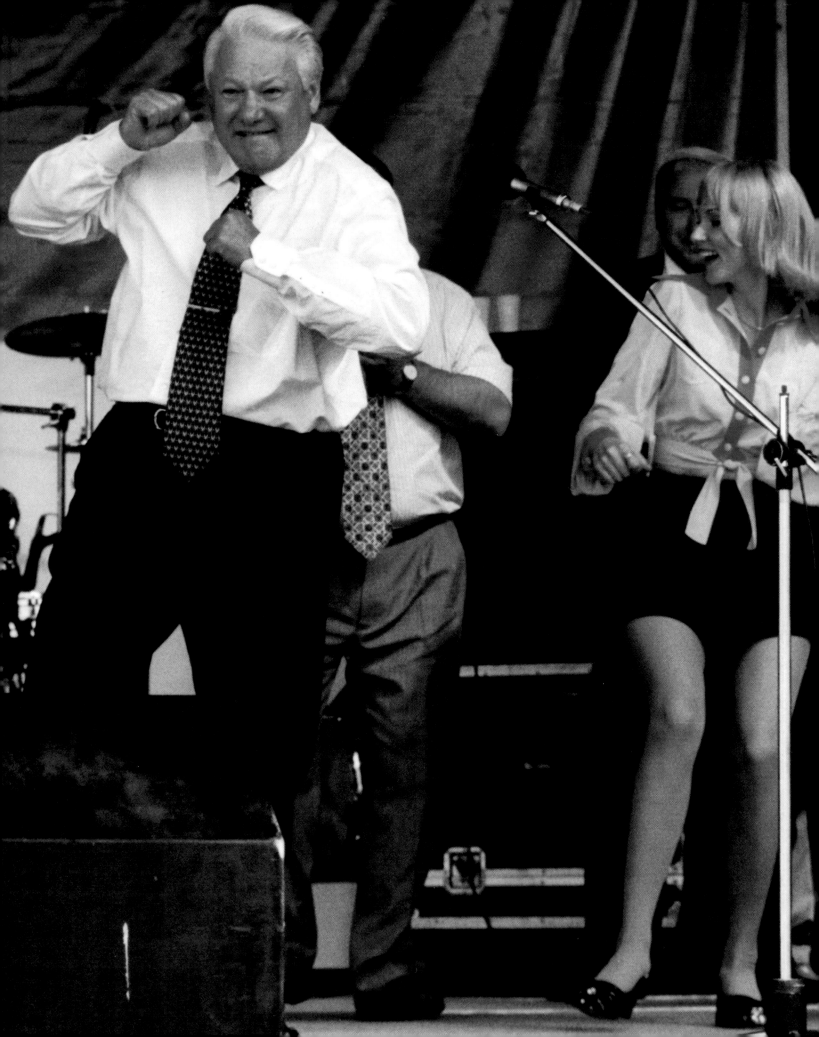

ALEXANDER ZEMLIANICHENKO/AP/WIDE WORLD PHOTOS

FANCY FOOTWORK

When he go-goed at a rock concert on June 10, Boris Yeltsin didn't look much like a world leader or a man facing open-heart surgery or an unpopular president of Russia just before a big election. But that was the whole idea. Plagued by rumors of ill health (denied), cabinet dissidents (disclaimed) and widespread discontent over corruption, crime and unemployment (blamed on underlings), Yeltsin, 65, boogied to burnish his youth appeal. Then he 1) canceled appearances, 2) squeaked in first in the 10-man election, 3) fired four top aides, 4) hired popular general and rival Alexander Lebed as national security adviser, 5) won the July runoff for the presidency against Communist party leader Gennadi Zyuganov. He soon sacked Lebed and in November had the quintuple bypass (observed by famed American heart surgeon Michael DeBakey) he finally confessed was needed. Post-op prognosis? He'll be back on the dance floor.

F

Michael Johnson

ireflies were thick in the heavy Georgia air in July. Thousands of them, flickering and fading: Fuji fireflies, Canon, Nikon and, suitably, Olympus. Sparked by the starter's gun, they flared in Olympic Stadium. For no one did they flash so brilliantly as for the gold-shod golden boy. The smart, stoical, driven 28-year-old from Waco, Tex., came to Atlanta with 16 relatives, a personal assistant, a manager, two coaches and several pairs of customized gold running shoes. He also came with his June world record in the 200-meter sprint (19.66 seconds), a 54-match winning streak in the 400 and a plan to become the first athlete to win the 200- and 400-meter races in the same Olympics. He won the 400. Then came the ferocious 200. After a fast-food burger with cheese, side o' fries, he was ready. When the gun went off, he exploded off the blocks. "I was running faster than I ever had in my life. It was a thrill, just thrilling," he said later. "The only feeling I've had that could compare, when I was a kid, my dad bought me a go-kart, and there was a big hill . . . Get a go-kart and find a hill, and you'll know what it's like." But no one else will soon know what it's like to run 200 meters in 19.32, reaching a top speed of maybe 28 miles per hour. Amazing stats, reflected by the amazement on Michael Johnson's face when he saw his time. And the gasp of the crowd. And then the burst of lights for the king of track and field, Lord of the Fireflies.

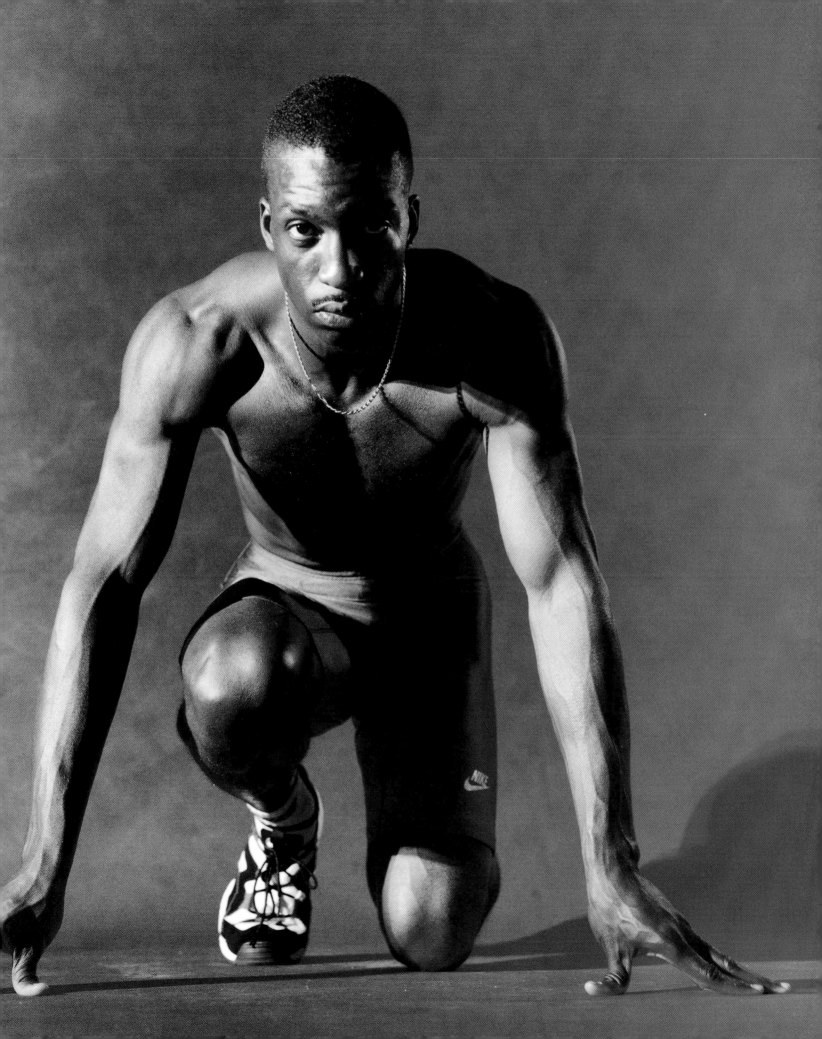

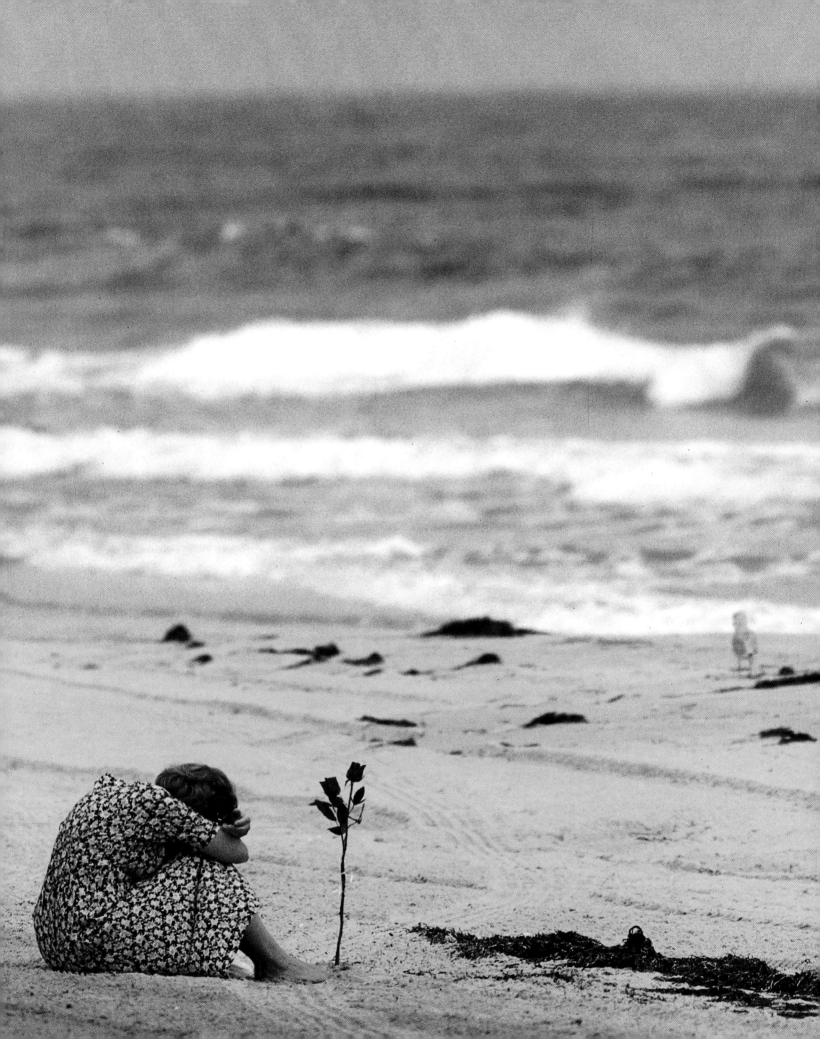

◀ WATERY GRAVE

The sea yielded up its dead slowly: 101 bodies after four days, 153 in 12 days. As relatives and friends kept vigil—some on the beaches of South Shore Long Island (left)—they mourned and held memorial services for those who had been aboard TWA Flight 800. All 230 had perished when the Paris-bound 747 plummeted, aflame and in pieces, into the Atlantic on July 17, just minutes after taking off from New York. Well into autumn, Navy and police divers scoured 730 square miles of ocean, making 3,200 dives 120 feet down, aided by sonar scanners, robots, cranes, underwater cameras and, finally, crude scallop dredges. But by year's end, despite having recovered 215 bodies and 95 percent of the jet, investigators still could not say for certain whether a bomb, a missile or, more likely, a mechanical malfunction had suddenly split the plane into two fiery sections on that dark evening, leaving the waves to wash ashore the wreckage of lives.

July

■ At a **WIMBLEDON** tournament marked by early upsets of top players—**MICHAEL CHANG, MONICA SELES, ANDRE AGASSI** and **STEFAN EDBERG** among them—**STEFFI GRAF** wins her seventh singles title. The men's trophy goes to **RICHARD KRAJICEK**, the first Dutch player to win a Grand Slam championship.

■ *Columbia* returns from a 17-day mission—**THE LONGEST FLIGHT** in space shuttle history.

■ Presidential hopeful **BOB DOLE**, a supporter of pending legislation to eliminate federal affirmative action programs, declines an invitation to speak at an **NAACP** function and instead attends **BASEBALL'S ALL-STAR GAME** (won by the National League, 6–0). Dole claims that NAACP President Kweisi Mfume was "trying to set me up" for an exchange with a hostile audience.

■ **RIDDICK BOWE** wins a heavyweight bout at New York City's Madison Square Garden when Poland's Andrew Golota is disqualified in the seventh round for throwing illegal punches. **A RIOT ERUPTS** among the fans—many of whom join the fighters in the ring—injuring 12.

■ At the **11TH INTERNATIONAL AIDS CONFERENCE** in Vancouver, researchers predict that AIDS will soon be a treatable chronic disease, not a fatal one.

■ **MSNBC**, the 24-hour all-news cable channel and Internet site from the Microsoft Corporation and NBC, debuts on July 15.

■ Orlando Magic star **SHAQUILLE O'NEAL** signs a seven-year $123 million deal with the Los Angeles Lakers. **MICHAEL JORDAN** gets $30 million for one year from the Chicago Bulls. And Houston Rockets center **HAKEEM OLAJUWON** secures a $55 million five-year extension.

■ Pop Culture Report: high scores on the music charts from **THE FUGEES**' CD *The Score*. At the movies: the alien invasion adventure *Independence Day*. And with *How Stella Got Her Groove Back* flying out of bookstores, novelist **TERRY McMILLAN** proves she hasn't lost hers.

■ Athletes from 197 nations descend on Atlanta for the **100TH OLYMPIC GAMES**. Among the 11 nations participating for the first time: Palestine and Macedonia. The largest team: the U.S., with 667 athletes. The smallest: Brunei and Lebanon, each sending a team of one.

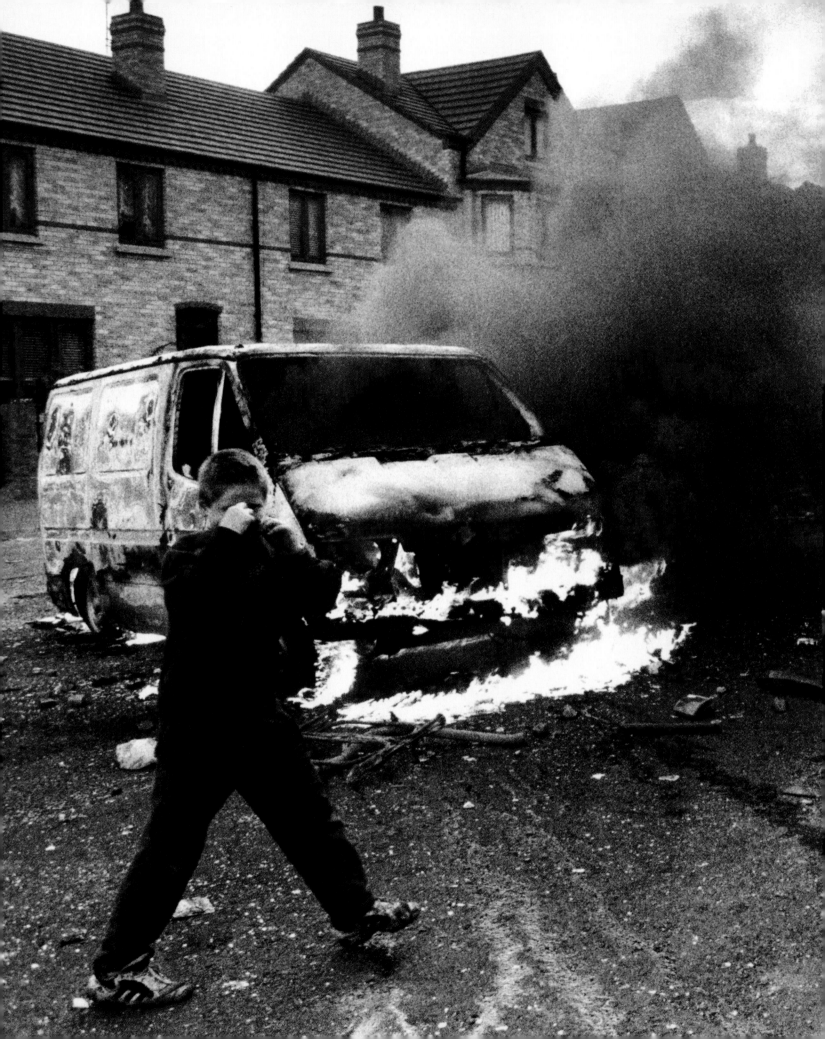

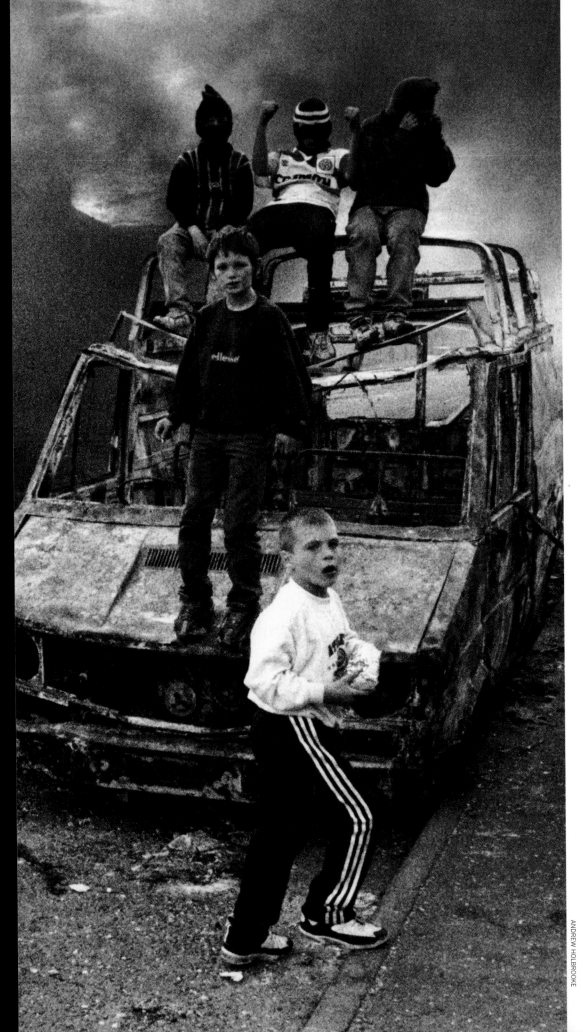

THE NEVER-ENDING BATTLE

The troubles really began with the Battle of the Boyne, in which a Protestant king defeated a Catholic one for control of Ireland. When police in Northern Ireland told Protestant marchers planning to celebrate the battle on July 7 that they couldn't take their annual swing through Drumcree, a predominantly Catholic village near Belfast, outraged Protestants hurled bottles at police, set Catholic homes afire and burned cars. After authorities reconsidered and approved the parading, the violence spread through the region. Catholics threw gasoline bombs, looted shops and shot three policemen. In a Catholic area of Belfast (left), children fearlessly played by a burning van. The scene was but one of a thousand acts of violence over seven days—the worst unrest in 20 years for a land rarely at peace. In Ireland, after all, fighting is a venerable tradition: The battle that so inflamed the populace in the summer of 1996 took place in 1690.

SREBRENICA

The man died, probably clutching his holy book, the Koran, on or about July 12, 1995, the day Serbs call Liberation Day. Bosnian Serbs had marched into Srebrenica, one of six enclaves designated as safe havens for Muslims in Serb-dominated Bosnia-Herzegovina. When the United Nations and NATO failed to protect it, the town surrendered. Families were separated as U.N. peacekeepers watched. Women and children were forced to flee across minefields. As many as 8,000 men were massacred. By the first anniversary of that day, the only Muslims left in Srebrenica were those being unearthed from mass graves. Other graves throughout the former Yugoslavia are believed to hold thousands more, in Europe's worst genocide since World War II. Though indicted by a war crimes tribunal for ordering the atrocities, the Bosnian Serbs' former leaders remained free, while civilians, refugees in their turn, moved into Srebrenica to live with the bones and ghosts.

SUMMER GAMES

It was America's biggest, gaudiest, most expensive bash of the year, and Atlanta's Centennial Olympic Park (left) was Party Central. While 3.5 billion viewers worldwide peered at the '96 Games through the TV window, 10,700 athletes competed and two million visitors celebrated—with the largest Olympic security force ever, 30,000 strong, keeping order. The park was the one place fans didn't need a ticket to enter, so on hot nights thousands enjoyed its misty fountains and corporate pavilions. In the wee hours of Day 9, July 27, the band Jack Mack and the Heart Attack was cranking on the huge AT&T stage when police were warned of a bomb; less than 20 minutes later, at 1:25 a.m., a knapsack exploded, spewing nails, injuring 111 and killing a Georgia woman. Within days, the FBI revealed that park security guard Richard Jewell was a suspect, but in October, when he was cleared, the crime remained unsolved.

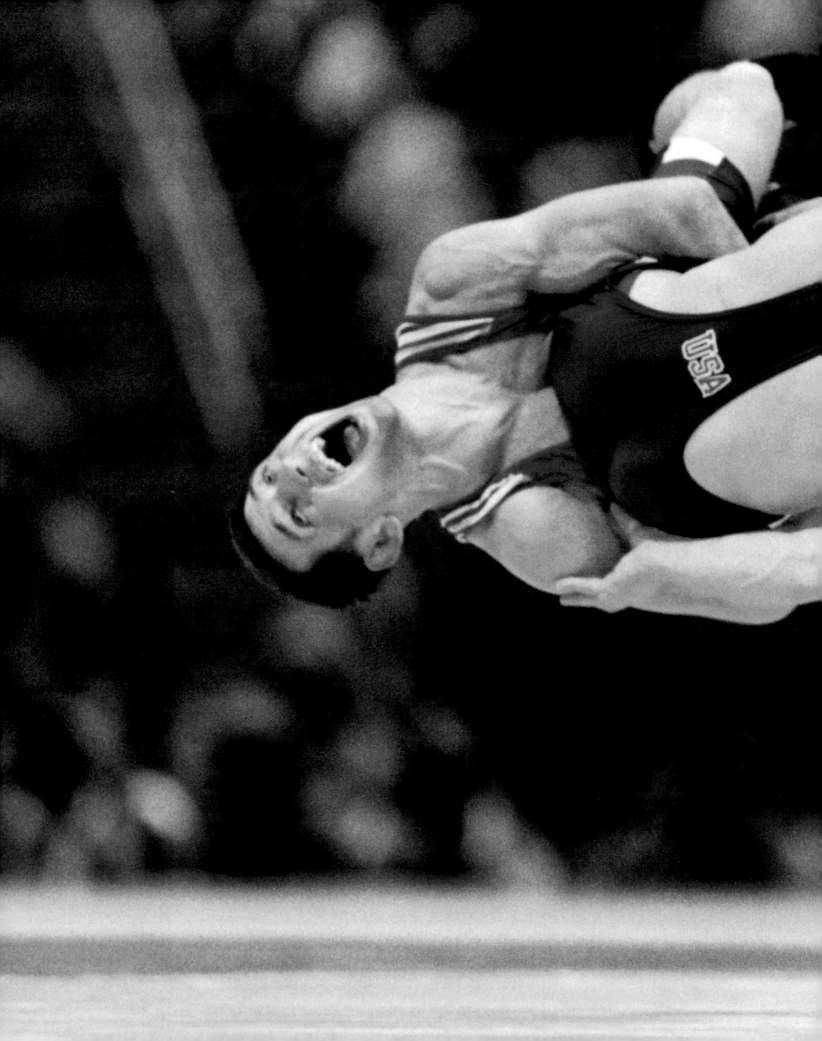

THROWING FOR
THE GOLD

All the right moves turned out
to be just one. In the 125.5-
pound class of Greco-Roman
wrestling, in which no holds
are allowed below the waist,
favorite Dennis Hall of
Wisconsin, 25, hoped to
become the third American
to win Olympic gold in the
classic sport. But Yuriy Mel-
nichenko of Kazakhstan, 24,
upended him 92 seconds
into the five-minute bout,
earning three points for this
lift-and-throw and one
appreciation point from a ref
for his technical slickness,
for a total of four. That was a
high score for the event and
a virtual lock on the match.
Hall, who had got the
better of Melnichenko to
win at the '95 world champi-
onships, had shaved his
head for extra inspiration
and was loudly cheered by
fans waving Hall's Our Hero
signs. He scored only one
point with a takedown but, if
disappointed, was hardly
despondent. Looking ahead
four years, the silver medal-
ist vowed, "There's always
2000." Until Sydney, mate.

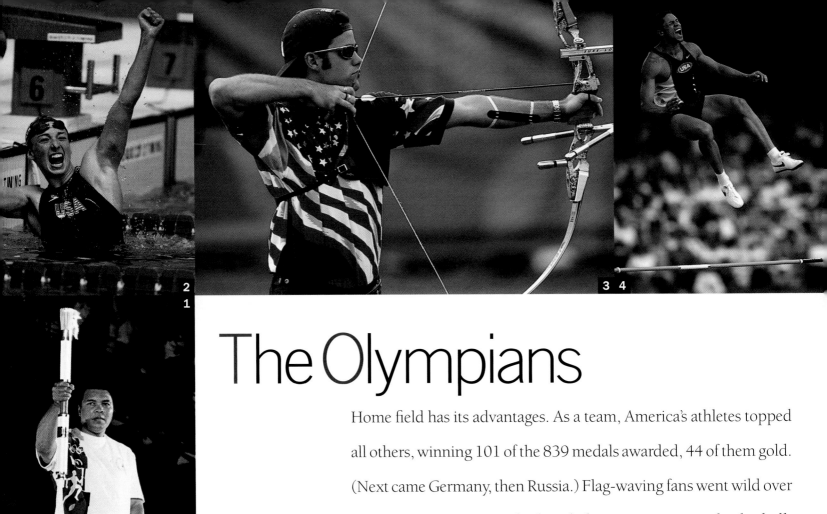

2
1

The Olympians

Home field has its advantages. As a team, America's athletes topped all others, winning 101 of the 839 medals awarded, 44 of them gold. (Next came Germany, then Russia.) Flag-waving fans went wild over U.S. women's teams, which ruled—in gymnastics, basketball, swimming, soccer, softball, tennis and track. Competing in the sport's first Olympiad, the U.S. men's beach volleyball team dug for both gold and silver. And track and field legends Carl Lewis, 35, and Jackie Joyner-Kersee, 34, completed their Olympic medal collections with a gold (his) and a bronze (hers)—and then said goodbye.

15 14

13

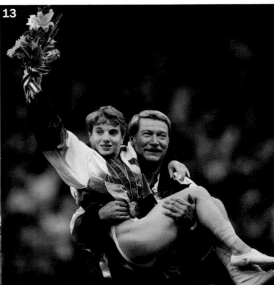

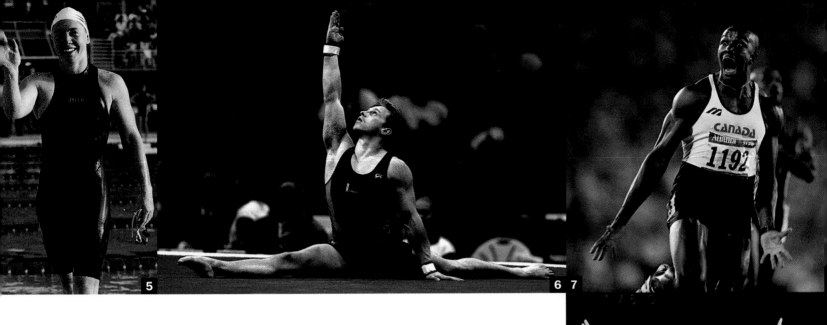

1. After Muhammad Ali ignited the Olympic torch, he was given a medal to replace the gold he won in 1960, which, he says, he tossed into the Ohio River in frustration over racism. **2.** Amy Van Dyken cheered the first of her four victories. **3.** Justin Huish often practiced by shooting arrows from across the street and through the doors of his parents' garage. At the Olympics, the California-cool archer hit two golden bull's-eyes. **4.** Decathlete Dan O'Brien put his 1992 failure in the U.S. Olympic trials behind him and won his long-awaited gold. **5.** Michelle Smith's three gold medals—Ireland's first-ever gold wins by a female athlete—were tarnished by unproven steroid accusations. **6.** An angry Vitali Scherbo (six golds in '92) of Belarus called his three bronze medals "the wrong color." He had stopped training to care for his wife, who nearly died in a car accident. **7.** At the finish of the 100-meter dash, Canada's Donovan Bailey looked at the digital timer and saw what he had done: At 9.84 seconds, he had become the planet's fastest man. **8.** Russian Andrei Chemerkin lifted 573 pounds for a world record—and took home a half-pound gold medal. **9.** The much-hyped beach volleyball duo of Holly McPeak (pictured) and Nancy Reno sank early. **10.** Carl Lewis soared to a fourth long jump win. His nine career golds tied an Olympic record. **11.** Basketball stars Lisa Leslie and Venus Lacey celebrated Team U.S.A.'s 24-point golden victory over Brazil. **12.** A retiring Mary Ellen Clark, 33, overcame her vertigo for a bronze. **13.** Coach Bela Karolyi delivered Kerri Strug, who had vaulted on an injured ankle (and into fans' hearts), to the medal stand. **14.** Virginian Tom Dolan sealed a 400-meter individual medley gold as his lungs seized up from recurrent asthma. **15.** "Dr. Dot" Richardson, an orthopedic resident, rounds the bases after hitting a homer in the U.S.'s gold-medal softball win over China.

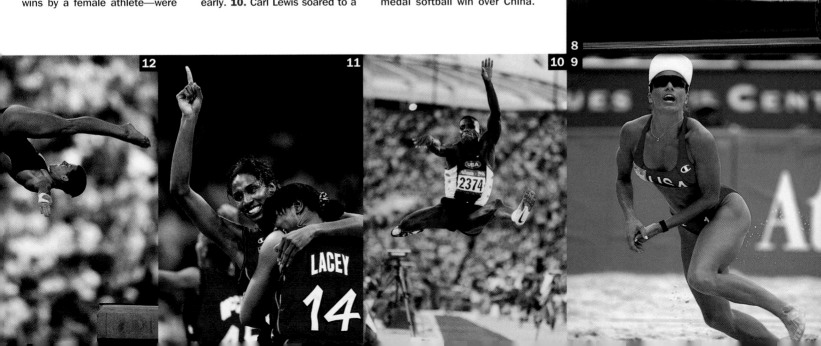

August

■ NASA reports that a 4.5 billion-year-old meteorite offers evidence, but not "ultimate proof," of **LIFE ON MARS**—though the "life" in question is extremely primitive. A NASA administrator cautions: "I want everyone to understand that we are not talking about little green men."

■ Promising to "free the American people from tax tyranny," Bob Dole unveils his economic plan. At its core is a **15 PERCENT ACROSS-THE-BOARD TAX CUT**—a supply-side tactic the senator-turned-presidential-candidate often criticized in the past. The plan is assailed by economists, in part because it fails to address how the cuts will be paid for.

■ President Clinton signs a bill **UPPING THE MINIMUM WAGE** from $4.25 to $5.15 an hour.

■ Four female cadets begin Hell Week at the **CITADEL**, the revered military college in Charleston, S.C. The state-funded all-male academy had waged a bitter battle against opening its ranks to women (most notably against cadet wannabe Shannon Faulkner) but bowed to a recent U.S. Supreme Court ruling that the taxpayer-supported **VIRGINIA MILITARY INSTITUTE** admit women or lose its government money. VMI says it will go coed in the fall of 1997.

■ At the **POLITICAL CONVENTIONS**: Republicans (gathering in San Diego) and Democrats (in Chicago) try to outdo each other as the most moderate and family-friendly party. Although the **GOP PLATFORM**, largely influenced by Christian Coalition chief **RALPH REED**, calls for a total ban of abortion and an amendment barring the American-born children of immigrants from automatic citizenship, speakers sidestep these and other hot-button issues in an effort to avoid the fiery conservatism displayed in '92. Featured instead are **COLIN POWELL**, the very moderate noncandidate, and **SUSAN MOLINARI**, a pro-choice congresswoman who delivers the keynote speech—during which TV cameras tirelessly cut to shots of her cooing baby girl.

■ Soon after, at the Democratic convention, **HILLARY CLINTON** succeeds with a speech extolling the American family, but Indiana Governor **EVAN BAYH**, a rising centrist and New Democrat, gives a bland keynote address. Among the more interesting twists: **JAMES AND SARAH BRADY**, gun-control lobbyists and longtime Republicans, appear; **DICK MORRIS**, choreographer of the Clinton campaign's family values theme, resigns suddenly when the *Star* reveals the married strategist's trysts with a prostitute; and much ado about Clinton's support of GOP-advanced **WELFARE REFORM**, considered draconian by many.

■ "They can buy paper, twine and glue for their crafts—they can pay for the music, too," asserts John Lo Frumento, chief of ASCAP (the American Society of Composers, Authors and Publishers), defending his decision to **CHARGE FEES TO SUMMER CAMPS** that use such copyrighted songs as "This Land is Your Land" and "God Bless America." Faced with bad press, ASCAP soon relents, saying it never intended to charge "Girl Scouts singing around the campfire."

■ On August 28, London's High Court ends the troubled 15-year marriage of their highnesses **PRINCE CHARLES AND PRINCESS DIANA**. The settlement, which comes on the heels of the May divorce of **PRINCE ANDREW** and the former **SARAH "FERGIE" FERGUSON**, grants Diana a reported lump sum of $22.5 million. Though she remains a member of the royal family, Di loses the title Her Royal Highness—a provision that technically requires her to curtsy to her children, princes William and Henry.

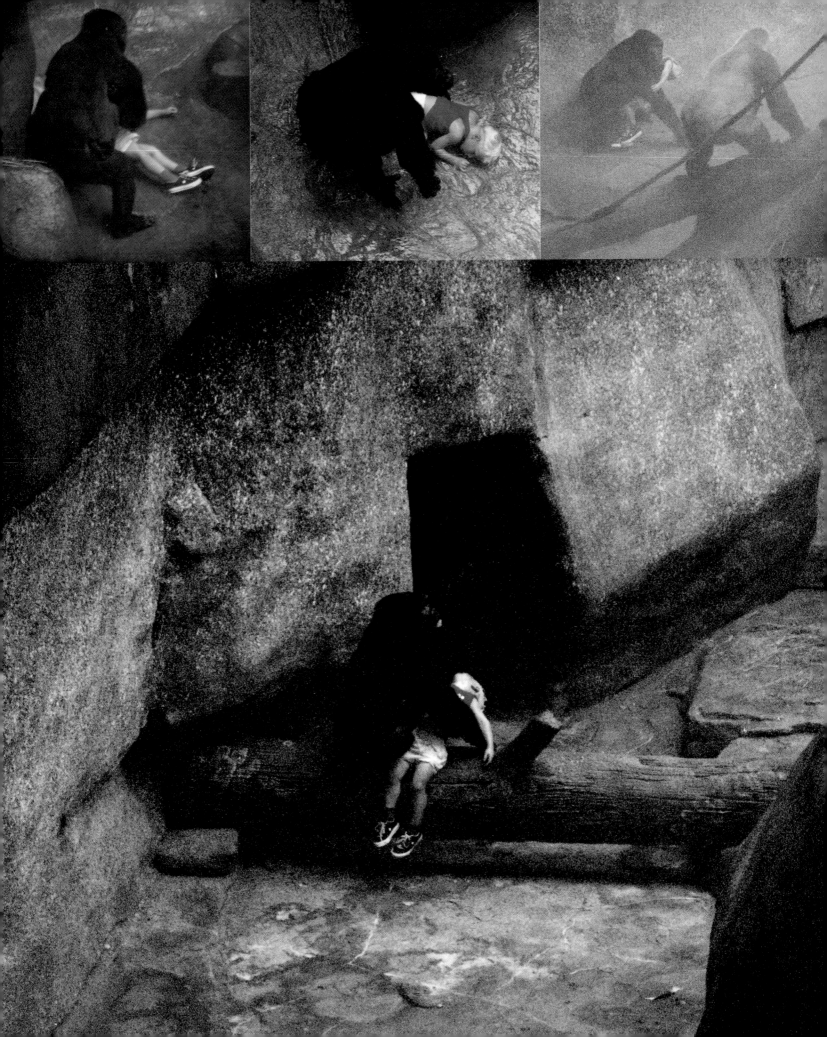

THE DOLE SHOW

He had decided to run in January, soon after *The Washington Post* reported his approval rating at 62 percent—17 points above Bill Clinton's. Election '96 would be the 73-year-old's last chance at the White House (he'd tried twice before), but by the start of the Republican convention on August 12, Bob Dole was behind by as much as he had once been ahead. Although the GOP's right wing was seething because the moderate from Russell, Kans., had chosen moderate Jack Kemp as a running mate, the four-day conclave was so scripted that, with fewer than 15 percent of TV viewers tuning in, the crew of *Nightline* ruled the event newsless and packed up on Day 3. The one shining moment belonged to the nominee's nomination-worthy wife, Elizabeth, 60 (with him at right). "Liddy" strolled Oprah-like onto the floor and in a flawless soliloquy praised her husband as a man twice voted by Capitol Hill workers as "the nicest, friendliest of all 100 Senators." The warm-up act proved better than the star attraction. "Let me be the bridge," intoned WWII veteran Dole, "to an America that only the unknowing call myth." He gave the Democrats a theme for their own convention two weeks later. Said Clinton, "We do not need to build a bridge to the *past,* we need to build a bridge to the *future,* and that is what I commit to you to do."

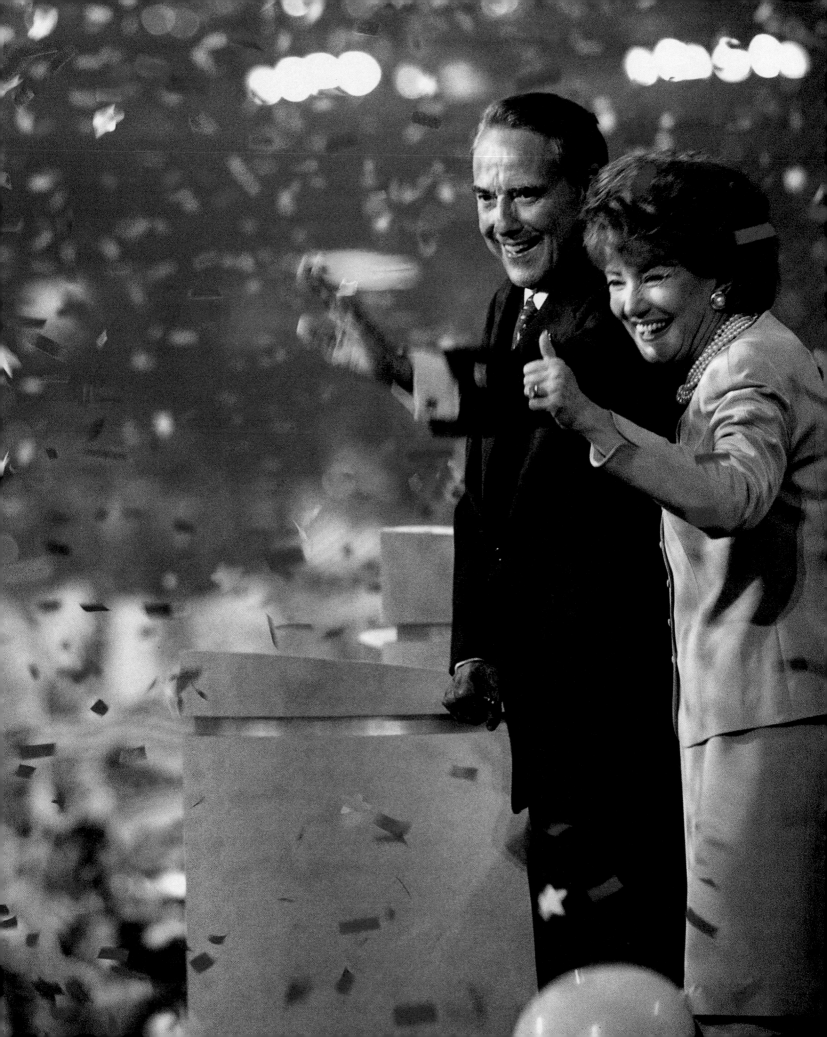

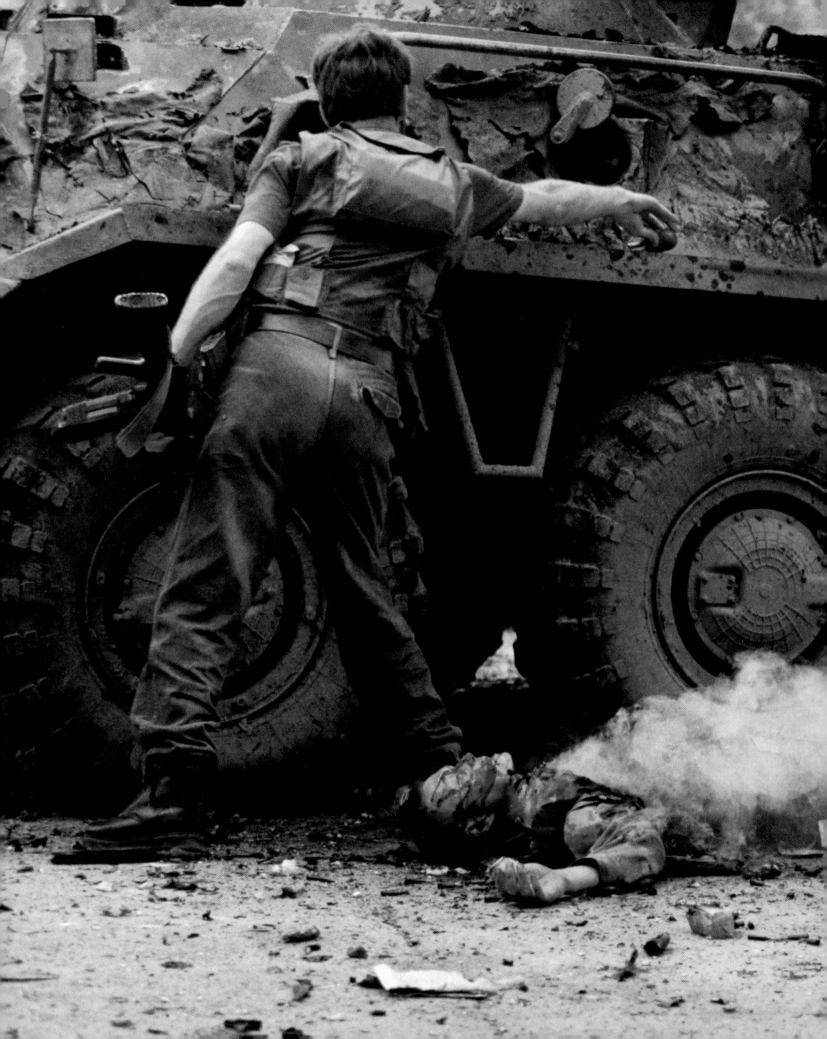

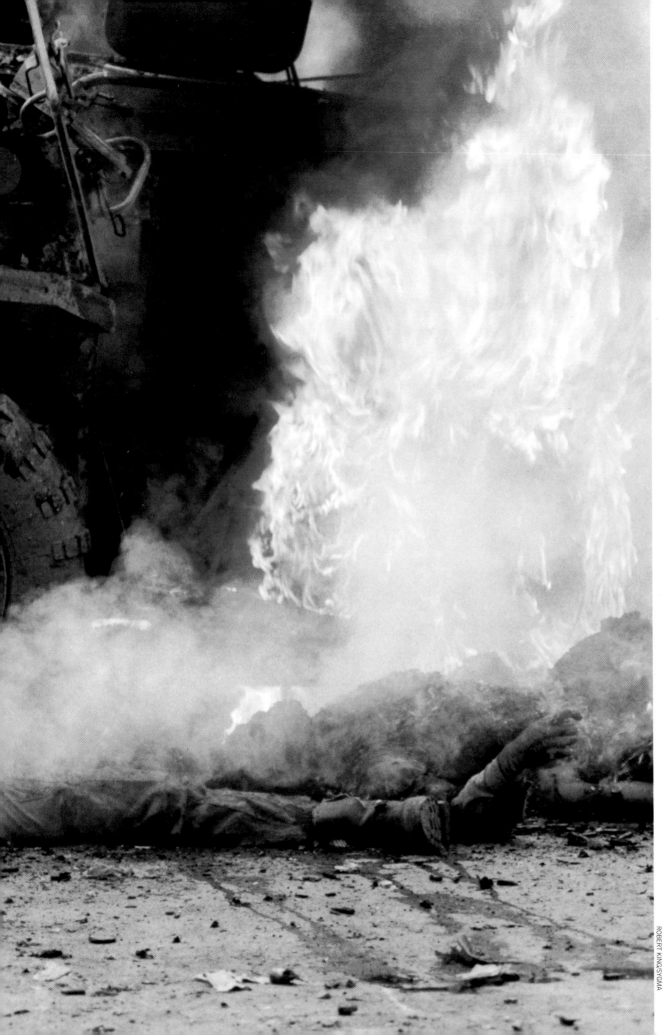

CHECHNYA BURNS

In 1994, Boris Yeltsin sent troops to Chechnya to quell uprisings by rebels seeking independence for the Muslim-dominated republic. Russia prevailed and held the capital of Grozny, where lulls in the fighting and shaky cease-fires allowed moments of calm. But at dawn on August 6, Grozny erupted again. In a surprise attack timed to humiliate Yeltsin just days before his second inauguration, Chechen fighters trapped Russian troops holed up in government buildings and in tanks (left), killing hundreds. Sent to rebuild peace in the ruins, Russian Gen. Alexander Lebed found his soldiers, many barely out of their teens, "hungry, lice-ridden, underclothed weaklings." He hammered out yet another cease-fire, which shelved until 2001 any decision about the ravaged republic's independence but left flying the Chechen flag—featuring a lone wolf.

101

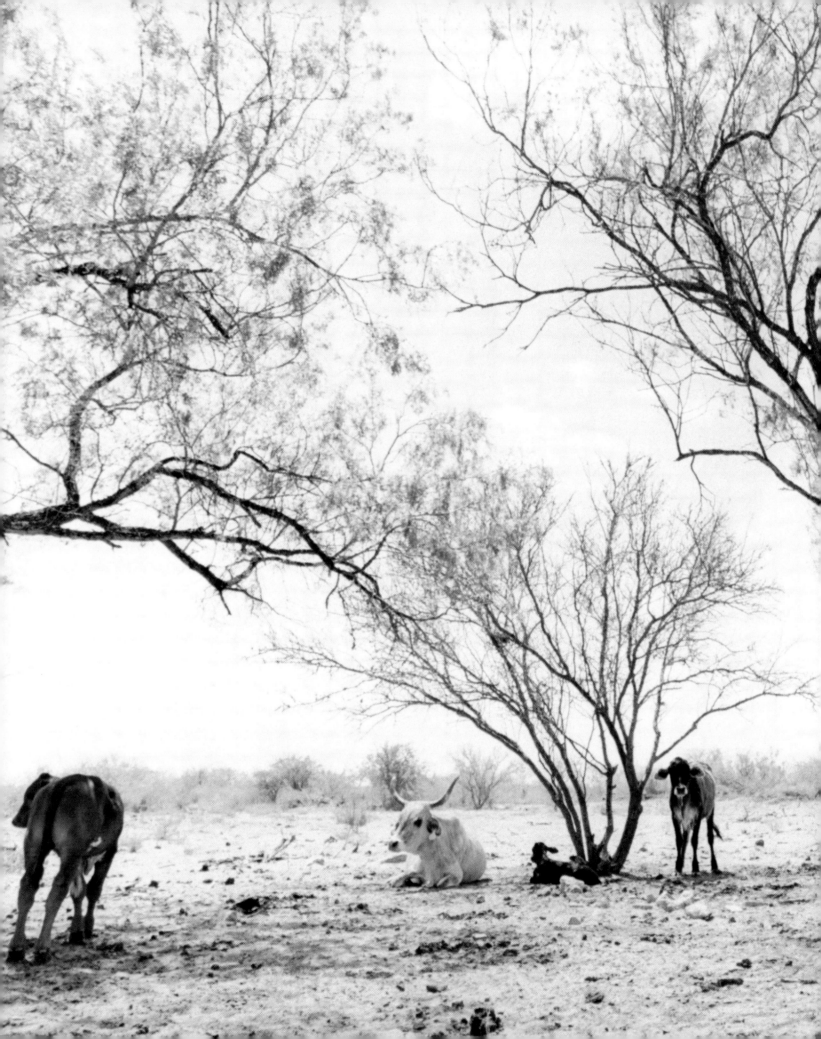

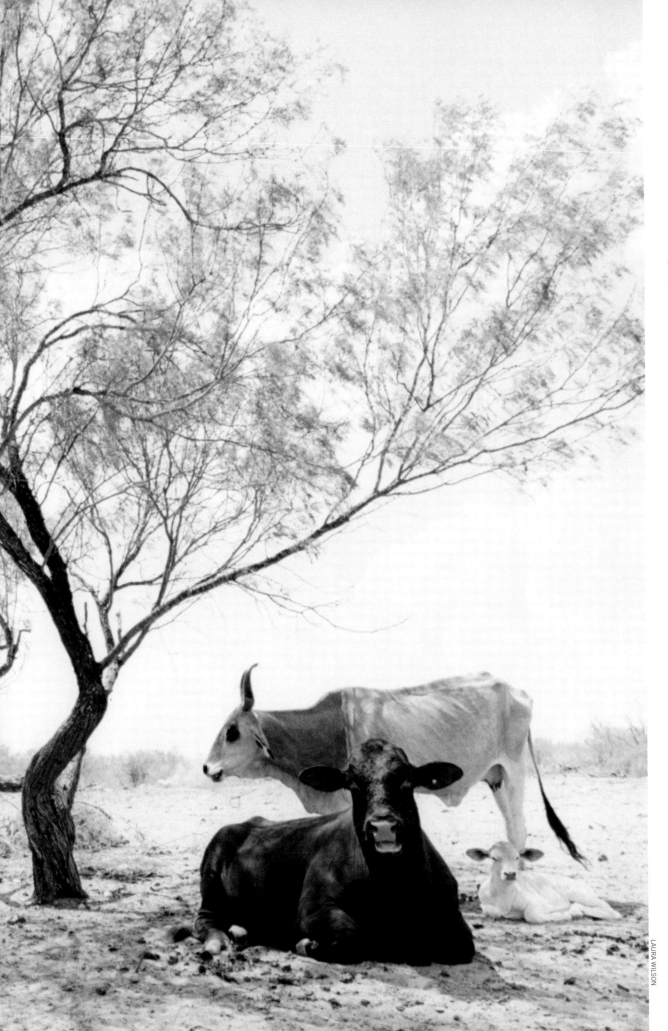

AN AMERICAN SAHARA

The drought of '96 settled in slowly, dry day by dry day, across the Southwest and lower plains of the United States. In some parts it was the worst dry spell since the Dust Bowl era of the Great Depression. Forty percent of Texas pastureland grew too arid for grazing. Cattle, like these Brahmans near Rio Grande City in August, withered. Feed costs tripled, and prices for the cattle that ranchers tried desperately to unload plummeted. Kansas expected to bring in half its usual wheat crop, Texas half its cotton and corn. Thanks to decades of improved conservation, the soil didn't blow away this time, but underground water aquifers were sucked so low to irrigate the parched land that experts feared much of it might be dry forever. In some towns, official proclamations asked people to pray for rain. At summer's end, storms spinning from Hurricane Dolly sent down a few precious drops of hope.

LAURA WILSON

103

H

Tiger Woods

e was so perfect, his swing so perfect, his results so near perfect. At times it was hard to remember that this sports superstar was still a kid, maybe not the toddler who first picked up a golf club, but, at 20, too young to spend the rest of his very public life as something superhuman. On August 25 (right), Tiger Woods won his third straight U.S. Amateur title, a feat even Jack Nicklaus never achieved. And he did it in an astonishing comeback, winning three holes in a row down the stretch to force a playoff, which he also won—sinking a putt for par on the second hole of sudden death. He had said he wanted to finish his studies at Stanford University before going pro, but at summer's end the time seemed right. Then Woods pulled out of a tournament he had committed to play. The unwritten rules are: Even though you're tired, if you're healthy, you play. Some veterans criticized the kid, others said he'd learn. Rested, Woods won his next time out, and won again before the season was through, in the most brilliant pro debut anyone could recall. The kid was vanishing, the multiracial superstar was emerging. Marketed as Asian in Asia, as black in America, Tiger Woods, with his gazillion-dollar endorsement contracts (Nike, Titleist) and his victories, was fast becoming Michael Jordan or Michael Jackson or Mighty Mouse—an icon, a thing. When Tiger—he officially changed his first name from Eldrick—crushes a drive 370 yards down the fairway, it is important to remember: He is human. Almost perfect, perhaps, but still a human being.

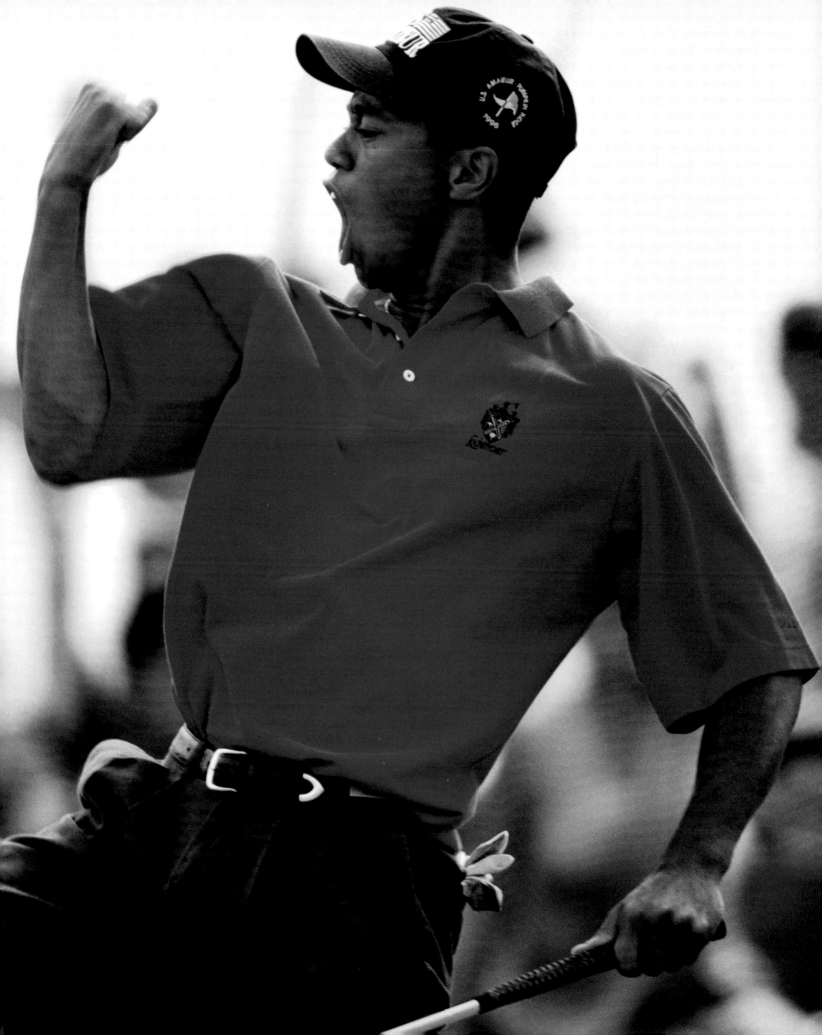

September

TV stars sweat it out—literally—at the **EMMY AWARDS** in Pasadena, where the mercury hovers near 95°. *ER* wins Best Drama Series; *Frasier,* for the third time, Best Comedy Series. Other winners: for drama, Best Actor, **DENNIS FRANZ**, *NYPD Blue;* Best Actress, **KATHY BAKER**, *Picket Fences;* Best Writing, *The X-Files.* For comedy, Best Actress, **HELEN HUNT**, *Mad About You;* Best Actor, **JOHN LITHGOW** of *3rd Rock From the Sun,* a sitcom about extraterrestrials posing as an Ohio family.

The **U.S. BOMBS IRAQ** on September 3 and 4, forcing Iraqi troops, who had seized Erbil, a Kurdish city under U.N. protection, to withdraw from the region. A week later, after Iraq fires at two Air Force jets patrolling the no-fly zone over northern Iraq, President Clinton dispatches several F-117 stealth fighters and B-52 bombers to positions near the Persian Gulf.

Back home, President Clinton accepts GOP-initiated legislation denying state-to-state and federal recognition (such as tax benefits) to gay couples who marry. Clinton, who opposes gay marriage but calls the **DEFENSE OF MARRIAGE ACT** unnecessary, signs the bill after midnight to minimize media coverage. Two days earlier, IBM had announced its plans to extend health benefits to the partners of its gay employees—the largest company to do so.

Moments before Richard Allen Davis is sentenced for the 1993 murder of 12-year-old **POLLY KLAAS**, whom he abducted from her home in Petaluma, Calif., he alleges that the reason he did not sexually assault the girl was "a statement [she] made to me while walking her up the embankment" that her father had molested her. The baseless slur provokes Marc Klaas to lunge at his daughter's killer. Davis is sentenced to death.

According to the U.S. Census Bureau, **HOUSEHOLD INCOMES ROSE** in 1995 for the first time in six years, with half of American families reporting incomes of at least $34,074. An increase, but for many still not enough to easily finance a college education. The **AVERAGE TUITION COST** (not counting room, board and books) for one year at a private college is $12,823; at a public one, $2,966.

Jonathan Prevette, a North Carolina first-grader, is suspended from school for **SEXUAL HARASSMENT** after bussing a female classmate on the cheek. Soon afterward, a seven-year-old pal-pecking New Yorker, De'Andre Dearinge, meets the same fate. Roundly criticized for the charges ("Sometimes a kiss is just a kiss," notes one harassment lawyer), the schools vow to reexamine their policies.

The FDA approves as safe and effective **RU-486**, the so-called abortion pill; the drug is expected to be available by mid-1997.

Women flock to *The First Wives Club,* a comedy about three dejected-turned-empowered fiftyish pals (**BETTE MIDLER, GOLDIE HAWN** and **DIANE KEATON**) who take revenge on husbands who dumped them for young girlfriends.

At about 10 p.m. EST on September 26, starry-eyed astronomy buffs, assembling under the heavens, witness a **TOTAL LUNAR ECLIPSE**—the last one to be seen in North America until the year 2000.

NASA

STORM AT SEA

The cops say it happens every time: A hurricane is on the way, evacuation orders are issued . . . and some people just won't listen. "We've survived hurricanes before," they say. "It's just wind and rain," they say. "What's the big deal?" they say. In the future, however, such skeptics may be fewer in number because of a visit from Hurricane Fran. She came roaring ashore at Cape Fear, N.C., on September 5, her 115-mph winds sweeping across the region, killing 34 and destroying more than $1 billion worth of property. Take a look at this terrifying computer-enhanced satellite portrait, made when the northbound storm swirled over the Bahamas. What's the big deal? More than 60,000 square miles of heavenly fury, that's what.

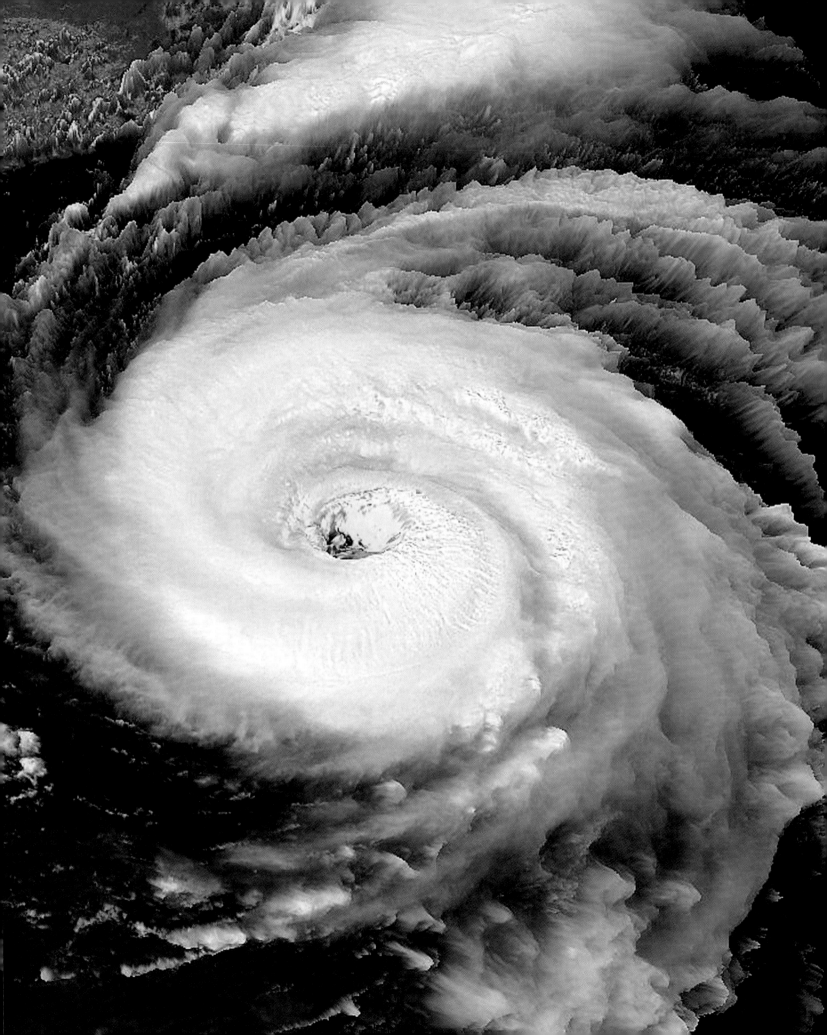

LOWERING THE VEIL

Having conquered most of the countryside, the Taliban took control of Afghanistan's capital, Kabul, on September 27—and turned back the clock. In accordance with their rigid interpretation of Islamic holy law, the ultra-fundamentalist Muslim faction declared that thieves' hands would thenceforth be severed and men would be given 45 days to grow full beards, or else. But Kabul's women suffered the most. They had experienced relative freedom during and after the Soviet Union's decade-long occupation of Afghanistan, which ended in 1989. Now, by Taliban decree, female workers—many war widows supporting their families—were forced to quit their jobs immediately. When venturing out, women were required to wear a *burqa,* a head-to-toe covering with a mesh nose and eye opening (right), and to be escorted by a male relative. The disobedient were beaten. Condemnation by the United Nations and even by Iran left Taliban leaders unmoved. A woman is like a rose, one said: "You keep it at home for yourself."

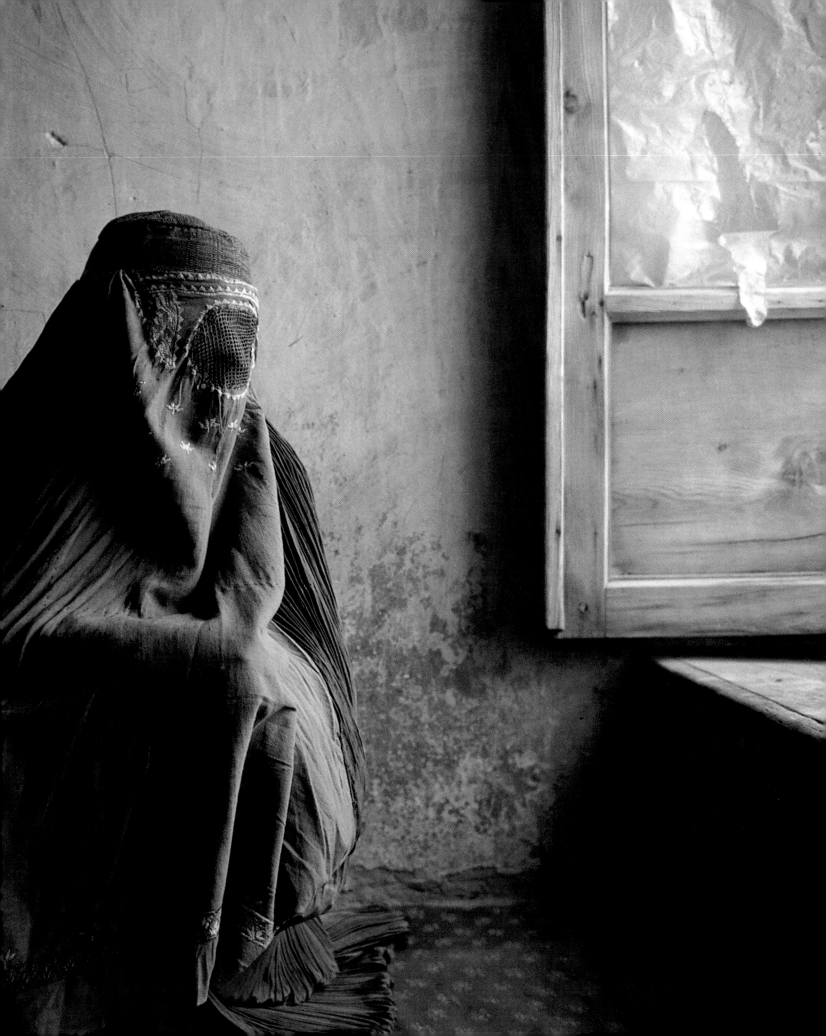

THIS LAND IS OUR LAND

Surrounded by national parks—Zion, Bryce Canyon, the Grand Canyon—the 1.7-million-acre parcel of federal land in southern Utah is a spectacular landscape of red rock, canyons and sky. Unknown territory to most Americans, it was a battleground between Utah's congressional delegation, which supported mining the area's vast reserves of coal, and conservationists who wanted to preserve it. Then, on September 18, President Clinton declared the region the Canyons of Escalante National Monument, blocking development. This pre-election flourish of environmental leadership was a coup: While Clinton would have needed the approval of Congress to designate a national park, Presidents can independently assign monument status to resources of "national significance." Still, details of the truce are unclear. One mining company that had leased land agreed to settle, but another vowed to fight.

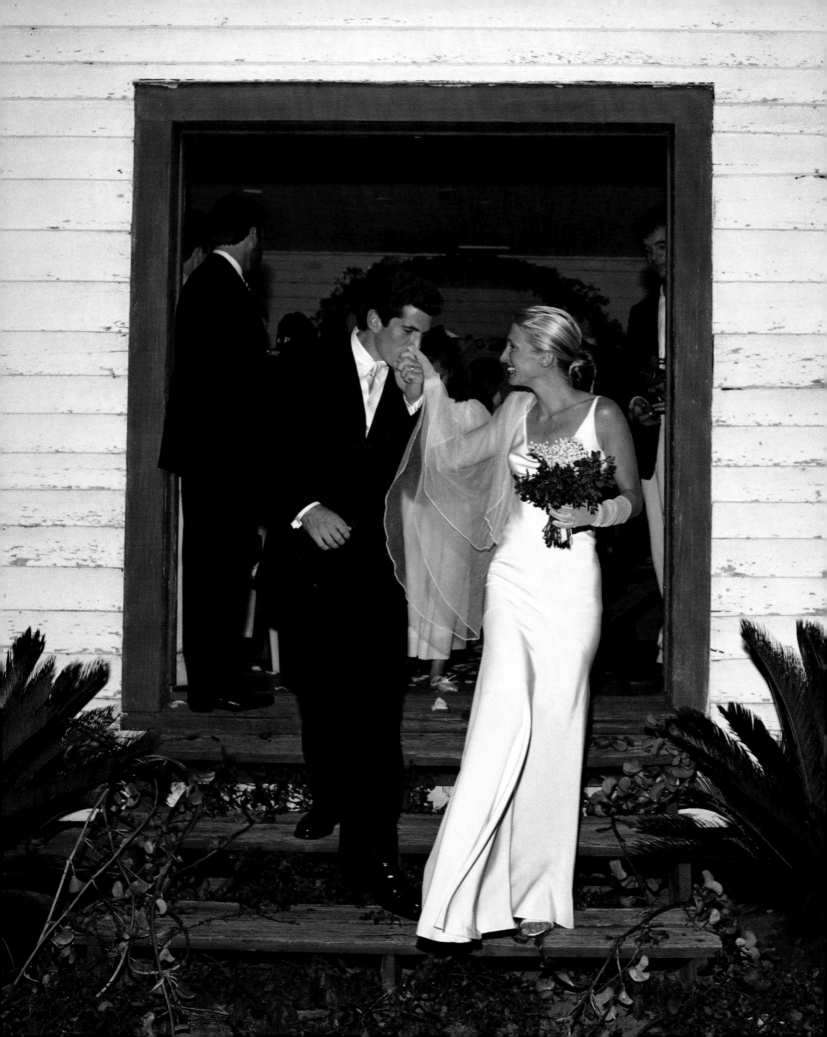

John F. Kennedy Jr. and Carolyn Bessette

The positive spin would be that America's prince had found himself a princess. The grim truth was that John F. Kennedy Jr., 35, Camelot's comely heir and the nation's most eligible bachelor, dubbed the Sexiest Man Alive, had officially taken himself off the market. What's more, he and Carolyn Bessette, 30, a former Calvin Klein publicist, had finessed their September 21 nuptials—held in a small African-Baptist chapel (left) on Cumberland Island, a private enclave off the Georgia coast—with nary a tabloid leak. So secret was the event that only a few close friends and family members attended; the groom's sister, Caroline, was matron of honor, his cousin Anthony Radziwill served as best man. JFK Jr. wore a midnight-blue wool suit adorned with a cornflower boutonniere, President Kennedy's favorite flower. Bessette Kennedy (she's not hyphenating) made such a stunning bride in her simple, bias-cut silk crepe gown and silk tulle veil, designed by pal Narciso Rodriguez of Nino Cerruti, that the fashion press quickly declared her "the symbol of American style." Known for her fondness for glamorous parties and her shrewd handling of high-profile men, the Greenwich, Conn.–raised bride is, a Kennedy friend noted, "a lot like the woman who would have been her mother-in-law." The newlyweds chased a honeymoon in Turkey with a cruise on the Aegean, but the paparazzi caught up with the pair at their New York City loft. "This is a big change for anyone, and for a private citizen even more so," said a protective Kennedy to the throng outside the building. "I ask that you give Carolyn all the privacy and room you can." They didn't. They won't.

115

October

■ On the docket for the **U.S. SUPREME COURT'S 1996-97 SESSION**, which opens on October 7: cases from New York and Washington states questioning the constitutionality of **DOCTOR-ASSISTED SUICIDE**. In October, **DR. JACK KEVORKIAN**, the retired pathologist and thrice-acquitted practitioner of euthanasia, helps three chronically ill people end their lives—bringing to at least 45 the number of suicides he has assisted since 1990.

■ Former Los Angeles police detective **MARK FUHRMAN** receives three years probation and a $200 fine for lying under oath during **O.J. SIMPSON'S 1995 MURDER TRIAL**. Fuhrman, portrayed by Simpson attorneys as a racist and accused of planting evidence (e.g., the infamous bloody glove), pleads no contest. While testifying at the Simpson trial, Fuhrman said he hadn't used the word "nigger" anytime in the past decade. Audiotapes proved otherwise.

■ Also in October: opening arguments in **O.J. SIMPSON'S CIVIL TRIAL**, a wrongful-death suit brought by the families of his murdered ex-wife, Nicole Brown Simpson, and her friend Ronald Goldman. Cameras are banned in the courtroom, but the cable entertainment channel E! fills the gap by using court transcripts as scripts for staged reenactments of the previous day's testimony.

■ **BILL CLINTON** and **BOB DOLE** meet in Hartford for the **FIRST PRESIDENTIAL DEBATE** of Election '96. As both had promised, they avoid personal attacks. But at Debate No. 2, the trailing Dole reluctantly takes the offensive, making several failed swipes at the President's character. Former Capitol Hill colleagues **JACK KEMP** and **AL GORE** square off at the **VICE PRESIDENTIAL DEBATE**, where Gore attacks Kemp for backing away from his long-held support of affirmative action upon being named Dole's running mate. Shut out of the forums by the debate commission: Reform Party candidate **ROSS PEROT** and his choice for V.P., economist **PAT CHOATE**.

■ The Pentagon announces it will inform thousands of gulf war vets that they may have been **EXPOSED TO POISON GAS** while destroying Iraqi ammunition depots in March 1991. Until June of this year, the government had denied that U.S. troops—many of whom suffer from mysterious illnesses—were exposed to chemical or biological weapons. Since then, the Pentagon's estimate of potential victims rose from zero to 350 to the October count of 22,000—roughly 32 out of every 100 Americans who served in the gulf war.

■ Making its debut: the eight-team, all-female **AMERICAN BASKETBALL LEAGUE**.

■ On October 14, the **DOW JONES INDUSTRIAL AVERAGE** closes above 6,000 for the first time ever. Six weeks later, it tops 6,500.

■ Citing unspecified "fresh knowledge," Pope John Paul II declares the **THEORY OF EVOLUTION** to be "more than just a hypothesis." The Church had long warned against promoting Darwinian theory as "certain doctrine," fearing it might eclipse the Bible's teaching that God created the universe.

■ A team of American scientists finds a direct link between **TOXINS IN TOBACCO** and a mutation in a cancer-thwarting gene called *p53*. Despite statistical and other evidence of the health risks of smoking, tobacco companies have argued that there is no scientific proof linking cigarettes to cancer. Says one medical researcher of the *p53* discovery: "It is the smoking gun that makes the connection." The Tobacco Institute does not comment.

■ Claiming she's a "biker from way back" and sporting a black leather jacket with the words "Bikers for Bob," **ELIZABETH DOLE**, American Red Cross president and a former secretary of labor, makes her entrance on *The Tonight Show*. Perched behind motorcycle-driving host **JAY LENO**, the wife of the GOP presidential nominee orders, "Rev it, baby." Leno obliges.

CALLIE SHELL/THE WHITE HOUSE

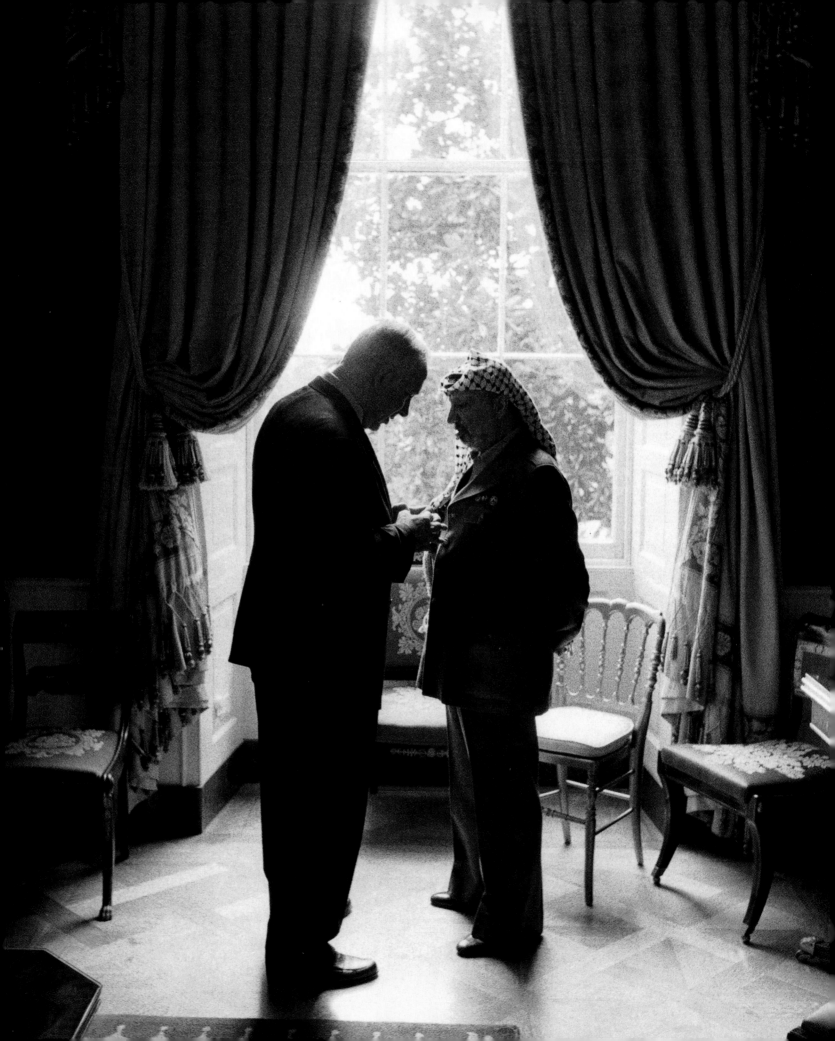

LOKI'S ICY FURY

A volcano's wrath is usually writ in fire. But Iceland's remote Loki volcano, smoldering perpetually beneath a glacier (right) as big as Puerto Rico, has a less conventional weapon in its arsenal: water. When Loki (named after the Norse god of mischief) erupted at the beginning of October, its lava and ash posed little threat to distant human settlements. The real menace was the buildup of billions of tons of meltwater near its steaming crater—and Icelanders, recalling a 1938 eruption that caused a devastating flood, were determined to be ready. As the water level rose beneath the glacier's surface, they reinforced riverbanks, dug diversion channels and evacuated villages. Still, weeks later, when the hidden lake overflowed, the deluge—complete with careening icebergs—wrecked three major bridges and miles of the island nation's main highway.

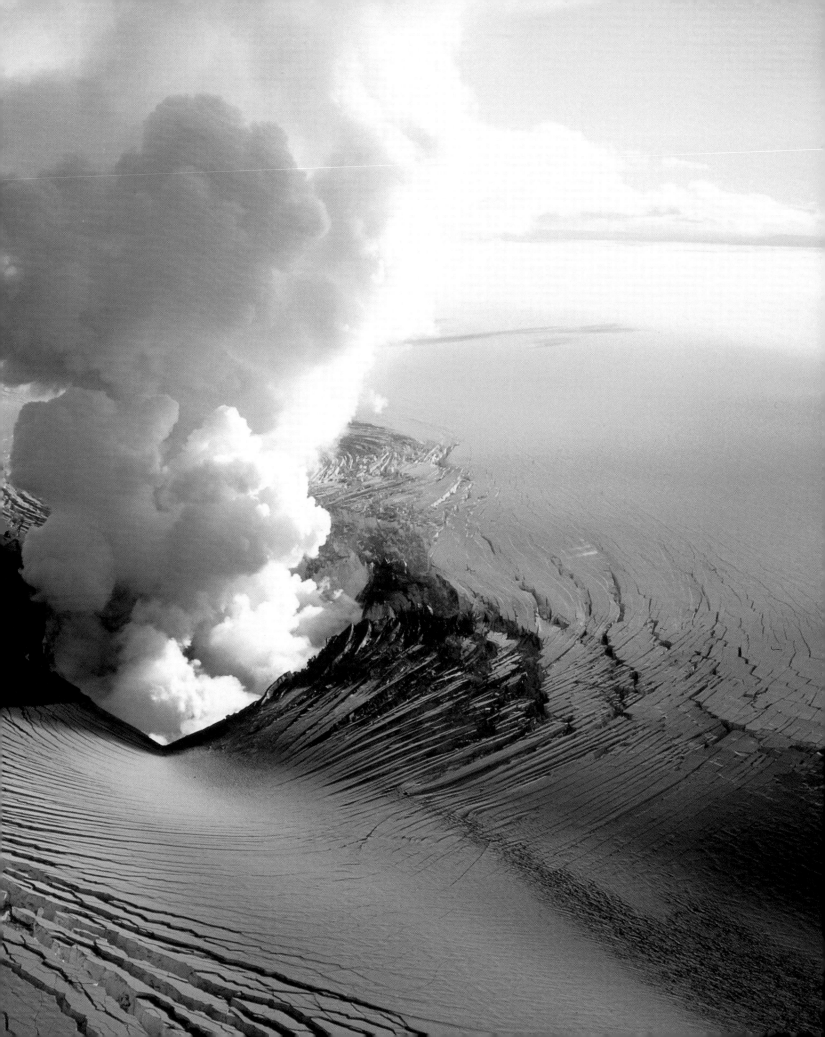

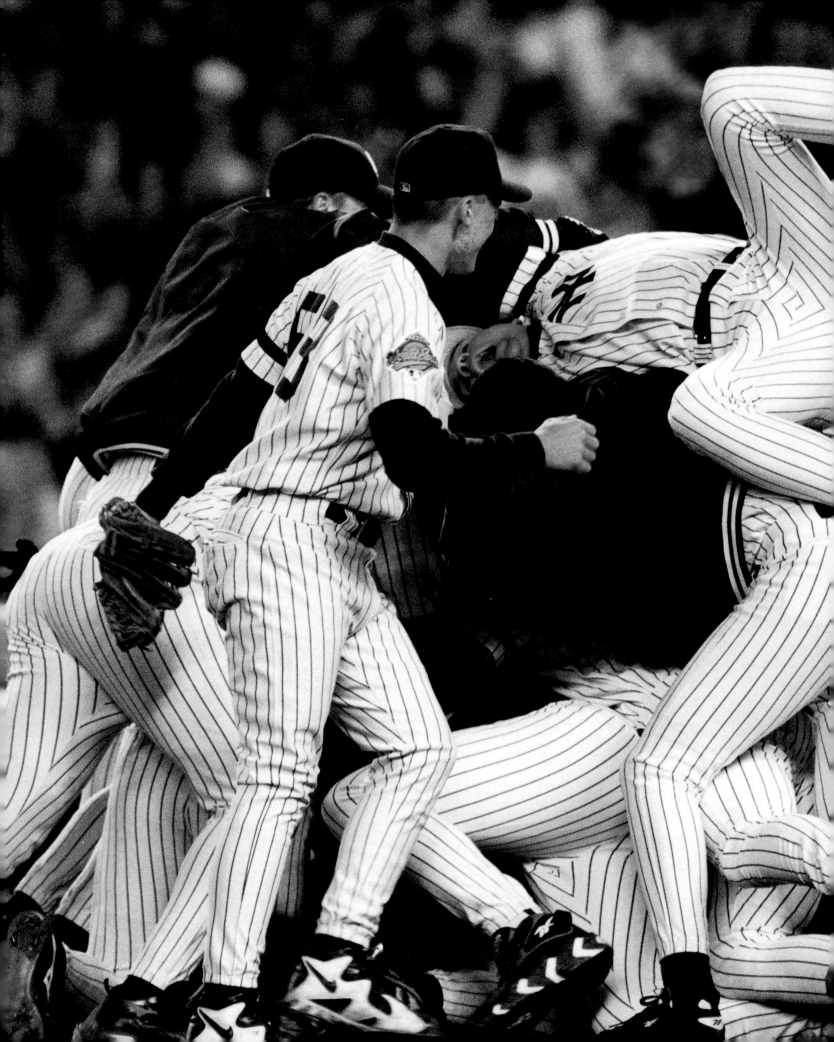

THE YANKEES BURN ATLANTA

They wore the famous pin-stripes of Babe Ruth, Lou Gehrig and Mickey Mantle, but that was about all the New York Yankees seemed to have in common with their team's legendary past. The club that boasts the most World Series wins hadn't won one in 18 years. And owner George Steinbrenner was threatening to move the famed Bronx Bombers to better real estate in Manhattan or, worse, New Jersey. But in October, the Yanks finally lived up to their legacy. They began the Series at home by losing twice to the Atlanta Braves—in Game 1 by an embarrassing 12–1. Then they began playing like the icons in whose cleat-steps they walked. The Yankees swept four straight, covering themselves with glory and one another (left). New York City gave them so huge a parade that the Yankee Clipper, Joe DiMaggio, 81, riding with the victors, noted: "I've never seen a ticker tape like this, and I think I've been in a few of them."

Madonna

Just as she has routinely made the shocking seem normal, this year Madonna made the normal seem shocking. Forsaking conical bras for sedate tailored suits, platinum Marilyn-dos for a sleek chignon, Madonna lived up to both her name and her knack for periodic reincarnation. First she became—drumroll—Eva Perón, starring as the beloved wife of Argentine dictator Juan Perón in the film version of Broadway's hit musical *Evita*. In January, having lobbied hard for the role by writing an "impassioned" (her description) eight-page letter to director Alan Parker, the singer-actress-music-video seductress was off to Buenos Aires, outfitted with caps (to fill the gap between her front teeth) and a sophisticated 1940s wardrobe that transformed her physically (in costume at right). But morally? Argentina's public was split. While throngs of fans serenaded her hotel window, dissenters protested the casting of the pop star with the raunchy past. In response, the Boy Toy turned Diplomat, dining with Argentina's President Carlos Menem and sighing that, like Mrs. Perón, she was misunderstood. Then, in April, Madonna, 38, announced that she was with child. The father: Carlos Leon, 30, her fitness trainer. On October 14 the Material Girl checked in to a Los Angeles hospital and at 4:01 p.m. became—another drumroll, please—the Maternal Girl. Lourdes Maria Ciccone Leon weighed six pounds nine ounces and quickly de-vamped her mother's image. The woman ex-beau Warren Beatty once said didn't want to live off-camera became extremely private, to protect her little girl. Shockingly normal.

MARIO TESTINO

122

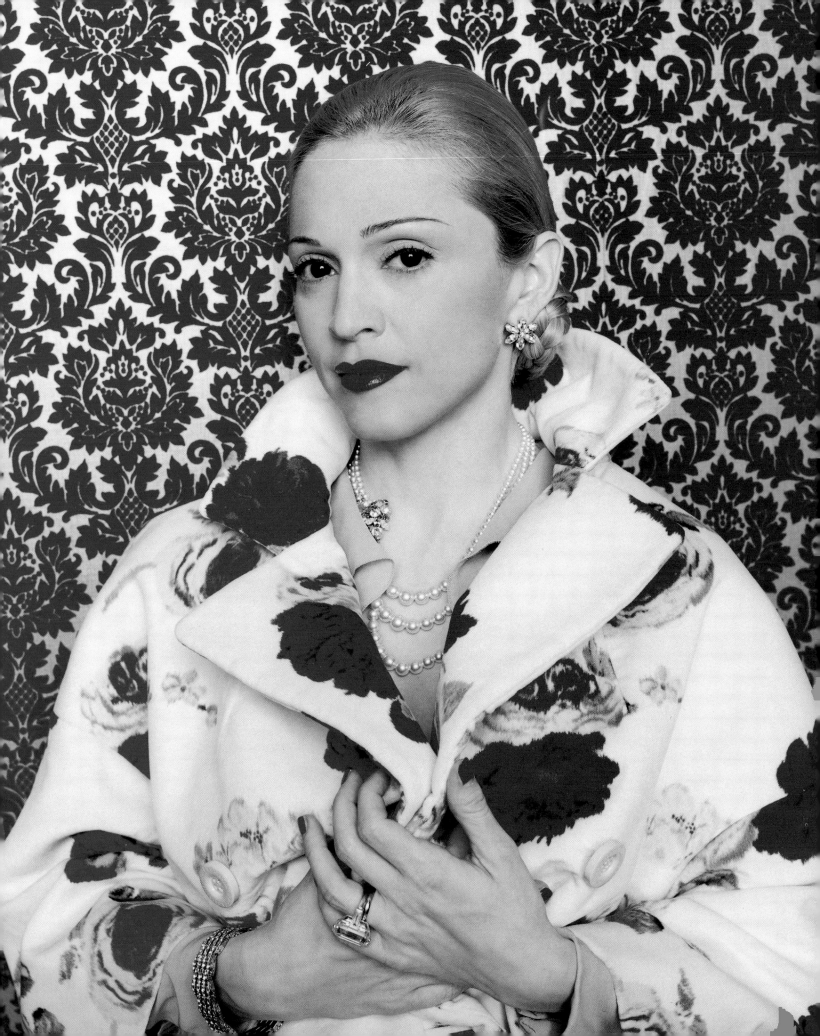

November

■ Among the voter initiatives that pass on **ELECTION DAY**: a 68¢ per pack **TAX ON CIGARETTES** sold in Oregon to fund a state health plan; and in California and Arizona, **LAWS LEGALIZING MARIJUANA** for medicinal use. Also approved in California: a ban of most of the state's affirmative-action programs. Notable among the freshmen-elects to Congress: New York Rep. **CAROLYN McCARTHY**, whose husband was killed, and son injured, in a 1993 shooting spree by gunman Colin Ferguson on a Long Island commuter train. McCarthy, a longtime Republican, decided to run as a gun-control Democrat when her representative, Dan Frisa, voted to repeal an assault-weapons ban. She beats him with 57 percent of the vote.

■ Facing bad press and a boycott called by Jesse Jackson, **TEXACO** settles a discrimination suit brought by six black executives. Audiotapes revealed that white executives referred to their minority colleagues by such epithets as "black jellybeans." Some of what Texaco's 1,400 black employees (past and present) win: $115 million cash and $26 million for 10 percent raises over five years.

■ Pakistani Prime Minister **BENAZIR BHUTTO**, the first female leader of an Islamic country, is ousted amid accusations of "corruption, nepotism and violation of the rules." First elected in 1988, she was removed 20 months later on similar charges but came back in 1993. Bhutto calls the latest coup a "knife in the heart of democracy."

■ The **LIQUOR INDUSTRY** ends its more than five-decade voluntary ban on TV and radio advertising, claiming a competitive disadvantage against beer and wine companies, which sell their wares via both mediums. Fred Meister, head of the Distilled Spirits Council of the U.S., assures critics, "We're not going to run ads during *Sesame Street*."

■ Three male instructors at the Army's **ABERDEEN PROVING GROUND**, a training base in Maryland, are charged with committing crimes—ranging from sexual harassment to rape—against female cadets under their command. After setting up a toll-free hotline for military women to report current or past abuses, the Army deems 762 additional cases worthy of investigation.

■ In **THE WORST MIDAIR COLLISION EVER**, 349 people traveling on two planes are killed near New Delhi. Soon after, a hijacked Ethiopian Airlines flight runs out of fuel and crashes into the Indian Ocean, 500 yards from a Comoro Islands resort. More than 50 of the 175 aboard are saved by vacationers and the hotel staff.

■ The Chicago White Sox lure **ALBERT BELLE** away from the Cleveland Indians with an $11 million-a-year contract, making the volatile outfielder the highest-paid player in baseball.

■ Testifying in court for the first time, **O.J. SIMPSON TAKES THE STAND** in his civil trial. Responding to questions about dozens of alleged instances of domestic abuse against his murdered ex-wife, Nicole, Simpson denies ever hitting her. When shown a photograph of his battered spouse, he says the bruises might have been the result of Nicole picking at her face. When asked about Nicole's infamous 911 call, made eight months before her death, in which she said she feared her ex-husband would kill her, Simpson states, "I will debate forever that she was not frightened." In response to other challenges, Simpson says he cannot explain why, the day after the murders, he had cuts on his left hand or how blood (his own, Nicole's and her friend Ronald Goldman's) ended up in his Ford Bronco.

▶ FOUR MORE YEARS

On November 5, the First Family (right, with the Second Family, Al and Tipper Gore et al., in Little Rock that night) learned they wouldn't be house-hunting for another four years. Victory had come relatively easily, but not without some disappointments. Yes, Bill Clinton was the first Democrat to be reelected President since FDR—but Republicans retained control of Congress. Yes, Bill Clinton won 49 percent of the popular vote (to Bob Dole's 41 and Ross Perot's 8)—but he once again failed to achieve the majority mandate he so desperately wanted. As a two-term winner, Bill Clinton, only 50, will have no more presidential campaigns; neither will his GOP opponent, Bob Dole, who, at 73, was already considered by many to be too old for the job. But was Election '96 the last Clinton vs. Dole race for the White House? Only Hillary Rodham Clinton and Elizabeth Hanford Dole —both worthy contenders— can know for sure.

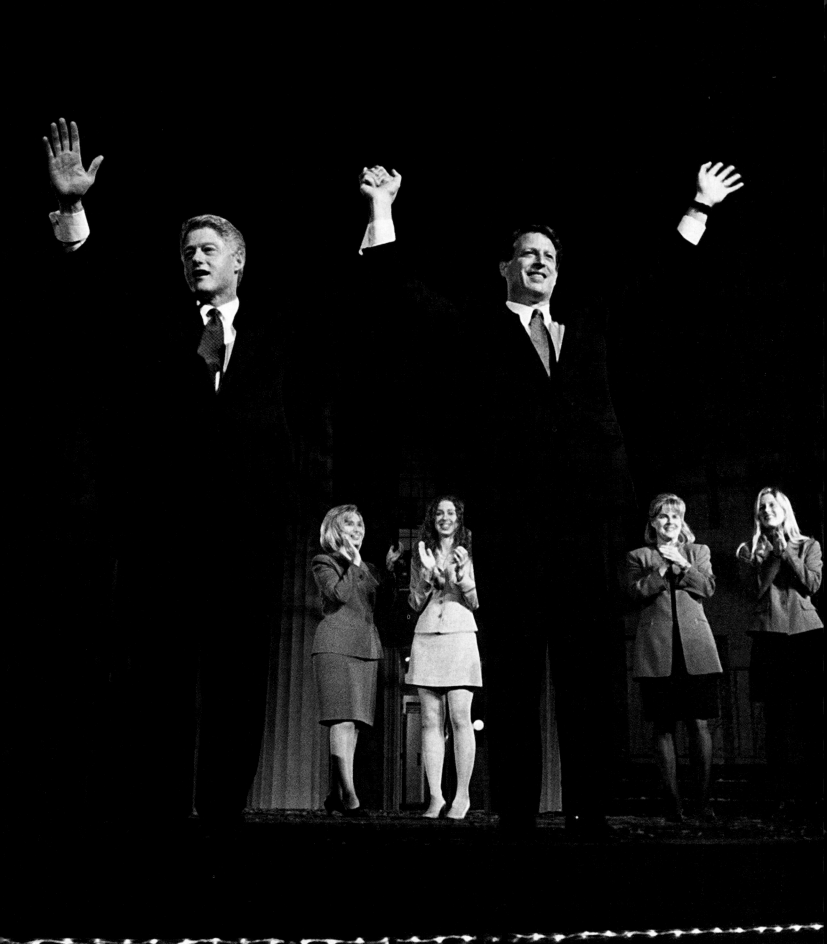

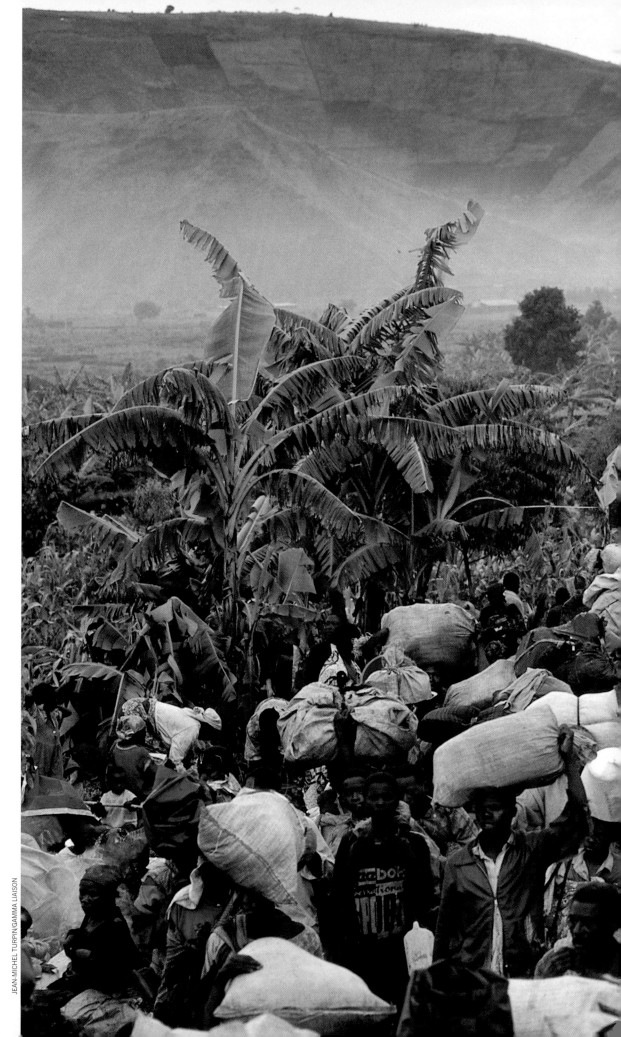

EXODUS FROM EXILE

Zaire's refugee camps were nightmarishly bleak places—but it was hard to get anyone to leave. Among the more than one million Rwandan Hutu crowding the camps were soldiers and militiamen who had massacred at least 500,000 of their Tutsi compatriots, and even fellow Hutu, in 1994, then fled a victorious Tutsi rebel army. For two years, despite repeated promises by Rwanda's new Tutsi-led government that returnees would not be harmed, armed Hutu militants barred any Hutu in the camps from departing. But in November, Zairean Tutsi, backed by Rwanda, broke the militants' grip. Most of the Rwandan Hutu refugees trekked home to an uncertain future, clogging roads (right)—and sometimes losing children—along the way. Others, still fearful of vengeance by the Tutsi, hid in the region's forests. Within a month, a similar scenario played out in Tanzania, leading Rwanda's Tutsi president to stand at the border with open arms. "You are welcome here," he told returning Hutu. "You are welcome in your own country."

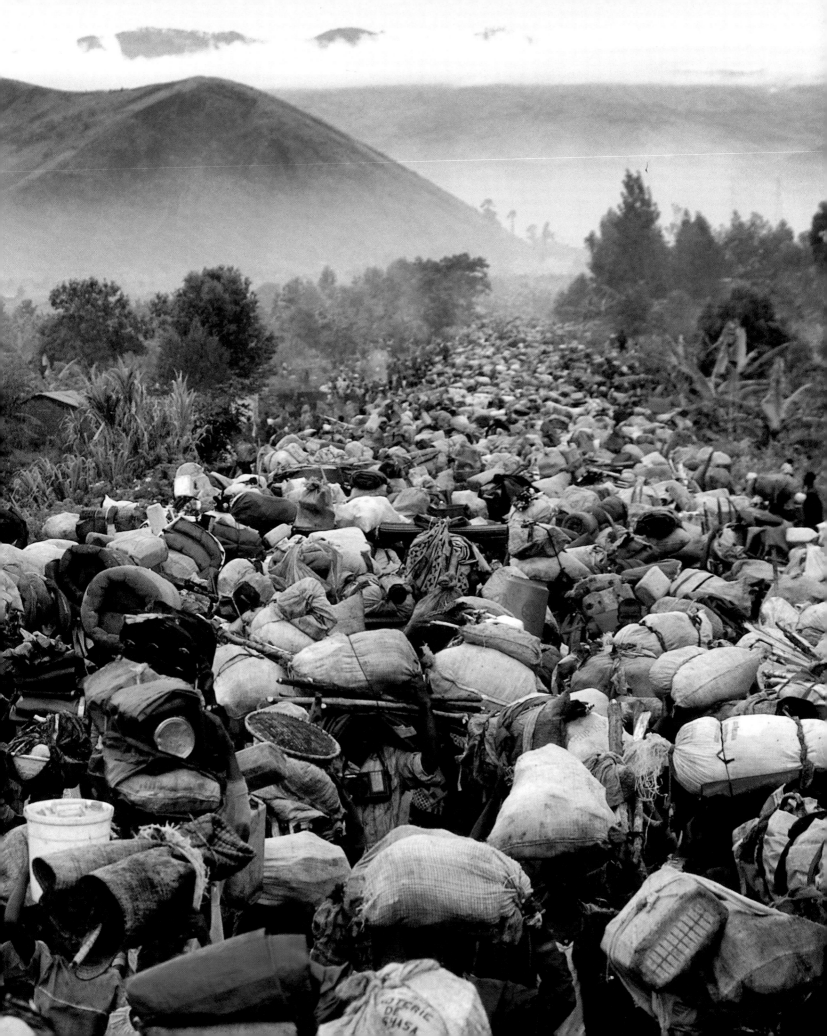

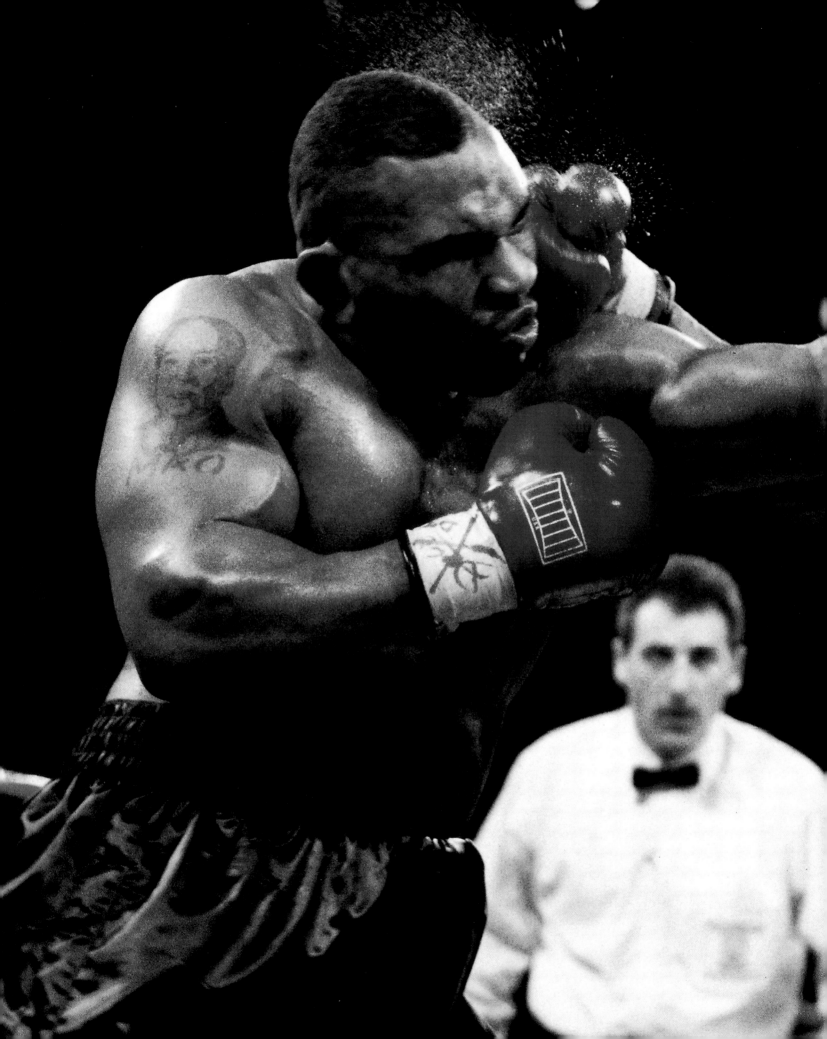

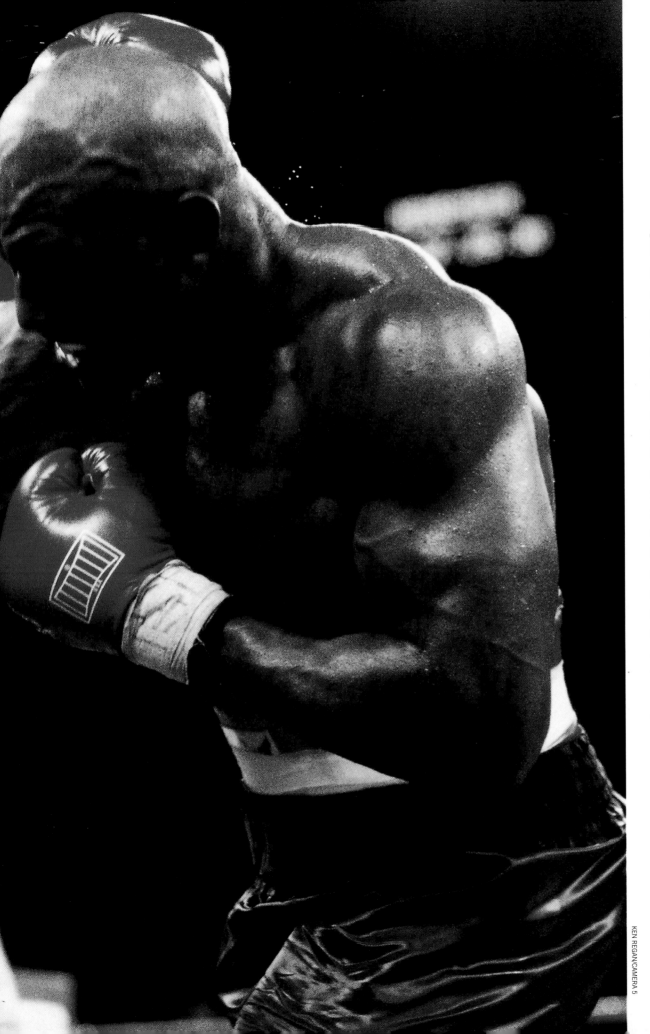

GOOD CONQUERS EVIL

Evander Holyfield, 34, was a nice religious man who'd had heart trouble and been beaten in two of six bouts since losing the heavyweight title in 1994. Glowering, trouble-prone Mike Tyson, 30, was champion again, having annihilated four opponents since his release from jail in 1995 after serving three years for rape. The November 9 fight in Las Vegas was billed as Good vs. Evil, with the odds 7–1 on Evil. Uncowed, strong and smart, Holyfield (in the blue shorts) stalked Tyson relentlessly, floored him once and won an 11th round TKO to become the second three-time heavyweight champ in history. (Ali was the first.) Afterward, Tyson said he couldn't remember what had happened. Still, he was gracious in only his second defeat in a 47-fight career, telling Holyfield, "I just want to shake your hand, man." The victorious Good earned only $11 million, while Evil's purse was $30 million. Come the inevitable rematch, Holyfield should get financial retribution as well.

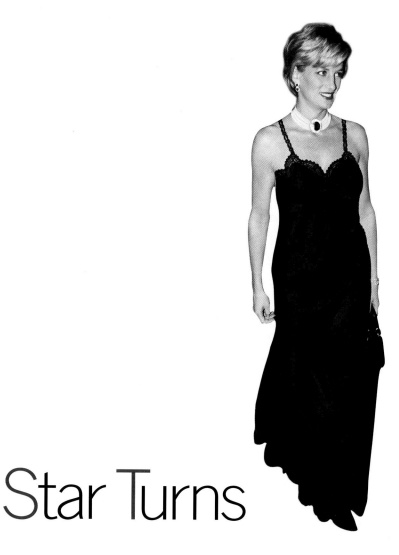

Star Turns

For better or for worse, for at least 15 minutes or almost continuously, they hovered in the collective subconscious. Since 1996 was an election year, political types like Pat Buchanan, the far-right pundit and hopeful GOP presidential candidate, kept popping up on the campaign trail, as did an anti–Bob Dole, antismoking creature called Buttman. Newly single, a divorced Princess Di (above) made the society pages for attending parties. Newly single, a widowed figure skater made headlines for performing solo for the first time in her career. A vulgar beauty and a vain basketball player both made certain they were never far from a camera. While others—among them TV talk show host Phil Donahue, veteran newsman David Brinkley and tennis star Gabriela Sabatini, only 26—made news by retiring from the limelight, at least for a while.

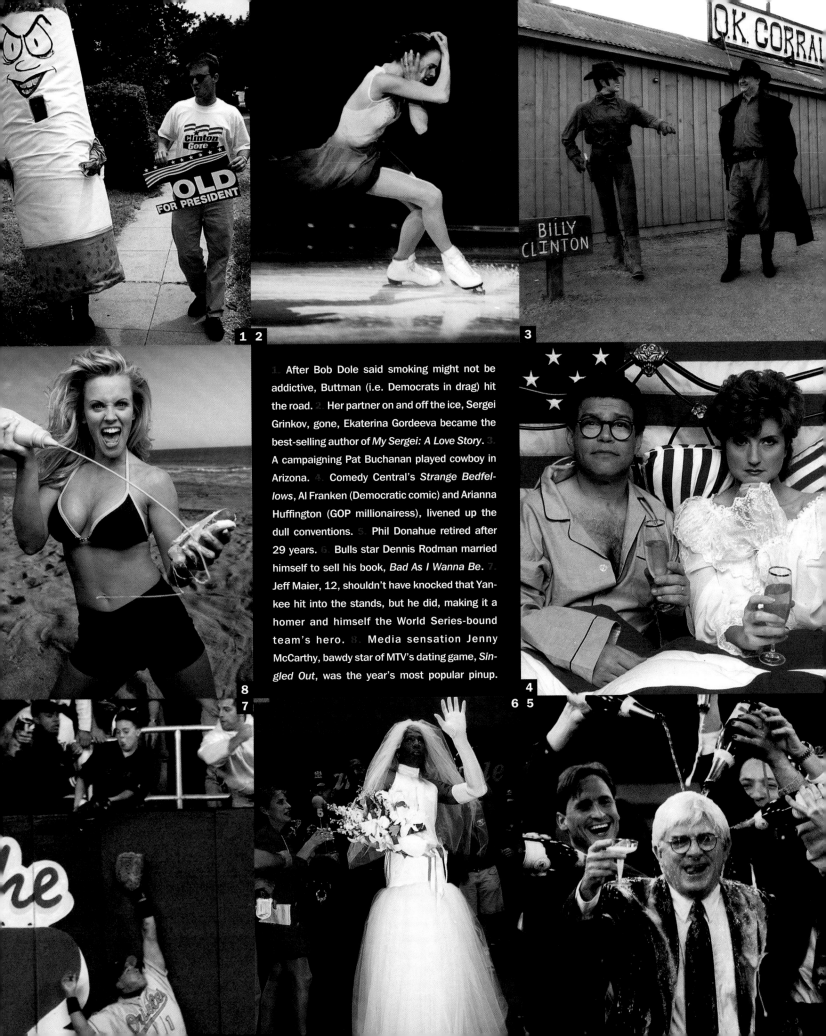

1. After Bob Dole said smoking might not be addictive, Buttman (i.e. Democrats in drag) hit the road. **2.** Her partner on and off the ice, Sergei Grinkov, gone, Ekaterina Gordeeva became the best-selling author of *My Sergei: A Love Story*. **3.** A campaigning Pat Buchanan played cowboy in Arizona. **4.** Comedy Central's *Strange Bedfellows*, Al Franken (Democratic comic) and Arianna Huffington (GOP millionairess), livened up the dull conventions. **5.** Phil Donahue retired after 29 years. **6.** Bulls star Dennis Rodman married himself to sell his book, *Bad As I Wanna Be*. **7.** Jeff Maier, 12, shouldn't have knocked that Yankee hit into the stands, but he did, making it a homer and himself the World Series-bound team's hero. **8.** Media sensation Jenny McCarthy, bawdy star of MTV's dating game, *Singled Out*, was the year's most popular pinup.

December

■ With many of Bill Clinton's top-echelon staffers leaving at the start of his second term (which is when adviser-at-large George Stephanopoulos will take up teaching and memoir-writing), **THE PRESIDENT STARTS HIRING**: Nominated to replace Warren Christopher is **MADELEINE ALBRIGHT**, U.S. ambassador to the U.N.; if confirmed, she will be the nation's first female secretary of state. Other nominations: to take the reins at the CIA, National Security Adviser **ANTHONY LAKE**; and for secretary of defense, **WILLIAM COHEN**, a retired Republican senator from Maine. Sticking around for Clinton II: U.S. Attorney General **JANET RENO**, who keeps her job despite (or perhaps because of) her un-flinching investigations into the administration's alleged wrong-doings.

■ Radar signals from a U.S. spacecraft indicate there might be **WATER ON THE MOON**, a discovery that, if true, could help pave the way for lunar space stations.

■ A Christmas miracle in New Orleans: No one is killed when a **FREIGHTER THE LENGTH OF TWO FOOTBALL FIELDS** crashes into, and partially destroys, the Riverwalk, a shopping complex along the Mississippi.

■ Two male **CITADEL** cadets are suspended for harassing two of the newly coed military college's four female freshmen. As part of what was considered a hazing ritual, they allegedly poured nail polish on the women—and then set their clothing on fire. The women escaped unharmed.

■ Members of Peru's **TUPAC AMARU REVOLUTIONARY MOVEMENT** (MRTA) storm a party at the Japanese ambassador's home in Lima on December 17, taking dignitaries hostage and demanding amnesty for their imprisoned comrades. (Among those in jail: American Lori Berenson, who in January was sentenced to life for collaborating with the group.) By New Year's Eve, more than 400 of the hostages are released, although 81 remain.

■ Six International Red Cross workers in Chechnya are shot in their sleep. The killings, by unknown assailants, are the **WORST PREMEDITATED ATTACK AGAINST AID WORKERS** in the organization's 133-year history.

■ FBI agent Earl Edwin Pitts is indicted for **SELLING SECRETS TO RUSSIA**. His capture comes less than a month after the arrest of Harold Nicholson—the highest-ranking CIA official ever nabbed for betraying the U.S.—who is accused of identifying the CIA's trainees to foreign agents. Both men plead not guilty.

■ Guatemala officially ends its **36-YEAR CIVIL WAR**, in which 100,000 were killed and an estimated 40,000 "disappeared."

▶ **TAKING IT TO THE STREETS**

A year after Serbia's dictatorial president, Slobodan Milosevic, a backer of the Bosnian Serbs, cosigned the Dayton Peace accord that ended five years of ethnic warring in the former Yugoslavia, he pulled a bit too tightly on his reins of power. In November, Milosevic annulled opposition party election victories in 14 cities, including the mayorship of the capital, Belgrade, and citizens took to the streets. The coalition of peaceful demonstrators that called itself Zajedno, "Together," brought Belgrade to a halt every afternoon with crowds of up to 250,000. Theirs was a democratic revolution, they said. No, said the Milosevic government, they were terrorists, influenced by the "dark powers" of Germany and the U.S. December snows came (right), but the protests didn't end. In fact, they spread to 30 cities. In Belgrade, Milosevic brought in his own supporters—bolstered by police in riot gear—raising the specter of civil war in Serbia, a land that had largely been spared bloodshed in the Bosnian conflict.

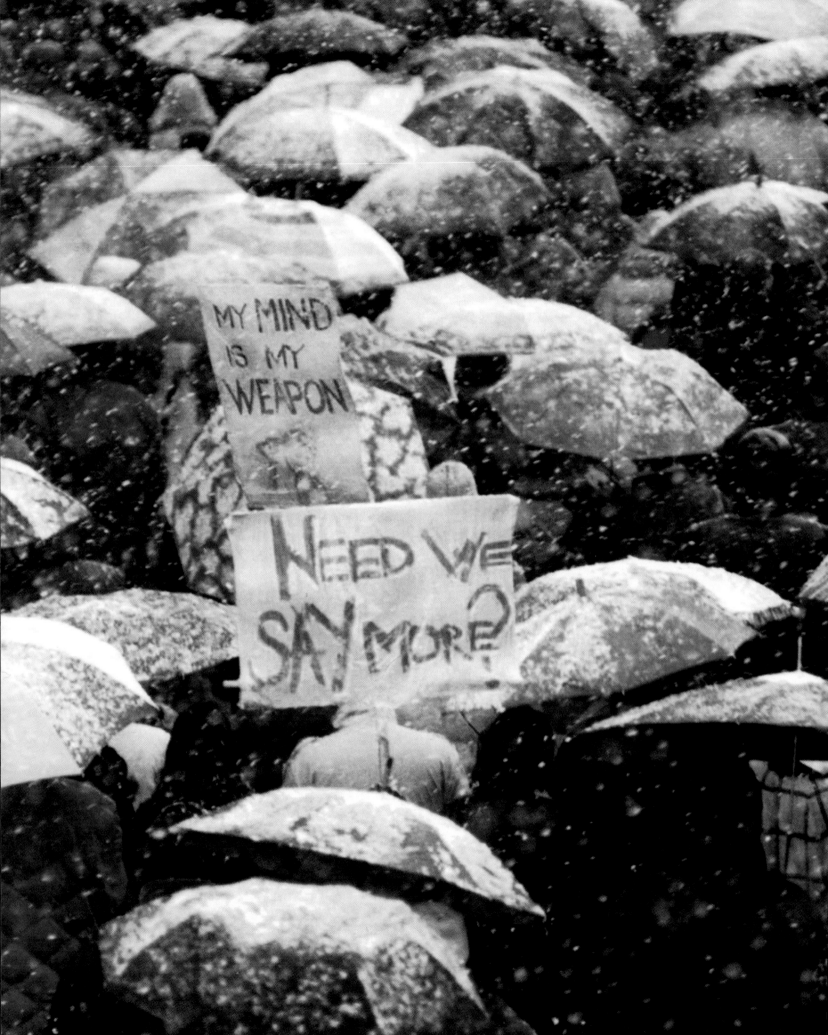

'TIS THE SEASON

The holiday season brought *The Nutcracker* to the nation's capital, where First Daughter Chelsea Clinton (the third flower at right) performed with the Washington Ballet. In Greenfield, Wis., middle school principal Gene Sheldon, too, donned a tutu—he had promised students he would dance to music from *The Nutcracker* if they collected 10,000 food items for the Salvation Army. In Newton Township, Pa., two dozen Christian families displayed menorahs after a Jewish neighbor's menorah was destroyed by teenagers. And at the movies, in *Jingle All the Way,* Arnold Schwarzenegger played a father in search of the holiday's must-have toy. Among the season's real life must-haves: N64, Nintendo's new video game system ($200) and Tickle Me Elmo ($30), a giggling Muppet doll in such demand that its black-market price tag hit $1,000. The Most Wanted Toy, by concerned parents: the Cabbage Patch Kids Snacktime doll, designed to munch on toy fries but accused of chomping children's hair and fingers.

Voices

"I was an equal opportunity eater. Every ethnic group got a shot."
—a campaigning President Clinton, about sampling BBQ pork, egg rolls, corn bread, burgers, pierogies and both tandoori and jerk chicken at a Chicago food festival

"If something happened . . . and you had to leave your children with Bob Dole or Bill Clinton, I think you'd probably leave your children with Bob Dole. . . . It all boils down to, 'Who do you trust?'"
—GOP presidential candidate Bob Dole, at a campaign rally

"You go home tonight, and you decide to order a pizza. Who do you trust to select the toppings?"
—President Clinton's response, made at a White House correspondents dinner

"I was trying to do that new Democratic dance, the Macarena. I'm not going to try that anymore."
—Bob Dole, joking about his fall from a stage (above) at a campaign rally in Chico, Calif.

"I got a job answering phones at the Red Cross. My wife pulled some strings: 'Hello, Red Cross. How may Bob Dole direct your call?'"
—a post-election Bob Dole, mocking his habit of referring to himself in the third person, on Saturday Night Live

"I need to know the price of a gallon of milk and a dozen eggs. I need to know right now!"
—Lamar Alexander, ex-Tennessee governor and short-lived GOP presidential candidate, to an aide when a question catches him off guard. (For the record: The milk cost about $2.60 in 1996, the eggs $1.15.)

"Somewhere up there, Elvis is smiling."
—a music executive after Lisa Marie Presley (above) announced she was divorcing Michael Jackson

"With effect from 2 September 1996, any expenditure incurred by or on behalf of Her Royal Highness the Princess of Wales, on or after that date should be invoiced directly to the Princess of Wales's Office, Apartment 7, Kensington Palace, London."
—from a letter sent to some 40 stores, signed by the administrator of the divorce settlement between Prince Charles and Princess Diana

"She's such a sad soul. It is good that it is over. Nobody was happy anyhow. I know I should preach for family love and unity, but in their case . . ."
—Mother Teresa, about the royal divorce

"If the entire universe tried to persuade me to reconcile with the defendant, I would not."
—South African President Nelson Mandela, 77, testifying in his divorce proceedings against Winnie, 61, his wife of 38 years

"Don't get mad. Get everything."
—Ivana Trump Mazzucchelli, who didn't quite get everything from ex-husband Donald, playing herself in The First Wives Club

"I'm tired of hearing about money, money, money, money. I just want to play the game, drink Pepsi, wear Reebok."
—Shaquille O'Neal, celebrity spokesman for Pepsi, Reebok and others, and the signer of a seven-year, $123 million contract with the Los Angeles Lakers

"Our 13- and 14-year-old readers see him as classic boyfriend material."
—Kate Thornton, editor of the British music magazine Smash Hits, about 14-year-old Prince William (left)

"She wanted it strapless. Do you know what an engineering feat that is?"
—designer Saul Bostwick, about the gown singer Aretha Franklin (above, at a concert in Chicago) asked him to make for her performance at President Clinton's 50th birthday bash at Radio City Music Hall on August 18

"The United States has got some of the dumbest people in the world. I want you to know that we know that."
—media mogul Ted Turner, to foreign journalists, lamenting the low ratings of issue-oriented programs in the U.S.

"Welcome to the Central Stupidity Agency ."
—greeting received by visitors to the CIA's Internet home page after hackers breached security, adding obscenities and links to X-rated Web sites

"When I was in prison I was wrapped up in all those deep books. That Tolstoy crap. People shouldn't read that stuff."
—boxer Mike Tyson

"So I said to them that if people tell you your mother is not prime minister anymore, you just turn around and say, 'So what? She's been prime minister twice. How often has your mother been prime minister?'"
—**Benazir Bhutto (above) of Pakistan, on the advice she gave her three children after she was ousted (again) in a coup d'état**

"Bill Clinton . . . has not a creative bone in his body. Therefore, he is a bore and always will be a bore."
—**David Brinkley, veteran ABC News political commentator, on an election night broadcast. He later apologized to the President.**

"Let me just say one thing to President Clinton. David Brinkley is the David who thinks you're boring. I'm the Dave who thinks you're fat."
—**talk show host David Letterman**

"A mere forty years ago, beach volleyball was just beginning. No bureaucrat would have invented it, and that's what freedom is all about."
—**House Speaker Newt Gingrich (R-Ga.), at the GOP convention, about the sport's Olympic debut at the Summer Games in Atlanta**

"Heavens no! It could get subpoenaed. I can't write anything."
—**Hillary Rodham Clinton, when asked if she is keeping a diary about her life in the White House**

"Did they get the Brookings [Institution] raided last night? Get it done! I want it done! I want the Brookings safe cleared out."
—**President Richard Nixon, on a newly released White House audiotape dated July 1, 1971, three years before his resignation**

"The Pope is dead tired and should be left in peace. Anyone who tries to approach him, even to wish him well, is committing a sin."
—**a parish priest in the Italian village of Lorenzago di Cadore, where Pope John Paul II, 76, vacationed shortly before undergoing an appendectomy**

"I catnap now and then . . . But I think while I nap, so it's not a waste of time."
—**Martha Stewart (above), the superhumanly efficient doyenne of domesticity, who says she gets only three or four hours of sleep a night**

"Obviously, I'd better say 'my family' because they would feel really bad if they thought they came in second to some real gooey desserts."
—**astronaut Shannon Lucid, when asked what she missed most about Earth during her 188 days in space**

"I'm sorry I ever was such a big-mouth frog about the engagement. This is my biggest public regret."
—**Oprah Winfrey (right), explaining that she still has no plans to marry Stedman Graham, her live-in beau and (for the past four years) fiancé**

"Who's Barbra Streisand? I want to see Smashing Pumpkins."
—**a teenager named Kate, unimpressed by the legendary star shooting a movie scene (for *The Mirror Has Two Faces*) on a Manhattan street**

"All of a sudden it dawned on me that the golden boys were trapped inside. I said, 'Don't let the boys burn!'"
—**Mel Gibson, winner of two Oscars for *Braveheart*, calling from New York to friends in Los Angeles as wildfires neared his Malibu home**

"They took my Walt Disney [video]tapes that I play for the children I baby-sit for . . . They took all of my Tupperware."
—**Barbara Jewell, mother of Centennial Park bombing suspect Richard Jewell (since exonerated), about the FBI agents who searched her home**

"When [Hitler] came in, he was good. They built tremendous highways and got all the factories going. . . . Everybody knows he was good at the beginning, but he just went too far."
—**Cincinnati Reds owner Marge Schott, suspended for two years from the management of her team, explaining her swastika armband**

"People don't realize how normal New Yorkers are. They're just like everybody else."
—**Myles Johns, general manager of the first Kmart store in the Big Apple**

"A whole generation could grow up without seeing a head of lettuce in the house."
—**Edith Garrett, president of the International Fresh-Cut Produce Association, on the popularity of prepackaged salads**

"MONTANA: At least the cows are sane."
—**slogan on a T-shirt being sold in Montana, home of Unabomber suspect Theodore Kaczynski, the Freemen (an antigovernment militia) and herds of cattle free of mad cow disease**

"When I bought the tape measure, the first thing I measured was my sanity."
—**decorator Juan Molyneux, who paid $48,875 for the sterling silver item, valued at $600, at Sotheby's auction (above) of Jacqueline Kennedy Onassis's estate**

137

The dancer whose moves were balletic, athletic and fun; the jazz diva with a voice of gold. The actresses who lit up the silver screen; the musicians who made instruments sing. The rapper who ran on the wild side; the government insider suspected of treason. The stogie-smoking stand-up; the homemaker turned beloved writer. They died this year, some having lived long, full lives, others still living it up. We bid them farewell.

Late Greats

Dorothy Lamour

As an actress, she ran the gamut of emotion from sarong to sarong. But this New Orleans beauty, one of Hollywood's top attractions—most memorably in the seven *Road* flicks she did with Bob Hope and Bing Crosby—made more than 50 films in a career that began when Paramount put her on contract in 1935. World War II's first pinup queen, Dorothy Lamour marshaled all her talents in service to her country: Her extraordinary success at raising funds for the war effort earned her the sobriquet Bond Bombshell. She died at 81.

Gene Kelly

Whether singin'—and dancin'—alone in the rain, or paired with Judy Garland (in *For Me and My Gal*), Leslie Caron (in *An American in Paris*) or a cartoon mouse (in *Anchors Aweigh*), Gene Kelly's élan and athleticism were spellbinding. He co-opted his low and wide moves from the ice hockey he played as a teenager in Pittsburgh; he opted for *Pal Joey*–style tight T-shirts, baggy khakis and loafers over the top-hat-and-tails formality of fellow hoofer Fred Astaire (with whom he performed in *Ziegfeld Follies*). "It wasn't elegant," said Kelly, who died at 83. "But it was me."

141

Carl Sagan

Carl Sagan—the Ph.D. in astronomy and astrophysics, Pulitzer Prize–winning author and Cornell professor, who died at 62—believed the wonders of the universe could be understood by all. So he went on TV and explained the mysteries of science, and why the existence of life beyond Earth is not necessarily a sci-fi fantasy. He spoke plainly, and so carefully that he was often mocked for his precise enunciation of each syllable in his trademark phrase, "billions and billions," a reference to the vast quantities of stars and galaxies. But in 1980 more than 400 million viewers tuned in to PBS's 13-part series, *Cosmos,* to hear Sagan say it again and again.

1981 TONY KORODY/SYGMA

Marcello Mastroianni

He was Italy's sexiest masculine export since the Vespa scooter. In a 160-film career launched by director Federico Fellini, who called the actor his alter ego, Marcello Mastroianni was the consummate romantic lead: charming sophisticate, bumbling clown or—in the presence of his frequent costar Sophia Loren—howling wolf. His secret, he believed, was that rather than seducing, he irresistibly succumbed to his leading ladies, whether to Loren's striptease in *Yesterday, Today and Tomorrow* or Anita Ekberg's Trevi Fountain dip in *La Dolce Vita*. In life, he loved as voraciously. When Mastroianni died at 72, his companion of two decades, Anna-Maria Tato, attended his memorial service in Paris, as did ex-lover Catherine Deneuve, the French actress, and their grown daughter. His wife of 46 years, Flora Carabella, and their daughter later buried him in Rome.

Mary Leakey

Matriarch of the world's most famous family of archaeologists (Louis, near right, was her husband; Richard, her son), Mary Nicol Leakey was a self-educated paleoanthropologist from Britain who, for a half century, dug, dusted and documented the origins of humankind. In the 1930s her findings helped establish that the human race hails from Africa, not Asia. In Tanzania in 1978, she uncovered 3.6-million-year-old hominid footprints—proof that human ancestors had walked upright some three million years earlier than previously believed. Leakey died at 83, in Nairobi.

1960 ROBERT F. SISSON/© NATIONAL GEOGRAPHIC SOCIETY

Timothy Leary

He was the ultimate Pied Piper, an irrepressible proselytizer for everything from LSD to cybernetics to dying. A psych professor at Harvard, Leary was fired for "sharing" LSD with undergrads. Later, he busted out of prison (he had several penal alma maters). Richard Nixon once called him "the most dangerous man in America." He even defied death. Knowing he had cancer, Leary mused, "You've got to approach your dying . . . with curiosity, hope, fascination, courage." And lots of drugs—coke, pot, tobacco, nitrous oxide, caffeine, wine. His Web site carried the details of his final days. He was 75.

Tupac Shakur

His life was a tragic rap opera. His first rap, written in high school after a friend was shot, was about gun control. His lyrics, chanted in a crisp baritone, dealt with racism, poverty and the "thug life" as lived by "gangstas" he both celebrated and scorned. When Shakur was a boy, his father was shot and killed; his mother, a Black Panther, was in jail on a bombing charge while pregnant with him. (She would be acquitted.) The rapper's career veered dangerously between wild material success and a need to stay in touch with his inner-city roots. *Me Against the World,* his third solo album, entered the charts at No. 1 while he was serving a prison sentence for sexual abuse. During the trial he was shot—five times—outside a recording studio. "I wish they didn't miss," he later sang in "Only God Can Judge Me." Next time, they didn't. At 25, Shakur was gunned down in a Las Vegas drive-by after leaving a Mike Tyson prizefight.

Alger Hiss

A Harvard Law graduate who clerked for Supreme Court Justice Oliver Wendell Holmes, advised FDR at Yalta and helped create the United Nations, the patrician Alger Hiss seemed an unlikely traitor. But that's exactly what Whittaker Chambers, a *Time* editor and ex–Soviet agent, said Hiss was when he worked at the State Department in the 1930s. The case fueled the career of then-Congressman Nixon and the red-baiting crusade of Sen. Joseph McCarthy. In 1950, Hiss, claiming innocence, was convicted of perjury. He spent 44 months in jail—and the rest of his life trying to clear his name. He was 92.

Ella Fitzgerald

When she took the amateur-hour stage at Harlem's Apollo Theatre in 1934, 17-year-old Ella Fitzgerald hoped to launch her career as a . . . dancer. But she was shy, and her feet simply wouldn't move. Desperate, she opened her mouth and out came "The Object of My Affection." The moment was transformative: "I knew I wanted to sing before people the rest of my life." And so she did, better than anyone. The stats—13 Grammys, 21 times *Down Beat* magazine's top female singer of the year—don't tell the story. The scats—on the live-in-Berlin album, on a dozen versions of "Mack the Knife"—don't tell the story. The legacy—the fabulous songbook collections, the immortal duets with Louis Armstrong—even the legacy doesn't tell the story. The story was told in Harlem that magical night, when a voice like no other was revealed. The voice was a natural, and it made Ella one, too. She was 79.

Bill Monroe

A Kentucky-bred tenor with a high lonesome wail, Bill Monroe invented an American art form—that fiddle-laced blend of folk, blues, gospel harmony and jazz-style improvisation known as bluegrass. His band, the Blue Grass Boys, helped launch the careers of such legendary pickers as guitarist Lester Flatt and banjoist Earl Scruggs; his sound influenced artists from Elvis (who covered the master's "Blue Moon of Kentucky" on his first single) to the Eagles to Ricky Skaggs. Yet the Paganini of the mandolin—84 when he died—denied ever having written an original tune. "All that music's in the air around you all the time," he said. "I was just the first one to reach up and pull it out."

Minnie Pearl

Her howling "How-DEEE!" and recycled hayseed jokes made Sarah Ophelia Colley Cannon, who died at 83, the grande dame of the Grand Ole Opry—never mind that she came from a well-to-do Tennessee family and was a finishing school grad. As country's favorite comedienne for more than 50 years, she donned the gingham dress, battered shoes and straw hat ($1.98 price tag nearly always a-dangle, symbolic, she said, "of all human frailty") of her alter ego, delighting audiences with raucous tales of Grinder's Switch—the fictional Minnie Pearl's fictional hometown.

Greer Garson

She was Mrs. Miniver, the handsome, brave, dignified British housewife, the title character of the World War II film that won the hearts and minds of nations. (Winston Churchill called it "propaganda worth a hundred battleships.") Greer Garson, of the truly green eyes, golden-red hair and porcelain skin, was born in Ireland in 1903 of Scottish ancestry. Plucked from the London stage—where some lesser lights had dubbed her "Career"—she would earn seven Oscar nominations (winning in 1942 for Mrs. M.) for such films as *Goodbye, Mr. Chips*, *Madame Curie* and *Sunrise at Campobello*.

udrey Meadows

Audrey Meadows died at 69. She was survived by Alice Kramden, who will live forever. The wife of blustermeister Ralph Kramden (Jackie Gleason, with her at right), Alice anchored the TV classic *The Honeymooners*, putting her bus driver husband in his place with the Holy Triad of prefeminist weapons—patience, love and a leveling sense of humor. Consider the famous scene in which Ralph burns himself in the kitchen. Ralph: "Isn't there any lard around here?" Alice: "Only about 300 pounds of it."

1983 GUY LE QUERREC/MAGNUM

Barbara Jordan

When she arrived in Washington in 1973, no black southerner had served in Congress since Reconstruction. But it was during televised hearings on the impeachment of Richard Nixon that the lawyer from Houston served notice of a new era's dawning. Thanks to the long struggle for civil rights, the Texan declared, "I have finally been included in 'We, the people.' . . . I am not going to sit here and be an idle spectator to the diminution, the subversion, the destruction of the Constitution." The speech made Jordan a star (and helped seal Nixon's fate), but multiple sclerosis soon forced her from the House. She continued to address hearings and conventions from a wheelchair, her capacity to inspire undiminished, until shortly before her death at 59.

François Mitterrand

He had spent Christmas in Egypt with his mistress and daughter, and New Year's in France with his wife and two sons. A few days later he stopped his treatments for prostate cancer. When he died in January at the age of 79, François Mitterrand, the longest-serving president in French history, was still very much in control: He left instructions for both women to accompany his coffin. The son of a stationmaster in southwestern France, a soldier who escaped from a Nazi prison camp, Mitterrand was so secretive a man that reporters called him the Sphinx. (He kept his World War II affiliation with the collaborationist Vichy government hidden until 1994.) During

Spiro Agnew

Speechwriters penned the infamous antiliberal invective—"pusillanimous pussyfooters," "nattering nabobs of negativism"—that he delivered with gusto. But alliterative arrows did not protect him when it was revealed that, as governor of Maryland, he'd been on the take. In 1973, just 10 months before Watergate toppled his boss, Spiro Agnew became the first Vice President to resign in disgrace. He died at 77.

Erma Bombeck

She was her most hilarious at wit's end, which, appropriately, was the title of the syndicated column in which she spun myriad tales about her quotidian life. Bunk beds, septic tanks, dirty ovens—as a homemaker in Centerville, Ohio, she knew all about them. Bombeck started writing at age 37 because, she said, she was "too old for a paper route, too young for Social Security and too tired for an affair." She died at 69.

Cardinal Bernardin

In the 1980s, when Joseph Bernardin was a bishop, he condemned the nuclear arms race. As cardinal of Chicago, he sponsored masses conducted by gay Roman Catholics and opposed the death penalty. But for all his liberalism, this activist priest stayed true to church doctrine: A week before he died of cancer at age 68, he wrote to the U.S. Supreme Court urging it not to recognize the right to doctor-assisted suicide.

Margaux Hemingway

She was beautiful. She was also bulimic, alcoholic, depressed, epileptic, divorced (twice) and broke. And, as if that wasn't bad enough, she had a younger sister (Mariel) who'd made it as an actress—she hadn't. Destructive furies raged in and around her. Almost 35 years to the day after her grandfather Ernest put a shotgun to his head, the former million-dollar supermodel took a few too many pills. She was 41.

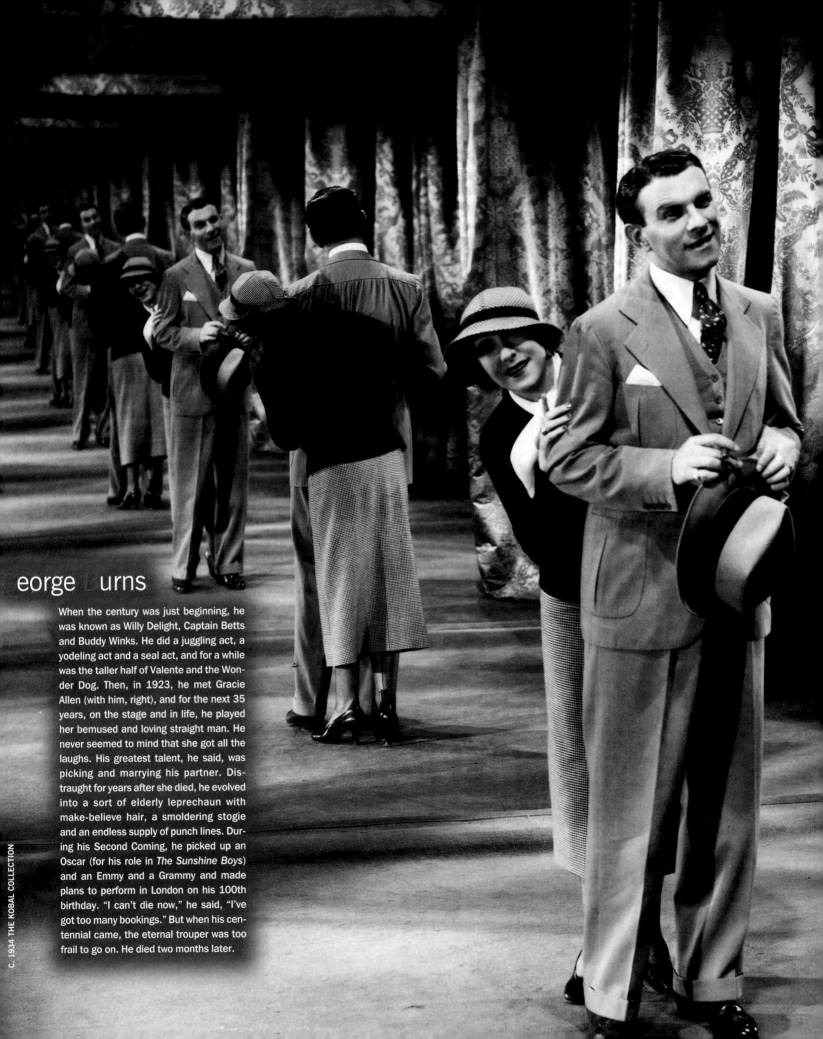

eorge urns

When the century was just beginning, he was known as Willy Delight, Captain Betts and Buddy Winks. He did a juggling act, a yodeling act and a seal act, and for a while was the taller half of Valente and the Wonder Dog. Then, in 1923, he met Gracie Allen (with him, right), and for the next 35 years, on the stage and in life, he played her bemused and loving straight man. He never seemed to mind that she got all the laughs. His greatest talent, he said, was picking and marrying his partner. Distraught for years after she died, he evolved into a sort of elderly leprechaun with make-believe hair, a smoldering stogie and an endless supply of punch lines. During his Second Coming, he picked up an Oscar (for his role in *The Sunshine Boys*) and an Emmy and a Grammy and made plans to perform in London on his 100th birthday. "I can't die now," he said, "I've got too many bookings." But when his centennial came, the eternal trouper was too frail to go on. He died two months later.

Brown

Growing up in Harlem's Hotel Theresa among sports heroes and jazz legends, Ron Brown learned that ambition and energy can beat long odds. At Middlebury College, his fraternity pledged him as its first black member. He was a caseworker for the National Urban League and, later, a political strategist and elite D.C. lawyer. But the purpose of power, he believed, was to secure freedom for others. And that is what America's first African American secretary of commerce, only 54, was doing when his plane crashed in Croatia.

Roger Tory Peterson

Blessed with phenomenal hearing, keen vision and unwavering energy, this ornithologist-artist-author—who spent many childhood days eyeing birds in upstate New York—published his first field guide to birds in 1934. He combined concise writing and an innovative identification system with lovely, accurate paintings. The pocket-size books—there are now some 18 million in print—simplified bird watching and helped create a community of 60 million birders in the U.S. The man they fondly called King Penguin died at 87.

1980 HARRY BENSON

Edmund Muskie

The senator from Maine drafted a slew of historic environmental bills in the '60s and early '70s. In 1972 he was the favorite for the Democratic presidential nod. But while denouncing rumors (planted by Nixon's dirty-tricksters) that his wife liked to drink, smoke and curse, Muskie appeared to shed tears. He later claimed the moisture came from melting snow-flakes, but his race was over: "They were looking for a strong, steady man, and here I was weak." Still, he was tough enough to be secretary of state during the Iran hostage crisis. He died at 81.

1958 UPI/CORBIS—BETTMANN

Carl Stokes

In 1967, Carl Stokes told an elated crowd that, for the first time, he knew "the full meaning of the words 'God Bless America.'" He was the newly elected mayor of Cleveland—the first African American ever to govern a major city. But the elation was short-lived: Race riots erupted in the city as black nationalists battled police. Stokes was praised for containing the violence, but his administration was "haunted" (his word) ever after. He went on to become a TV news anchor, a judge and, a year before his death at 68, ambassador to the Seychelles.

1969 UPI/CORBIS—BETTMANN

Tiny Tim

It was a strange moniker for a man who stood over six feet tall. Stranger still were Herbert Khaury's looks: beak nose, ghostly complexion and long frizzy hair. Strangest of all: This ukulele-plucking crooner of forgotten love songs was a world–famous celebrity. In 1969, more than 40 million viewers tuned in to *The Tonight Show* to see him wed a 17-year-old fan he called Miss Vicki. (They later divorced.) Tiny Tim suffered a heart attack at a benefit in Minneapolis while singing his trademark "Tiptoe Thru' the Tulips." The last sound he heard was applause. He was 64.

Gerry Mulligan

In many ways, the words Gerry Mulligan epitomize what jazz has meant to many Americans in the decades since World War II: wine, women, song. Great song. A composer and arranger, Mulligan (who died at 68) coaxed beautiful, supple sounds from his baritone sax. He left high school in Philly to work with the big bands and soon landed gigs in New York with Gene Krupa and Claude Thornhill. There he met Gil Evans, and then Miles Davis, with whom he created "cool jazz." His influence on jazz is so ingrained that pianist John Lewis once observed, "they won't know to give him credit in the next generation."

Claudette Colbert

"I just never had the luck to play bitches," she said long ago. "Those are the only roles that ever register, really." Well, not really. For instance, the runaway heiress in *It Happened One Night* (pictured)—Colbert's Oscar-winning performance—isn't bitchy, though she is thoroughly spoiled. When it came to Claudette Colbert, Depression-era America wanted saucy-but-nice. The former Lily Claudette Chauchoin of Paris lifted that skirt above the knee and gave it to them. After she wrapped *One Night*, she told friends, "I've just finished the worst picture in the world." The lovely Miss Colbert, 92 when she died—so right as an actress, so wrong as a film critic.

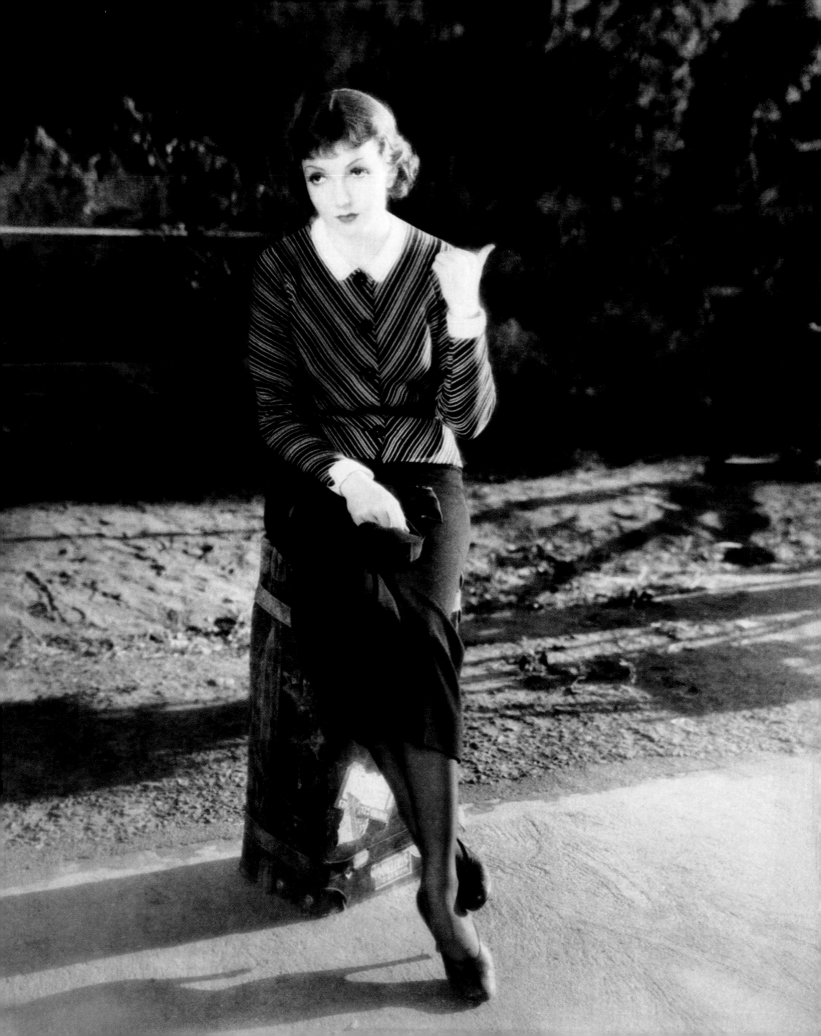

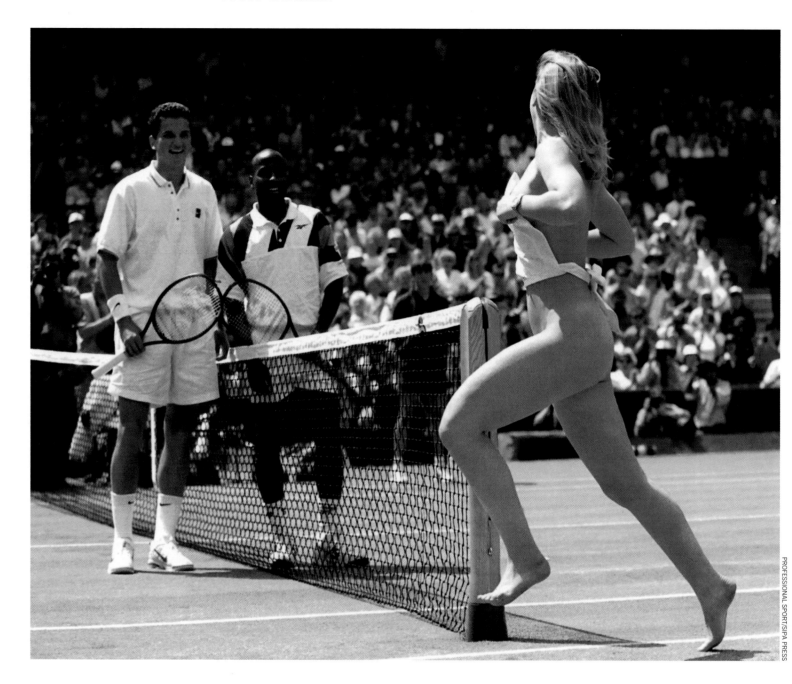

It must be love

The men's singles final at Wimbledon hadn't even started when catering assistant Melissa Johnson decided it was time for a service break. Wearing only her apron and a smile in the July sun, Johnson caused a racket with her own hot streak—and gave the Netherlands' Richard Krajicek (above, left) and MaliVai Washington of the U.S. an especially memorable warm-up. The 23-year-old was escorted off the court by blushing bobbies, but charges were dropped. Oh, yes, Krajicek won easily. Said Washington of his two brief encounters, "I got flustered, and three sets later I was gone."